THE GOD CHILD

NANA OFORIATTA AYIM

BLOOMSBURY CIRCUS
LONDON · OXFORD · NEW YORK · NEW DELHI · SYDNEY

BLOOMSBURY CIRCUS
Bloomsbury Publishing Plc
50 Bedford Square, London, WC1B 3DP, UK

BLOOMSBURY, BLOOMSBURY CIRCUS and the Bloomsbury Circus logo are trademarks of
Bloomsbury Publishing Plc

First published in Great Britain 2019

A catalogue record for this book is available from the British Library

Library of Congress Cataloguing-in-Publication data has been applied for

ISBN: HB: 978-1-4088-8242-9; TPB: 978-1-4088-8243-6; EBOOK: 978-1-4088-8240-5

2 4 6 8 10 9 7 5 3 1

Typeset by Integra Software Services Pvt. Ltd.
Printed and bound in Great Britain by CPI Group (UK) Ltd, Croydon CR0 4YY

To find out more about our authors and books visit www.bloomsbury.com
and sign up for our newsletters

For John Berger

My mother was my first country,
the first place I ever lived.

Nayyirah Waheed

PART ONE

I

I cannot remember how I first knew my life was not my own. It came to me, not at once; not in words, or visions; not in capitals, or in imperatives or assertions; but as a perennial wordless whisper, a stream, whose beginnings were beyond sight, and whose ends I somehow seemed to carry.

I looked over at him; he was the one they would have chosen for me, and yet I had arrived here by my own volition.

I had watched in, all these years, on both sides, from close quarters, as if at a poker table, too smoky, too male, too shrouded in codes I had neither the ability nor willingness to understand.

I had thought of the generation above me as still too tainted by colonial malaise; of my generation as a bridge; of our daughters and sons as the ones to be truly, hopefully, free.

And yet, quietly, imperceptibly, I had been witness to a transformation; from a narrative too large, too unwieldy, too unconcerned with the small and the human, too couched in arrogance and entitlement – to one of hard work, nobility, loyalty, fidelity.

Though the clarity, the vision, the truth of it, was not yet apparent, it seemed a certain grace had set in, and that it was all of ours.

There was tiredness, exhaustion, disillusion, cynicism, mistrust, on all fronts, but strangely, it also felt like something new was beginning, not for one side or the other, but for us as human beings sharing a geographical space, creating a common story.

All that was missing was the joy, the lightness and innocence, of my mother, her brothers, of Kojo; and yet they had not survived.

I looked at him now, as he walked towards me – at all of them, they who had finally won – but I was more my mother's daughter, Kojo's sister, than theirs.

Could I look back to that first splintering, that first awakening, and learn?

Could I win as they had, and still, as they had not, remain open?

Could I, as my mother and Kojo had not, survive?

2

'*Abele*,' my mother sang at the dressing mirror, as I lay on the satin quilted cover on the bed behind her, watching.

'*Abele*.' She danced in her chair, the ends of her mouth turned half downwards in appreciation. 'It's a pity my child did not take my beauty,' she told her reflection, putting cream on her face, caressing it into the softness, surveying the escarpment of cheekbones, the glow trapped in the amber recesses of her skin. She turned to me as if remembering. 'You must always look more than perfect. Not just good enough, but perfect. You must always be better than them in everything you do, otherwise they will think you are lower.'

My mother came out, the smell of her powdery luxury encasing me, watering my eyes. I opened them. She walked sideways down the stairs, her shoes clacking against the heels of her feet.

Would it arrive overnight, the desire to perfection, like the ability to smell expensive and wear fitted petticoats?

'Maya, what is wrong with you this girl? Do you want your father to come home and trouble my life? Ah.'

I walked down the stairs, slowly, sideways, towards my mother, far like the rest of the world. When I reached

her, she buttoned on my coat. My arms stuck out to both sides. I looked past her at my reflection in the mirror, half there, half in another place.

She was stepping back to look at me, edging towards the open box by the front door.

I closed my eyes, not wanting to see her fall.

'*Aich*,' she shouted.

I opened my eyes.

She was not sitting on top of the large new television, but suspended above it, her arms stemmed behind her against the wall, her legs spread out, skirt hiked up.

I began to laugh.

'Ah!' This time, her harshness came through her laughter. '*Kwasea!* Come and help me.'

I pulled her up, her weight threatening to knock me over.

She looked into the box, turning the corners of her mouth down. 'Hmm,' she said, her skirt still hiked up around her thighs, 'they shall see.'

I walked next to her, through the more-than-perfect neighbourhood of semi-detached red-brick houses, made only less so by the African family camouflaged within one of them. Less than perfect, but not jarringly so, because he was a doctor and his wife was beautiful and his daughter immaculately groomed. Less than perfect, because they hung their washing out in the garden until the neighbour told them not to. Less than perfect, because their television was propped up with books and not a stand. Less than perfect, because the father deemed the new television with stand the mother bought with his credit card too expensive, and was having it returned. But still, separate from the men that stood huddled outside the

6

Bahnhof and McDonald's reeking of illegality; the women that sat in the Afroshops chatting in mismatched syncopated chorus as the hairdressers braided hair and the cloth sellers took out dotted, striped, stamped lengths of Dutch wax, like multicoloured species of exotic animals.

I looked up at my mother talking too loud in her unperfected accent. People looked at her as she walked past, but she did not notice, because even if I had not taken her beauty, she did not understand that, to be better than them, you had to be like them so completely that they no longer noticed your difference.

I do not know whether it was there from the beginning, this knowledge that I was never just I, myself, but an I that was in me and also outside and that watched and witnessed all I did and everything around. When I later heard in words about the ancestors, I already knew, and when my father gave me the name – *εno*, grandmother – while almost still a baby, it was because he too could see that what I saw and understood was not mine alone.

It began to rain. She wrapped me close to her, her pea-green silk raincoat giving shelter to us both as we ran.

We reached the department store and rode on the escalator up past the electronics, the cosmetics, the household goods, and underwear, to the women's designer section. It was almost empty. Outside it was getting dark and the Germans were sitting down to their *Abendbrot*.

The sales lady looked us up and down as we passed, still dripping. My mother was weaving in and out of the racks, like a person drunk, her hands scanning silks, polyesters, sequins and feathers, taking down one after the other, until her arms were full, clothes trailing behind her on the floor.

The saleswoman stood behind us now, but my mother still did not notice.

'*Kann Ich helfen?*' she asked in a thoroughly unhelpful tone.

My mother turned around now and laughed. '*Ich will Alles kaufen,*' she said, '*Alles. Hier hilf mir.*' She addressed the woman in the familiar *Du*, not the formal *Sie*, and handed her the clothes. She looked vaguely left then vaguely right, brow furrowed as if concentrating, but her body movements betrayed no focus at all. She dropped her scarf behind her.

I looked at it on the floor, looked at the woman's frowning face as she bent to pick it up and followed my mother like a lady's maid. I turned towards the children's section. I ran my hands through the clothes like my mother, stopping at velvets and soft dark cords. I closed my eyes and saw myself in the cords: a perfect German girl, a young Romy Schneider running through the forest, arms outstretched towards a fenced-in deer, smiling like the girl on the Rotbäckchen six-fruit juice bottle, cheeks apple-red to match the kerchief on her head.

'*Guck mal! Guck mal der Neger!*'

It was a little girl's voice behind me. My hand stopped on the wine-red velvet dress. I looked up to see who she meant, then turned towards her. She was pointing at me. She had mistaken me for a boy. Her mother looked at me angrily, took the girl's hand and walked away. I stopped to look in the small full-length mirror on my left. My hair was in four large plaits. It was true I was wearing trousers, but how could she mistake me for a boy? My father always told me to wear earrings and I did not. I touched my ears.

'Beautiful,' I heard behind me. 'Yes.'

My mother was picking up the red velvet dress and another, peach with white lace ruches and a satin band. She was picking out white shoes and a white dress with

strawberries on the left breast. She was picking cord dungarees and a matching shirt.

'*Ich bin Prinzessin, wissen Sie?*' she was saying to the saleswoman. '*Prinzessin Yaa.*' She was telling her that where she came from her clothes were made of lace and gold and that she had servants and grew up in a palace.

The woman was looking a little frightened now.

My mother went into the changing room and I followed, to be turned into a little princess-in-the-making, beauty's heir.

When we left with five plastic bags, there were four saleswomen tending to my mother. She paid with my father's credit card. They walked with us. They patted my hair. They helped my mother onto the escalator. '*Tschüss Prinzessin Yaa. Tschüss.*'

She did not look back. Her eyes were fixed downwards. I followed them and saw what she saw: a large cupboard full of plates of all sizes and depths; white plates with solid ink-blue borders and swirls of gold that nestled inside the borders like gold-tipped swans at the edge of a lake, bewitched.

We reached the ground floor and she headed towards them, not straight, but walking in a kind of zigzag. I looked around. No one was watching. She stood in front of the cupboard, and this time a man came to her side.

'*Ja?*' he said, his eyebrows raised.

'*Wie viel?*' she asked.

'*Wie viele Teller?*' he asked the eccentric woman wanting to know the number of plates.

'*Wie viel kostet sie?*' She pointed at the plates.

The man looked confused. Did she want to know the price of one plate?

'*Sie will wissen wie viel alles zusammen kostet,*' I offered.

'Ah,' the man said, and went to the counter and opened a book. He came back with it and showed my mother, silently, looking up.

'*Ich kaufe,*' she said.

His eyebrows moved up higher. He closed the book and led us to the counter.

My mother handed over the card and told the salesman that the plates must be delivered during daytime before six and not at weekends. She did not want my father to see.

'*Natürlich,*' the man said, smiling tightly. He handed her the receipt and looked down at me. '*Du sprichst aber gut Deutsch,*' he said, not a compliment so much as a statement of fact.

It always surprised them that my German was fluent.

I put on my broad little-girl smile and shrugged my 'I don't know how it came to be so fluent either' shrug, my apologetic and surprised by my own ingenuity shrug, so that he would not realise that I had worked at the mastering and not, as they assumed, acquired it by accident or oversight. I smiled the smile that was rose-patterned wallpaper over the extant unpapered cracks through which, if they looked hard enough, they might have seen a room within a room. A bulb, naked and alone. A bare table, covered in layered faded scrawl, its wood splintered and creviced. An empty chair. Against the wall a shadow of something or someone that had already long left. And at the far end, barely visible, but there, an open door.

3

England was always the place we dreamt of. I dreamt of a room of my own and midnight feasts and tuck boxes and girls called Gwendolyn and Catherine and of school uniforms. My father dreamt of the great halls of Cambridge to which he might have gained entry if only he had not been too nervous and overslept his exams. My mother dreamt of piano lessons and riding lessons for me and of the dreams of her father for herself. My room was filled with English books and at breakfast we drank milky light brown sugary tea and ate soft soggy white bread with margarine and marmalade we got from the English shop near the English army barracks, where my father took me to see my first films on a big screen, *E.T.* and *The Jungle Book*. Both E.T. and Mowgli were like us, far away from home. They were also like the characters in one of the books on my father's shelf, *The Three Sisters*, forever dreaming of returning to Moscow, except the three sisters did not return in the end.

Which were we like, I wondered, Disney or Chekhov? I went up to get *The Three Sisters*, and put it on the kitchen counter in front of my mother.

'What am I going to do with this?' she asked. 'You and your father and your book learning.'

I did not mention the Danielle Steel romance novels I took from her bedside shelf and read by the light of a torch under the covers.

She picked up the Chekhov and threw it back down. 'All these books he brings back from his "medical conferences". Why? Hmm? Does he tell you where he's going? Does he tell you about his girlfriends? What bookshops are there at medical conferences? That name of yours. Maya... Is anybody in his family called Ma-ya? Hmm? Go and look back at his ex-girlfriends and see.'

I took the book and wiped off the stew she had fingered it with. I was in the hallway and she was still talking. I went and sat at the top of the stairs and opened the book, her voice and the air, peppery with chicken stew, rising up, as I waited for my father, for the sound of the key in the lock, the metallic rotation of comfort, of confirmation.

He had already sent a Peugeot 304 back, along with other things we would need for our return home. The only memories I had were of what my mother told me and of the village my father threatened to send me to when I did wrong, and they were second hand. Abomosu. It sounded like the Timbuktu that the cats in *Aristocats* had been banished to in my favourite cartoon, a dusty, arid place beyond the edge of imagination. I longed to ask him how it could be so bad if it had brought forth him; if the place we were going back to was the same place as that of punishment, but I would have been too known. And I was to arrive a young lady, who knew how to say please and thank you and pardon me like the English and not speak like the Germans who had no manners and were rude.

My father told me that Dr Lartey's son had gone to school in Oxford, and now he played professional tennis in his

spare time and sang for his school choir in red and white gowns just like they wore in Cambridge. So I began going to English classes after school, to learn the difference between my th's and my s's, to say think instead of sink. But the lessons only confused my tongue and gave it a lisp, an almost imperceptible protest at the excess of words, of things.

Finally, the click. I got up and dangled my foot over one step and then lowered my full weight onto it, step after step. He took off his coat, put down the black briefcase browned at the creases, which held his knowledge, stethoscope, pills and injections. I reached his side as he put his feet still in their socks in the brown leather slippers that had shown me, when I looked down that Christmas, that Santa Claus in the white plastic mask and beard was only my father. I had not told him about this discovery, just as I had not told him that I always won at Snap because I could see the doubles of the cards from underneath our glass table, nor that when I had shouted, 'Moonlighters,' at the sight of a keyboard player in the pedestrian area of our town, it was because I had learnt the word on *Sesame Street* that day, and not because I recognised Mozart's sonata, as he had so proudly thought.

'Boys will not like you if you are too clever,' he told me when I argued with him and would not let go, which made me fill inside with tears.

I led the way down to the cellar and turned on the light behind the bookshelf, which was filled with medical encyclopaedias, novels, and boxed classical music records. This was our world, his and mine. My mother never came down, except to clean. He sat in the leather swivel chair. I waited for him to look up, to give me the codes, the metallic click in the door.

'So?' he asked.

'I read the book,' I said. 'The children climb up a magic tree and there are all kinds of strange creatures there. And there is a dream where they are in a giant bed, so they are dreaming in their dream and...'

He was not listening. He was looking beyond me into space and he was not listening.

'I got ten out of ten in English dictation,' I said, 'and an eight out of ten.'

'Why eight out of ten?' He frowned. 'Why not ten out of ten? You must always do your best. Do you understand?'

I nodded. 'Yes.'

'Yes, what?'

I hesitated, not wanting to subject to this meaningless wordplay that I knew was his father's, because it was not in his own voice that he asked.

'Yes, what?'

'Yes, Daaad.' I got up to go. There were no answers here. But, maybe... 'Do I have to go to school tomorrow? I'm not feeling very well.' It was not even a full lie.

His look focused. 'Oh yeh,' he said, pronouncing the 'yeh' like the Germans said 'oh weh' but Ghanaian-Anglicising it. 'How do you feel?'

I opened my mouth, not knowing what would come out of it. 'I have a headache and I feel sick... And dizzy, like I'm going to fall down, like I'm going to fall down all the time, and as if there's something heavy in my stomach, painful,' I said, and tried to act out the symptoms in my face; not too much, just enough.

He felt my forehead, then opened up his briefcase and took out a thermometer and put it under my armpit. I pressed my arm hard against its coldness to make it warm.

'Normal,' he said, taking it out and shaking it. He reached for some tablets from his bag and gave me one.

'Take it,' he said, 'and go to bed early. No reading under the covers.'

I held the tablet in my hand, where it would melt until I could flush it down the toilet. I stood there in the book-lined room. I later thought how like a church it was: my father priest-like in his preoccupation and distance; the tablet melting in my hand, the sacrament; the books he gave me sacred texts full of pointers, like how to dream within the dream.

I tried again. 'Daddy?'

'Hmm?'

'Why does Mowgli have to leave his home and friends and family?'

'Because...' he rested his forehead against his fingertips '...he has to learn from the humans. Just like you have to learn from these people here.'

I sat down. Was this it?

'But he returns home. And you will too,' he said quietly. '*Hic sunt leones*.' He was looking again into the place that I was no part of.

I waited, but he said nothing more. 'What does it mean, Daddy?'

He turned to look through me. I put my palm against the backs of the books to feel that I was real; I was.

'It means that we are lions, you and I.'

And it sounded like a promise.

When they had gone to bed, I took my torch, and crept down to the cellar, holding my breath all the way in case something might hear.

In my father's *Encyclopaedia Britannica*, I found the phrase. *Hic sunt leones*: explorers used it to demarcate unknown territories, it said.

I had thought the space he was caught in, where I had no place, was one that had been before I was born. We

had been walking through the wheat fields bordered by the darkened factories with their impotent chimneys, when he told me how he, my mother, her brother, and others like them, were sent on scholarships to Germany, to England, to America, to Russia, to gather information and knowledge, so they could return, help build their new nation.

'Then why are you still here?' I asked, putting my hand into his.

'It did not work the way they saw it,' he said, not tightening his hand on mine. 'At home, they used to say it was the king alone who dreamt dreams.'

'Why just him?' I asked, wondering who 'they' were, taking two steps for every one of his. I lengthened my stride.

'Because he was one with the state, and even when his people dreamt, it was on his behalf. I did not believe them either,' he said quietly, stopping. He was looking in the direction of the tall faded signs bearing the armament legends of Mannesmann and Krupp, even though they were too far off for him to make out.

I pulled his hand, not wanting him to stay there looking at something he could not see. 'I can see them, Daddy,' I said.

Hic sunt leones. It did not mean that he would, like a lion, return home in all his power, but that he was the unknown in an unknown land, that he was lost, and that I was lost with him.

4

I stood next to Andrea. Even though she was a teacher, she let us call her by her first name and laughed when something was funny, rather than smiling benignly like the other adults. She wore rectangular hiking boots and her hair was thick and stood out from her head like candy-floss. I looked down at my own shiny black shoes that squeezed my toes inwards and smoothed my hair that had been straightened, so it lay flat against my scalp. I wiped the Dax grease off on my dress. In my right hand I was carrying a paper sun-shaped lantern. It had a small bulb inside that I could turn on by pressing a button on the plastic stick to which it was attached. Some of the other children had made their own lanterns. They were blowing hard to see if they could still see their breath in the cold night air. They stamped their feet and rubbed their hands and I did not know how to be close to them. I put on my lantern.

'You know, we eat goose on Saint Martin's Day, because Martin ran away and hid in a goose-stall when they wanted to make him Bishop of Tours?' Andrea was talking only to me, but she was talking loudly, in her tell-a-story,

school-teacher voice, even though I had heard her speak in other voices. 'He did not want to become a bishop. He wanted to stay a monk. He felt it was a very big role and that he was very small. But when the others came to look for him, the geese made so much noise that they found him. That's how he became a bishop and then a martyr.'

I waited for her to finish before looking around. All the mothers were there now, except for mine. She was always late. They shifted from foot to foot, shaking their heads, rolling their eyes. I could not hear what they were saying, but I could hear that disapproving de-de-de-de rhythm that Germans had in their voices when things did not go to plan.

I felt my face suddenly hot in the cold night air and waited for the painful pinpricks of chilblain to spread to my cheeks, wishing they would, so that I would not have to feel the mothers' eyes not looking at me. I stamped my feet and rubbed my hands like the others, telling them silently that that was why I was starting again at an English school the next day, because they were rude.

She was coming, running, in a triangular trench coat with three enormous buttons. She was wearing her Diana Ross wig, with its bouffant and side-parting, and patent black shoes with a gold buckle that perfectly matched her bag. The other mothers stopped shifting. They were all wearing jeans and parkas. She was talking and laughing and waving her hands and everyone was looking at her as if she had taken the little bulbs from all the lanterns and put them inside of her, and I wished that sometimes she would just turn the light off.

We started walking, our lanterns swinging in time with our singing. '*Ich geh mit meiner Laterne und meine Laterne*

18

mit mir. Dort oben leuchten die Sterne und unten leuchten wir.'

My mother was still talking and all the other mothers were laughing as if she was the funniest person in the world. All I knew was that she was the loudest.

I looked up at the stars. They were there and we were down here, shining in mirror image. My neck was hurting. I closed my eyes, holding on to my mother's hand, my face towards the sky. I could still feel the stars inside my eyelids even though I could not see them. I walked with my eyes closed, at first afraid of bumping into street lamps, walls, other children, but I kept going, and as I did, the space in front of me began to feel empty. Even the stars had moved from within my eyelids and it was as if they were not there at all. 'Where are you?' I asked. 'Do you know me?'

'Oh-ho, Maya, *adɛn?*'

Her voice was as far away as the other children had been, and I did not want to open my eyes, did not want to stop the stars from answering.

'*Nkwaseasem nko ara na wo nim.*' She was pulling my hand.

I opened my eyes. She was looking down at me, smiling, shaking her head. She only spoke Twi to me when she was throwing insults, and I wondered whether some languages were more projectile than others, in the same way that some had more compound nouns. The man riding on horseback at the front of the procession had stopped by the fields not far from our house. There was a large bonfire and the other teachers were already standing by it. He wore a white sheet wrapped like a toga and over that a red cloak, which he was now cutting in half. He gave the half he had cut to another man in a vest and jeans, who wrapped it around himself.

Andrea came to stand next to my mother. 'This is just like the rituals you have in your country. Our people used to sing and dance too, but probably not as well as yours.' She smiled. 'They used to carry the lanterns to drive away the winter demons—'

'I am a Christian,' my mother said and turned away from her.

I looked at Andrea and saw her stand against the blizzard of my mother's back, blinking, not knowing what to say.

As we walked away, I turned, wanting to tell Andrea that she did not have to speak English, in a voice that she thought would make my mother feel at home, because my mother already knew what home felt like.

I tried to bring back the empty space behind my eyelids, but it was already filled with my mother's words.

Would the stupid German woman have stood next to any of the other mothers and talked that non-sense about demons? And she was supposed to stand and listen to such non-sense from a woman who did not wear proper shoes and had never taken a comb to her hair. Non-sense.

We were walking on the main road by the fields. I could see the industrial signs that my father had not seen, the M of Mannesmann now flickering on and off.

———————

'See you tomorrow,' Andrea had said.

My parents had not even told them I was leaving.

5

Miss Prest had a voice that originated neither from her nose nor her throat, but somewhere in between. She stood next to me at the front of the class, introducing me in long sentences like a Japanese translator I had seen on television, whose streams of words relayed a simple yes or no. She was not saying, 'This is Maya,' but speaking quickly, with her mouth moving hardly at all. I wanted, but did not know how, to tell her about the pressure in my bladder. Did I say 'pardon me' or 'please'? Did I hardly move my mouth like she did or speak properly? I did my 'pipi' dance, which she did not know how to recognise, though my mother did. I squeezed my legs together, moving my hips slightly from side to side, and stared out into the distance, concentrating on not letting the liquid pass. She said something and looked down at me and smiled. What did she want? I smiled back and in that moment my muscles relaxed. All I had held in came rushing down at full speed, washing the itch from my new thick grey woollen tights, filling the non-place between my feet and shoes, stopping at the sanitised-smelling dirty-looking linoleum floor.

In the tea break, after I had changed into clothes from the lost and found, I sat with the teachers, their talk a grey-noise chorus in the background.

I dipped my digestive biscuit into my milk, sucked it soggy, and wondered where the other children were, whether they would like me, or whether I would be different here too.

When I was finished, I was allowed outside. Only one or two of the others' faces were in focus.

Robert McNally had dark orange hair that held gold in it like my mother's skin, though his skin was transparent and covered in orange felt-tip-like marks.

Tom Anderson, who had laughed louder than anyone else in class that morning, had short bristly hair and soft-looking margarine hands. He was shouting now: 'On your marks, go!'

Everyone ran wildly to the edges of the playground, and back and across, bumping into each other, screaming. I ran too, in lost property's mismatched clothes. I turned. No one was behind me.

I looked for Robert's orange hair. He was chasing a girl. Her hair was long and shiny and light. It swung from side to side in one movement as she ran, squealing. Tom Anderson was chasing her too and so was everyone in the world.

Someone bumped into me. I started running again, squealing like the girl. I wanted to turn and look at her. Instead I ran, pretending that I was laughing, though inside the face I was making was one I later recognised when I saw Munch's *Scream*. Everyone stopped. Robert McNally had caught her.

I watched her now. How her shiny hair fell onto her notebook as she wrote. How her clothes were more at ease

with themselves even though they were not as elaborate as mine. How her nose went slightly upwards and her skin was always the colour of holidays. In our music lesson, I sat next to her and watched how she mouthed the words to the song. I did so too, and she saw and smiled.

Soon we had paired our little ponies and were combing their fluorescent pink and purple hair on the school playground, holding the glow of buttercups' reflection against each other's skin and sending one another notes in class saying 'You are my best friend' and 'You are my best friend too'.

She was my best friend, even though the world did not refract for her. I wanted this simplicity, just like I wanted to reach in through the translucent clarity of Robert McNally's skin and find myself reflected there.

———

When Christine invited me to her house to play after school, my dreams were taken over with sequences of us running and laughing, little ponies in hand. When the teachers reprimanded me in class for dreaming, I looked over at her and we held our hands over our mouths, heads bent, bodies shaking, cheekbones high.

We got off the school bus; her mother was waiting for us outside the house. It was white and stand-alone. Her mother had the same hair Christine did, but cut shorter and with strands of grey in the blonde. Their house was larger than mine and had pictures of Christine and her brothers all over the walls. There was nothing on the kitchen counters. Dried flowers were arranged into wreaths and in slim vases that stood on the windowsills and hung on the doors. Christine's mother gave us sparkling apple juice and sandwiches with sliced-thin pepper-edged salami. We went up to her room to play shop-person with her giant supermarket, and girlfriend-boyfriend with her Barbies

and Kens. We lay back on the floor and looked up at her ceiling, which was covered in stars and moons.

'Tell me a story,' she said.

I thought for a while and then started, 'When my mother was little, she lived in a palace, because her father was a king. She had lots and lots of brothers and sisters and, when it was time to eat, her father shut the palace gates and they all came together and ate out of one giant bowl—'

She sat up. 'That's a stupid story.'

I sat up also. 'But it's true.'

She looked angry now. 'Liar,' she said, 'liar.'

'I am not. I am not a liar. It's true.'

She had got up and was heading for the door. 'Stop saying your grandfather was a king. He was not. Say it now.'

I looked at her. 'It is true, he was,' I said finally.

She opened the door, closing it hard as she went.

I sat in the middle of the room. Naked, neutered Barbies and Kens, small plastic apples and shopping carts, were lying all around me, discarded. I picked up a Barbie, looked at it and put it back down. I went and stood at the window and looked out over her back garden, bordered off from the others by large trees. The door opened, I turned around. It was Christine's mother.

She was looking at me with something bordering on suspicion. 'Dinner's ready.'

———

At table, Christine and I did not speak to each other. I sat next to her father, who asked me questions about why my family had come here and what my father did and what it was like back home.

I found it hard to eat most things most of the time, but now the roast beef was like flesh. I ate little bits and Christine's mother complimented me on my manners.

'Would you like to watch a film after dinner?' she asked.

'I think I should go home. They'll be worried.' I did not look at Christine. We barely said goodbye.

I could only nod and shake my head at her mother's questions in the car.

I thought of the stories my mother told me of my grandfather. Of the boy, his *kra*, his soul, who always went before him and lifted my grandfather's hand heavy with the jewels of state when visitors came to shake it, deflecting and warding off bad spirits.

Of how she was younger than I was now when she saw my grandfather's body laid out on a wooden bed in the palace courtyard, surrounded by braziers of fire and trees like the forest from which our people came.

Of the luminescent gold in his bracelets and anklets, in the kente wrapped around his body, in the long pipe they had laid by his mouth, in the swords by his arms, the sandals on his feet; in his skin, and in his bones.

It was the middle of the night when they woke her. My grandmother had told my mother that he could turn himself into a cat at night, and so hear the secrets people whispered within their walls and in their beds; that he could change into the leopard that had given him his name and wander far across the forests and savannahs, taking note of all that happened through the land, and so retain its harmony.

Now, my mother thought, they had finally come to witness his transformation.

She had not understood. Even when she passed the Divine Drummer, drumming out his lone message of loss on the talking drums.

She had not understood. Even when she saw all hundred and three of her siblings standing around him in silence.

Only when the wives came in, all forty-three of them, wreathed in odum leaves, the green tears of state, their

heads already shaved, clutching their stomachs, a syncopation of pain and screams, did she understand.

She felt the bones in her legs lose hold of each other, but she did not fall. The wives sang and danced their grief. She joined them although no one had taught her to sing the lamentations: 'Father, take me with you where you are going. Father, do not leave me alone.' But he had gone, and left her, and with him taken the umbrella that had protected not just her, but the whole state from being scorched to death.

———

My mother stood in the doorway, waving at Christine's mother, who did not leave the car.

'How was it?' my mother asked.

I went past her on the way to my room and shrugged. 'OK.'

'Are you hungry?' She was trying to look into my face.

'We ate,' I said and ran up the stairs to the bathroom.

I took a towel down from the rail, put it over my head, and started running on the spot in front of the mirror, watching the towel swing from side to side as I ran.

When it fell off, I kept running, imagining shiny, straight hair swinging down my back, imagining Robert McNally running after me.

My mother tried to open the door. 'Maya, what happened? Are you all right?'

I stopped and tried to not sound out of breath. 'I'm fine,' I said.

I looked in the mirror, breathing in and out, trying to calm the painful air rushing in and out of my heart, wondering when I would ever know what stories it would be all right to tell and when.

6

I stood next to my mother at the New Apostolic Church. She was praying quietly. Fragments of her prayer came down to me. 'Cover my child in the blood of Jesus and commit her to your hands, Lord…'

Her faith was something astounding to me. She always believed, no matter what had happened and what might occur. It was like the laughter that was always inside her ready to come up even though she might be sad. My faith was different. I believed all that she conjured up through her belief would come to pass. I wondered what she knew that I did not and why it was her fear matched her faith. I leant into her and looked round at the coloured-glass depictions of scenes from the Bible in the windows, the stone and red-brick walls, at the tiled floors and the wooden beams that criss-crossed the ceilings, and thought just what an ugly church this was.

At times I lost myself with her in the songs, but not like I did at night, while reading, or watching ZDF, which in the daytime, like this church and its hymns, showed programmes that uplifted because of their familiarity, but by night transformed into a chapel of

frescoes whose beauty left in you something indelible. Night after night I went down, no longer needing to glut myself with reading, and turned on the television, sitting close enough to hear the whispers of the screen, far enough to see the subtitles though it was fine not to understand. I watched the women on the screen, their names like poems:

Monica Vitti,
Anna Karina,
Ingrid Bergman,
Catherine Deneuve,
Audrey Hepburn,
Katharine Hepburn,
Romy Schneider,
Grace Kelly.

The night before, there had been, for the first time, Brigitte Bardot. I sat closer to the television, taking in the way she threw back her hair, her hips out, how her pout brought down men. Doris Day and Sophia Loren were my mother's heroines. She had even had their names embedded in her passport along with the change in her year of birth, and she matched the extremity of her behaviour, her domesticity and carnal guile, to theirs. Yet here was Brigitte Bardot. In three films, one after the other. As if delivering a masterclass.

'*Tu vois mes pieds dans la glace?*'
'*Oui.*'
'*Tu les trouves jolis?*'
'*Oui, très!*'

The men that held her through their gazes were only punctuations, mirrors of her abandon. They had created the incarnation of desire, but now she inhabited its shape so thoroughly that it was clear they had sown their own destruction, her power hidden in plain view.

I lay back and closed my eyes, imagining myself her, the same shaggy hair, the same pouted petulance, striped top and capri pants. When I opened them again, the images on the television were grainy, muted; the characters mumbled; nothing was clear. Teletext told me this new film was *McCabe & Mrs. Miller*; and though the incoherence and flatness of it too closely approximated what I knew of life, threatened to let it in, curl up on my chest, and make me struggle painfully for air, I stayed, watching the men wade through the coarseness of the American New World, the mud and the grit; waiting for the pay-off, the reward for the hardship. And there she was: the beauty, the relief.

Only she had in her that same coarseness, that same mud and grit. I had seen her paired with the same actor in a film a few nights before, but now their interaction was stripped of all Technicolor lightness and escape; only a raw, Machiavellian will to thrive was left.

And yet, when at last he laid his head upon her breast, knowing he was going to die, with only this floe of intimacy, this brief moment of connection to ground him, something broke into place so thoroughly, as if in that surrender was all of life.

He died, alone, unheroically. And she was left behind, removed from the world, past feeling.

In the protracted, helpless silence of his death was more of the truth of life, and in her there was something of me, impassive, spent, even though I was still so new to the earth, and I wondered where it came from, this detachment, this sight, which was neither curse nor protection.

Now the hymns were over, tithes collected. We were on our way to the hairdresser's.

At the Afroshop, Paa Wilson, the owner, sat at the counter, selling dusty yams and powdered *fufu* and young

green and ripe yellow plantains and hair creams and pieces and balms. His shop was like an annexe of home. Everyone spoke Twi at once and shouted and laughed as if we were not in a side road in north-west Germany, but in Legon or Kokomlemle or Teshie-Nungua.

In the hair-salon room, there was superfluous hair from braid extensions all over the floor, even though one of the girls kept sweeping it up. There were almost as many girls braiding as clients, but the woman who was boss had longer nails and hair and lighter skin than all the others and she came to my mother, but my mother told her to take me first. She gave me a photo album to choose my style and there were cornrows and braids and long straight hair and asymmetric bobs; there was black and brown and red and blonde; there were straight lines and zigzags and rounds. My hair was thick and I was dreading having it combed.

The boss woman took some of my hair in her hand and squeezed. '*Eyε den*,' she said, it was hard.

I showed her the style I wanted: tiny, imperceptible braids that ended in long, shiny hair falling onto my shoulders, a layered cut to make the hair look shaggy. She took me to the mirror. She yanked a narrow comb through my hair quickly and painfully from the root up and I closed my eyes and gripped the seat.

'*Hwε nanim.*' She was laughing at me.

I heard my mother laugh too. I opened my eyes and looked in the mirror; she was having her hair washed behind me. My shoulders were hunched and my eyes looked haunted. The woman finished pulling out my hair. My eyes were already smarting, but now a toxic fume made them flow.

She used a bristled brush to put the white relaxer cream on my roots, tender from yanking. 'When it starts to burn, call me, eh?'

Some of the girls were eating *jollof* rice and stew or *gari* from plastic Tupperware bowls and there were children running or crawling round the floor. The television in the corner of the room was set to an American soap opera, *California Clan*; one of the hairdressers changed over just as we were going to find out if Rick had really cheated on his wife with his mother-in-law.

There was an American preacher on the screen: tall, white-haired, majestic. 'For the Lord is mighty,' the preacher said.

'Jee-sus, amen, yes sir,' the women in the room were saying.

'There is no might greater than his,' the priest was shouting now.

'Amen,' the women in the room shouted too. Some of them had their eyes closed.

A man came in. He had a large suitcase with him and, when he opened it, out tumbled gold sandals with diamanté, stretch jeans, polyester jumpers, encrusted watches and knock-off perfumes. The cream was burning my hair. The hairdresser was trying on a pair of shoes.

'It's burning,' I said to her, pointing at my hair.

'Wait a minute, sweetie.' She was looking in the mirror. The crevices of her feet were shades darker than the rest of her foot. I looked up at her face. The bleach had created a lightened band from the neck upwards as if her head had hatched from a different body.

'It's really burning.' I looked at my mother.

'Won't somebody look after my little girl for me?' My mother stood up from leaning over the open suitcase and one of the women took me to the basin and washed out the cream.

My curls had gone and my hair lay permanently straight, flat, dead against my head. The woman began to

blow-dry it and the hot hair burnt my scalp. I asked her to turn the temperature down.

'Oh-ho, *adɛn?*' she asked.

'*Eyɛ me ya.*' It hurt.

She sucked her teeth and turned the temperature down, getting a comb and yanking it through my hair while she blew. 'Cynthia,' she called when she had finished.

Another woman came with three different packets of hair. The throbbing of my scalp made it hard to see straight. I narrowed my eyes. One was black and curly, the other black and straight, the third brown and straight.

'This one,' I said, pointing at the black straight one. I looked over at my mother; she was having a weave sewn in and she was laughing her back-of-the-throat kh-kh-kh-kh-kh laugh. I opened my *Three Sisters*, but the three girls braiding my hair pushed my head down so that it was impossible to see the words on the page and the pain pulling from three directions made it hard to focus when I did.

I closed my eyes and tried to listen to one of the strands of television, radio, children and women. They were talking about how the president of our country had buried a live cow to get his power.

'*Adɛn?*' my mother said. '*Adɛn nti omo wɔyɛ saa?*'

All the women chorused in, hmm, nobody knew why. '*Abayisem*, the devil's work.'

Someone turned the radio up, so that it overpowered the preacher even.

My mother began singing, 'Amazing Grace', her voice vibrating on the aaaa's like an opera singer, except she was doing it on purpose.

The women braiding my hair and all the women in the salon sang with my mother. ''Twas grace that taught my heart to fear and grace my fears relieved,' they sang, but

their fears were not relieved. They put as much faith in the devil and in witches as they did in God and grace. It was like the German word *Ehrfurcht*, a grace that frightened as it gave.

My mother stood up. She looked like Doris Day and Sophia Loren and herself all at once.

My braids were tight and heavy and my scalp felt like it was being pulled away from me by a ten-ton truck.

A woman sprayed sheen on the braids to make them shinier and put strong-smelling cold sticky green Dax pomade on my scalp. '*Wo ho yɛ fɛ paa*,' she said, smiling at me.

'My sweetie little girl,' my mother said, pinching my cheek.

I smiled at them and it hurt my scalp. My hair was long now and it shook behind me. I looked in the mirror up at the women looking down on me so proudly, and my smile was not just on my face. Amidst all the noise of the TV and radio and the children and the talk of the women, and despite the tightness and throb of my head, I knew that I was now safe.

7

'Maya. There is a surprise coming this night.' My mother whisper-spoke the words as I sat on the kitchen counter.

A surprise, she said, and yet every year she told me in advance what my Christmas presents were, could not stop herself from leaving the price tags on.

She sang: "'You are my sunshine, my only sunshine, you make me happy when skies are grey, you'll never know, dear, how much I love you. Please don't take my sunshine away.'"

I jumped down and squeezed her breath out from behind with my arms.

'*Agyei*,' she said, undoing my arms with one hand.

'What is it?' I asked.

'It is a surprise,' she said.

'Mummy.' I put my hands on my hips and gave her a 'now, come on' look.

'Foolish girl.'

She was not going to tell me.

That night I could not sleep with the anticipation of what was coming. I rubbed the ends cut from my mother's wig against my cheek, but neither the rhythm

nor the texture sent me to sleep. I sat up on my knees and looked out until all the dark shapes became familiar. I stood up and jumped across the chasm under my bed so no arms might reach out from underneath to grab me. I held my breath going down the stairs in case something might hear. I looked into the front room, but all was quiet. I went into the kitchen. There, in front of the open fridge door, stood a boy, dark like me, wearing glasses and a gold-cross chain on his bare chest. He was wearing a pair of my father's pyjama trousers, which were too big for him, and he was looking deep into the fridge. I stood and looked at him. He turned to see me, closed the fridge door, walked past me up the stairs, and into the spare room. That was the surprise, a peeking boy?

My mother told me his name was Kojo. That he was her brother's son and that from now on he would live with us and I was to treat him like a brother. He smelt like the inside of the trunks we kept clothes in for when we finally went home.

When we got on the bus to go to school, they stared at us, two brown ones now instead of one. I hoped that he would not embarrass me.

I took small slow steps to the courtyard at break time, not wanting him to find me, not wanting to stand with him. Everyone it seemed was crowding around something in the courtyard. I walked a little faster, saw that it was Kojo. I still had time to turn around; no one had seen me. I stood where I was and looked. He was talking and they were watching, as if he were a teacher or preacher. Some of them were pushing to get nearer to him. I went closer.

'Sometimes the leopards even come into the post office and the clerks have to jump on the counters until they have had a good look round,' he was saying.

The bell rang. Tom Anderson had moved closer to Kojo. 'What a load of codswallop,' he said loudly.

Kojo turned and looked at him, then raised his hand and slapped him hard. Tom Anderson was holding his cheek. Everyone was talking and giggling and jostling. A teacher came and slowly they all went inside. I watched it all from afar. I watched and wondered how it was that Kojo had upset the order of things so completely on his first day.

I kept watching him, and on the outside the balance of things was on my side. When he came into my room I pretended to be reading. When he put his cheek against mine, I pushed him away and wiped my face of his warmth. And still his presence crept into my solitude.

He showed me how to bore surreptitious holes in the packets of sweets in the cupboard, until finally they were empty and we were found out. We raided the drawers and pockets of the house for pfennigs and bought paper cones filled with shiny black liquorice, sour multicoloured tongues and white foamy mice that we ate until we were sick. We constructed elaborate systems of Dungeons and Dragons in my mother's front garden until, in his enthusiasm, he cut off the head of her prized sunflower that had grown almost as tall as me, and we were banned from her garden's pleasures forever. We cycled the neighbourhood, everywhere gathering friends I did not know existed.

We went to one of their houses for a birthday; the girls played games outside and the boys disappeared indoors. I went to find them and there was Kojo standing by the kitchen counter with his hands in the girl's birthday cake.

'What are you doing?' I asked. 'Did you eat all of it?' It was almost gone. I looked at the other boys, eating handfuls of chocolates and crisps.

'Shh,' Kojo said, grinning. 'Let's go,' he said to the boys.

We cycled all the way to the large park; I looked ahead at them, and at myself in dungarees, as we cycled up the big hill, up, up. I wanted to not care about the girl whose cake had now gone. I wanted to keep up with them. 'Look at me,' I shouted at them. 'Look at me.'

All the boys turned to look as I swung my bike around right at the top, and sped downwards, faster and faster, freer and freer. 'Look at—' My bike went over a large stone, I was still going faster. I tried to press the brake. I did not stop. I threw myself sideways, down, crashed on the ground. My bike fell away. I could not hear a thing. I saw the light shining through the leaves of the trees, ringing somehow into the pain in the side of my head, chest, in my nose.

There was Kojo, he was bending over me, and there were the others; I could see them now, standing not too close, somewhere between shock and laughter. Would Kojo laugh too, like my parents would? Call me a silly girl? Embarrass me in front of them all?

He came to me and sat me up. 'Sit up, Maya,' he said, 'sit up, breathe. Can you hear me?'

I nodded, more fascinated now by the fear and panic in his face than by my own pain.

He was picking out stones that had pressed into my hand. He was telling me that I was going to be OK, that nothing would happen to me now that he was around, that he would protect me, that if anyone tried to hurt me he would kill them. He was talking so hard and so fast now that his voice was becoming high. Then he started to cry, suddenly, without warning, shaking from his chest outwards. I looked at him and at the boys standing around.

No one said a thing. They pulled him up, and pulled me up, and picked up my bent bike.

We walked slowly back towards the house, Kojo holding me up in a way that was annoying. I was not a cripple, I wanted to say, but still I let him.

At home, I said nothing about the fall. I knew that it was Kojo who would get into trouble, and I did not want anything to harm him.

Behind the back garden of the house we found pieces of plywood and began building a spaceship that would take us into orbit. We nailed together the floor and sides and roof. It began to hail. The others wanted to go home.

'Hail is like superglue for these walls,' Kojo told them, but they were already getting ready to leave. 'Weaklings,' he called after them, but they did not turn round.

Kojo walked slowly, kicking gravel, and putting his face up towards the hail, but it was beginning to hurt me.

'I want to go home,' I said.

'Wait. Look.' He stopped by an abandoned old yellow Volkswagen Beetle. He tried the doors and opened the passenger one for me. 'Perfect,' he said.

The seat was wobbly underneath me and I tried not to inhale the smell of mould and damp and danger.

Kojo got behind the steering wheel. 'We are going to do a tour of Europe and America, but first—' He reached into his denim jacket and pulled out a red-topped packet of cigarettes.

'Where did you get those?'

He put one in his mouth and pulled out a lighter. 'I walked in on Mummy in the bathroom, after she and Dad were fighting last week. She was sitting on the toilet, and she was smoking. I took them from her bag. What is she going to say?' He pulled something else out from his jacket.

'This is for you.' It was a small glass bottle of cherry-cola lip gloss.

I rolled some on my lips. 'Do I look like Donna Summer?'

'No, you look like greasy chips.' He lit the cigarette, then gave it to me.

I sucked the smoke into my mouth, blew out quickly and smiled. I did not feel like smiling. I was afraid. 'All those stories you tell,' I said, 'they're not true, are they?'

He looked at me for so long it seemed he had gone to sleep behind his eyes. 'Our language hides,' he said finally, 'in the dance, the drums, in cloth.' He sat back, even though the car was filling up with smoke and hail was beating down on its roof.

I watched his serious face behind his new, wet glasses. He looked like Clark Kent, and with him I never had to pretend that I did not know as much as I did. At night I dreamt that he was Superman, but now the dampness from outside was creeping in or perhaps it was the other way round.

'I grew up standing behind the Divine Drummer, Odumonkomakyerema Kwasi Pipim, watching him beat out the history of our state on the drums.'

He spoke quietly, so that I had to lean forward to hear him under the noise of the hail.

'Kwasi Pipim's eyes,' he said, 'were as hooded as the sticks he held to beat the drums, his skin was as black as the tar used to paint them, his hands were as leathery as the elephant ears that covered the drums' heads, his veins stood out as tight as the intestines that bound them. The drums and their truths entered him and made him theirs so completely that he had become one with them.

'I learnt from him to beat the *atumpan* drums, whose notes are so like our Akan words. I learnt from him to

strike the *fontomfroms* that were taller than me when I began. I learnt from him to scratch the surface of the *etwie*, its notes so like the growl of the leopard that gave the drum its skin. We all learnt from him, but not all of us were told the secrets of the drums. Only those who were born to the right of knowledge were told the meanings behind the tones, and those who persisted.

'Listen.' He began drumming on the dashboard with his fingers. 'You will hear the drum orchestras and you will hear only noise that clashes and makes more noise, but if you listen, then it will hold you still in its middle. You will hear only beats, but I will tell you their meaning.' He spoke in time with the beats:

'*Okwan atware asuo*
Asuo atware okwan
Opanin ne hwan?
Yeboo kwan no kotoo asuo no.
Asuo no firi tete.
Asuo no firi Odomonkoma oboadeɛ.

'The path crosses the river
The river crosses the path
Which of them came first?
We made the path and found the river.
The river came from long, long ago.
The river came from eternity.'

He told me it spoke of our constant striving towards knowledge, of our ignorance in the face of death.

'Then the drummer gives thanks, to the spirit of the tree that he fells for the drum, to the earth that gives birth to it, and in the language of the drums you will also hear the languages of these things, of the trees, the earth, but

40

you must listen, and you will hear all this and then you will know.'

I looked at him and nodded. It was this knowledge that gave him the power to upset the order of things. Could I learn these secrets and codes, even though I did not grow in our country? Could I tell them with the same conviction, so that I too would be believed? An image came of Brigitte Bardot, of her mastery of forms, of looks, of gestures. If I could learn one, as well as the other, I too would be known and could keep what was most sacred hidden away until it was safe to be revealed.

'There is a book,' Kojo said.

'A book?'

'Our grandfather knew there would come a time when all our secrets would be forgotten. When the young would no longer want to learn from the old. He was a member of a society of elders from across the world. In the same way he turned into a cat, he took on this cloak. He learnt from them, how to guard the most sacred wisdoms so that one would only have to look at them for power to be restored. He tried to teach this to them, our fathers and mothers, how to cross over from one world to another, and take the best from both. He sent them to the best schools and universities, trained them in the old ways and the new, but they were too soft. No one could hold the balance like he did, and when he died, it all fell apart. He asked my father to write the book, that holds the secrets of our kingdom.'

'Out in the open? After all this time?'

'Coded, still.'

'Where is it?'

'That is why I am telling you. Each of them, the elders, placed a book into a library—'

'A library? Where?'

'In America.'

'America?' I crossed my arms and looked out of the window. I had believed him, until then.

'Why not America? Should it be Russia with its weeping sisters?'

'At least Russia has depth and melancholy and poetry and soul. America has fat people and too much food.'

'Ha, what about Michael Jackson and Apollo 16? You think Russia is better, just because its people suffer? They suffer in America too.'

'Only in a Beach Boys kind of way, not truthfully.'

'Who says people have to suffer for there to be truth? We would be the most truthful people in the world if they did.'

'But we are. You know we are.'

He looked away.

'I just can't believe this library is there. And if it is, then just because it has to be the biggest and the best. Because all that information is a form of control, not because of any ideal symmetry.'

'Who said anything about ideal symmetry?' He crossed his arms now too. 'So you won't help me?'

'I will…'

'You have to do it with your entire spirit, with everything you have, otherwise nothing at all.'

'I do. I will.'

'My father made a copy of the book for our people. It is time now. I am telling you this because you were born to this knowledge. You asked if what I said was true… When I say "I" on the drums, it is not just I, Kojo, but also my father, my grandfather, the *sunsum* in us all. Our stories are not like your book stories that do not change whether they are true or not. Ours are born again with each telling and, if they were not true, they become true, and if they were true they might change.'



I looked at him and wanted to ask how this change had been written into the book, but instead asked, 'Who are we, Kojo, and who are you?'

He smiled. 'You, *oburoni*.'

I squeezed his arm hard. 'I am not *oburoni*.'

'*Aich*.' He unhooked my hand, rubbed his arm. 'You do not understand what I am talking about, and neither do they, but they will.'

I looked out of the window. I wanted to tell him that I did understand, that I had felt, as far back as I could remember, that something had been lost to us, that I had been called upon to bring it back, and that since he had arrived, that call, in all its silence, had become clearer; but it had grown dark.

8

'What in God's name do you think you've been doing, heh?' My mother was shouting even before she saw us. 'We were calling the police—'

'You think this is funny?' The anger in my father's voice was coming out to break. 'You shut that big mouth of yours when your mother is speaking to you.'

'I didn't say anything,' Kojo said, before I could stop him.

My father took him by the ear. 'I am damn tired of your damn stupid wickedness.' He was kicking off his leather brown sandal. 'You with your fresh mouth. You damn fool. Who taught you to talk back at me?'

Upstairs, I closed my eyes and put my head in my mother's lap.

'He has to be disciplined or there will be trouble for him later.' She stroked my head.

I hit her hand away. I wanted to hide in her, not for her to touch me.

I heard Kojo come up the stairs. I got up and went to my room. It was already past our bedtime. I turned out my light and put on the torch underneath the covers. I opened

The Three Sisters and read until I forgot about the smoke and hail and darkness and my father's slipper. My eyes began to hurt and I closed them, almost forgetting to go and see Kojo. I forced them open and went into his room.

He was banging his head, face down on the pillow, with a force that frightened me.

'Kojo.' I went to him. 'Kojo.'

His eyes were closed. He was asleep.

'Kojo!' I was shaking him now. 'Wake up, Kojo, wake up!' I shouted in his ear.

My parents were at the door.

'*Oh yei*,' my father said.

My mother put her hand on the back of his head. 'Shh,' she was saying. 'Shh.'

Kojo opened his sleepy eyes. 'Heh?' He looked up at us.

'You must learn to sleep quietly,' my father was saying. 'Turn around and lie on your back.'

Kojo turned heavily and fell back asleep.

We all three stood and looked down at him.

'Why does he do that?' I asked.

He looked strange now without his glasses.

'He is hyperactive,' my father said. 'If he does not calm down now, he will begin to work against himself.'

I put my hand in my father's hand and watched as my mother laid the fallen covers back on to Kojo and stroked his forehead to calm him down.

———

We were still under punishment rules, forbidden from going to the Amankwahs' party, though we knew that Uncle Guggisberg would be there, who, Kojo said, knew more than anyone else of our story.

Kojo was in my room now, picking up the books from my bedside table, telling me to ask.

'Why me?' I took the books away from him, one by one, and put them in a pile on the floor.

'Because they will say yes if you ask. You always know how to behave. And you look sweet. Go on. Ask them.' He sat by the pile, opening the books, as if to read.

I stood up to get away from the shouting feeling that was coming up in me, telling me to rip them out of his hands and bury them in the garden where they would lose none of their power, and I knew he would be hurt. I stood in front of the mirror and thought of Auntie Amankwah's son Anthony, of the pictures of him on her living-room walls, wearing the red and white colours of the national team, the only dark face in a uniform of pale; his football trophies, dwarfing the plates and glasses in the glass cabinets, standing guard over the television; proof of his having conquered this world, of the widening of possibility, so that when he sat me down on his lap, at one of Auntie Amankwah's parties, and told me he would marry me when I was grown, I knew that there was now at least one certainty. I pushed my lips out into a pout: *tu les trouves jolies mes fesses?* Over my shoulder I could see Kojo, bending my book the wrong way round. 'OK, I'll ask.' I snatched it from him, and took at least this one downstairs.

My father was in the sitting room. He had the thin multicoloured rods with elastic bands around them in his hair that would give him Michael Jacksonesque Jheri curls. He was watching a tape-recorded episode of *Dynasty* and his concentration on the television was absolute.

I waited, thinking that if my father were Blake Carrington, paterfamilias, and my mother were Alexis Colby, in all her powerful and glamorous capriciousness, then who was Crystal, the soothing calming white-fox-haired presence in my father's life?

There was black and white static on the screen. He had the remote already in hand. Now there were the opening credits of *Dallas*. I would not be able to get him away from Bobby Ewing.

'Daddy,' I said quickly.

He was looking for the play button.

'Daddy, don't you think it would be better if we all went tonight? Together? I mean, as a family? We are Kojo's family now, and he ours, and everyone there will be with their children, and they will ask and ask, where are the children, and how we are, and what would you say to explain? Wouldn't it be much easier if we all just went?'

He had found the play button and his finger was hovering over it. He was still looking at the screen. 'Yes, I suppose you're right,' he said.

I jumped up and ran before he would have the chance to think.

As my father reversed out of the drive, he looked back and reversed a little, looked back and reversed a little, stopping and starting, until Kojo and I could no longer keep our laughter silent.

'Errgh,' he said, waving his hand in annoyance, 'stop that.' He turned left onto the main road, passing the wheel through both hands.

At the petrol station, Kojo and I opened our doors, and took in large inhalations of the petrol fumes, which smelt like comfort and new car seats. On the motorway, we guessed the models of BMWs, Mercedes, VWs rushing past, speed unlimited, and discussed the merits of engine strengths and lightness of carriage. Each time a Porsche went by, Kojo pointed and said, 'That's my car.' My mother and he talked of the villas and cars we would

one day have. I watched them and thought how there was no badness in Kojo. How he did not sulk as I would have after what had happened. How he did not look at the world as if people were miniature soldiers on a battlefield. I listened to them talk and dream and laugh, and wanted to reach over and touch them, but I was strapped into the back seat and it was too far. My father looked cautiously into his rear-view mirror and once in a while crept past another car.

We drove into Bonn Bad Godesberg into the *Villenviertel*, past the large houses of diplomats and government officials, to the apartment of Auntie Amankwah. I was not sure if she was my real auntie, distant family or a friend of my mother's, but whenever they, like the rest of my mother's relatives, came together, they laughed and spoke louder and drank and ate more than I imagined possible.

My mother started laugh-shouting as soon as she went in. Kojo too disappeared. I stayed next to my father as he shook hands and had quiet conversations.

There was a long table with red *jollof* rice and beef, green *kontomire* stew and yam, *fufu* in palm-nut soup, fried chicken, *bofrot* doughnuts, salads slathered in white salad sauce, and every kind of alcohol imaginable. My father and I went to sit down on the sofa, watching the loudness of the room.

There was Uncle Guggisberg, with the curious downset of the mouth so many of my mother's family seemed to have, marking him out, just how English aristocrats bore the stamp of perennially expensive, clean-smelling hair that told stories of winters in Gstaad, summers in Mustique, and autumns hunting, despite the holes in their cashmere jumpers. When he looked our way, I smiled.

He frowned and came to sit next to my father. 'When are you going home, Kwabena?' Uncle Guggisberg shouted. He was already drunk and everybody else was shouting with him.

'Errgh,' my father said. We had been planning on it before the coup, had sent the car and other things, but now we were waiting.

'What are you waiting for?'

'*Lass mich in ruhe*,' my father said, 'and you, what are you waiting for?'

Uncle Guggisberg waved his glass now so that whisky splashed out over the sides. 'For our time to come. Were we not the ones educated for the purpose of leading our country to prosperity…? And they hold our privilege against us as if it were a badge of dishonour.' He spoke with a sonorous English accent and spat out on the plosives, so that my father sat further and further back.

'Look,' my father said, 'you had your chance with your Oxford English and all your book learning. Nkrumah won because he spoke to farmers and market women in their language, not because you were cheated out of your rightful place. You are not born to some spurious right, just because you are royal, or part of some bogus educated elite. Nobody's time will come until they learn to find balms for each man and woman in the country.'

Uncle Guggisberg leant into my father's face, spitting as he spoke. 'You have always been bitter, Kwabena. If you yourself were not part of this bogus elite, you would never have been allowed to marry my sister.'

And just then we heard her. I wondered how it was we could have shut her out. She was sitting on the sofa, talking loudly, drinking a very full glass of whisky quickly, throwing her head back skywards, laughing with her mouth wide open. One of the doctors pulled her to her

feet now and she began to dance. The room parted for her, cheering her as if she were walking towards an award. She had the corners of her mouth turned downwards in her family's expression of complete self-regard. She moved her hips from side to side as she moved forward. They were making a circle around her now, holding two fingers above her head in praise. The man who had pulled her to her feet came to dance with her and they descended in small hip movements towards the floor and up again.

I looked at my father. He looked unhappy and uncomfortable. The blood rose to the surface of my skin and I wished that not everyone was looking at her, that she did not always have to be the loudest, most beautiful, the sun around which we all orbited. That we did not have to flatten ourselves into her shadows to exist. And that once, just for once, she would be quiet.

Then the attention of the room shifted elsewhere. Anthony had come in. The presence of the man who had told me he would one day marry me as I sat in a dress my mother had chosen for me, sharing in my father's discomfort, was not then a welcome one. I watched him shaking everyone's hand, smiling, presidential, nearing me. My turn came. I tried to smile back at him, through the heat in my face, to appear more grown up than the child I was, wanted to shake back my hair and pout. He turned and loud-whispered to the handsome Italian-looking friend with greased-back hair that he had come in with. 'Pretty, isn't she?'

The friend nodded slowly, then said, 'But she knows it.'

They moved on, leaving me confused and wondering, for many years more, what he meant by what I knew. Whether it was that I knew that Anthony thought I was pretty, or that I knew that I was pretty. He had said it like a reprimand. Why did they tell me if I was not to know? Should I shrug with the same mock modesty with which

I had shrugged at the man in the department store? Was it true what my father said? Would I have to walk through life, feigning ignorance and modesty, making myself smaller to make men shine, flattening myself against walls and smiling abashed when they told me I was pretty, as if I had not heard it a hundred times before? Would I have to pretend each time that it meant more than that I conformed to somebody's standard of beauty somewhere, when inside it made no difference at all?

I watched my father not looking at my mother, and now I wanted her to be loud. I wanted to be loud with her, to dance and freely channel the thing beyond myself, rather than smiling and pretending and reversing in caution, and I wondered if I would have the courage.

There was a cry from the room next door. Jody Amankwah came out holding her large white dolls and their disengaged blonde-haired heads. In the background, I saw Kojo looking out of the room, smiling.

———

'Why did you do it?' I asked him in the dark.

'It was fun,' he whispered underneath their shouting, then, 'I wasn't thinking.'

They shouted all the way back to the car. My father was calling Kojo names, saying that all my mother's family thought of themselves as better.

'That's because we are,' my mother said. 'Who are you?' she asked, her mouth turned downwards, and on it went.

I looked out at the headlights of the cars, at people speeding past, unknown. When we got home Kojo came into my room. He was waiting to be punished, but they were too busy shouting at one another.

Kojo came close to me and started making a sound in my ear, *ttttttttttttt*, the same plosives Uncle

Guggisberg had been making, but consistently, incessantly, unbroken.

'Stop it, Kojo,' I said calmly, knowing my anger would inflame him.

Ttttt, he kept saying, *ttttttttt*.

I pushed him away. 'Stop it.'

There was a loud bang from our parents' bedroom.

Kojo was silent. We crept to their door.

My mother was shouting. '*Awurade*, oh God.'

We looked in.

My father was taking his clothes out of the wardrobe, putting them on the bed, saying that he would not let my mother ruin him.

She was crying, trying to stop him. His face was set.

He closed the door on us and we stood at the end of the corridor, waiting.

He came out. His footsteps made an echo on the floor. He had not put on his slippers. He did not say goodbye as he left.

Kojo and I went in to my mother. She was sitting on the bed, her head down, tears dropping into the short-haired beige carpet. We knelt by her and both began to cry in loud sobbing chorus.

'Oh-ho,' my mother said and laughed through her tears into her hands.

'It will be all right, Mama,' Kojo said. 'Soon all will be what it was, better, and we will be home.'

I put my face against her wet one to stem the tears and looked down into the open suitcase on the floor, full of the guilt of blue- and gold-rimmed plates.

I sat back on my calves, still holding my mother's hand, listening to the calm coldness lining the inside of my skin as if in insulation, wondering if I would be able to uncover what lay beneath, before the pieces were all undone.

PART TWO

9

When Kojo, my mother and I arrived in England, it was full of new ways, new codes, new uniforms: our names spelt out in cursive thread on labels, sewn even into socks; navy-blue acrylic jumpers and skirts for winter, patterned button-up cotton dresses for summer; green and white soft trainers for tennis, hard spiked shoes for hockey, stiff shiny leather loafers for every day. England was the place we had dreamt of, but when we arrived my dreams turned back towards Germany. The ordered streets. The hard-cover books and hard-sleeve classical records of my father's cellar library. The always-new smell of the dark beige stiff carpet.

My mother began work in a laboratory and bought an old worn-out yellow Golf that was not the car of a doctor's wife, or of a princess, and worked every day, sometimes through the night. We never asked her, or any of my aunts, what they did when they went to work. She once told me that when they came to Europe, no matter the amount of degrees they had gathered, or the stature they enjoyed at home, no one ever asked what they did now or how low they stooped to keep their children in good schools.

I did not know yet that this was the end of our to-getherness; that when my parents spoke now, it would only be to argue about school fees and mortgages.

In the mornings, I laid the thermometer on the radiator, stayed in bed, to summon my father.

Instead, a doctor came, who was not my father, but a Mr Smith.

I eyed Mr Smith with suspicion, both for his title and for his name.

He sat on the edge of my bed.

His trousers and jacket were as fusty as everything else around us, and I prayed the fustiness would not envelop me.

Kojo and I watched as he picked up a ruler from the side table and wiped it on his trousers.

Kojo began to open his mouth in disbelief as Mr Smith put the ruler on my tongue.

I looked at Kojo and at the doctor who called himself a mister sticking his tongue out and saying *aaaaaaah* as he looked down my throat.

I saw the grotesque chorus of our three open mouths, and it was so funny it hurt my stomach to stop from crying.

I knew, even before Mr Smith said it, that come Monday I would have to put on my uniform, which was neither thick enough nor strong enough, and go to school.

I wrapped my arms around my knees and drew the duvet over my head.

Somewhere underneath was a book we would be reading.

I opened a gap for the light to come in.

On the cover of the book were girls with pale skin and even paler dresses, long pearls around their necks and in their hair.

I traced the lines of their Empire dresses with my finger.

It was by Jane Austen and all the conversations took place in drawing rooms like the Russian books I had read, though instead of politics and war, they seemed to talk incessantly of marriage and tea.

'Maya!' My mother's voice was interrupting, coming nearer.

I closed the gap in the duvet and held still.

The door tore open. 'You this girl, why at all are you making my life so difficult. Ah?'

I pulled the duvet up tighter around me.

The air was hot and damp.

'Get up!' She tugged at the duvet. 'I said get up! Is it because of you that I should be late, huh? *Nkwaseasem nko ara.*' She was still talking as she left the room.

I threw the covers off.

The air was icy wind.

I counted to ten.

Up, up to the bathroom.

To the ancient fixtures.

The wallpaper blue carnations.

The sickly blue basin to match.

I ran the bath and sat on the toilet lid.

That too was cold, like everything in this country.

Even the hot water ran out as you filled up the bath.

I stopped the tap, got into the too-hot water, put my head on my knees, waited for it to cool.

The feeling of damp was here too.

Not the clean wet of German bathrooms, but the inherent dank of the wallpaper, the flowery sofas, the curtains that smelt of old women and of age.

'*Awurade!*' She was standing over the bath, holding a bottle of Dettol, looking at me. 'Is it because of you I should disgrace myself?'

I covered myself with my hands. 'What are you even doing here? Why have you come in? I am in the bath!'

She did not move. 'God, tell me what have I done to deserve this devil's child?'

What was she doing with the bottle? Why was she so stupid and repulsive and loud?

'If I am the devil's child,' I was shouting out of my stomach so that my voice was almost a cough, 'what does that make you?'

'I am warning you,' her finger pointed towards my face, 'be careful. Be very careful, hmm.'

She left the door open.

Cold wind blew in, at my knees, my face, my hair, entered the hatred in my stomach, that was larger now than the sadness and the anger and the lost parts of me rattling around.

I opened the tap, let the water run cold, and lay back until my teeth began to clatter.

I thought of how she was an ogre, worse than fairy tales.

Of how it was no wonder my father had left her.

I felt my hatred for her inside me, unending, and I knew that I would punish her, slowly, so she would not be able to stop me, so that she would not even notice.

———

I looked over at my mother's red lipstick, brown-gold make-up, large diamond-encrusted earrings, powdery perfume and bouclé suit, so incongruous with the dusty yellow Golf she was driving. I looked down at myself, dressed even more incongruously, as her daughter.

Kojo had briefed me on Attobrah, who was the one chosen to be our next king.

If he ascended, he told me, it was possible we would have another black stool.

The last three had all been white.

White, like the tall buildings we passed now in London.

Wide streets and trees. Areas with names like Victoria, Kensington, Knightsbridge.

White, he told me, was the colour of innocence and of beginnings.

But if a king was good – more than good; if he was noble and wise, and lifted our people higher than they were before – his stool would be blackened after he died.

The streets were getting narrower.

People were no longer of just one shade, one class, one tribe, and everywhere there were pound shops and chicken joints.

Black, he said, was the colour of knowledge and of ends.

Even though Kojo did not remember much of Attobrah, good things were said of him: that he was clever and knew the ways of the court. If he made it, it would be the beginning of change for all of us. That was how it was written.

We arrived at Uncle Guggisberg's block on a tall, dark grey council estate. Inside, the carpets were as thick and swirly as the wallpaper.

I could hardly move through the throng of family members, dressed in bright asymmetrical kente.

My mother pushed through and opened a closed door. We followed.

In the middle of the room sat a young, clean-shaven man, looking down.

All around him sat the older men.

My mother started around the room, shaking hands with each, Kojo and I behind her, round the circle, until finally we sat.

They were speaking a Twi so complicated and elaborate, it was hard to follow the weave and weft of words, so I watched Attobrah, shaking his head, saying,

'*Me yɛ Kristonii*, I am a Christian,' looking down at his hands.

He was refusing.

I looked at Kojo, but he was looking straight ahead.

My uncle got up and spoke.

Everyone else began to speak at the same time, my mother most emphatically of all.

Our failed king elect looked more and more afraid.

If only I could take his place and stand tall at the head of our lineage; find our locked-up, sold-off powers and restore them so they were more than new, imbued.

Yet here he was, sitting in a plastic chair that, if he only wanted, could be a golden stool; balking as if he were a mere actor, afraid to go on stage.

The men got up – to consult the old woman, they said.

Kojo left too.

I looked out of the window as the men stood in their royal cloths on the balcony of the council flat in Croydon, talking quietly amongst themselves.

I asked my mother which old woman it was they were talking to.

She hit her mouth with her hand. '*Wo pɛ saa dodo*,' she whispered to me, 'you like that kind of thing too much.' Out loud she said, 'This small girl is too inquisitive…'

The men who had stayed behind laughed quietly.

'She asks big questions for a small girl,' one said. 'Do you speak Twi?' He turned to me. '*Wo ho te sɛn?*'

'*Ɛyɛ*,' I said.

They all began to laugh again.

I bit my tongue.

Blood began to fill my mouth.

My mother was laughing loudest.

I squeezed my forehead at her.

She squeezed her mouth to the right and blinked at me, pretending friendship.

But I was not her conspirator, nor her friend.

The kingmakers came back in.

Kojo was not with them.

They spoke through the man appointed as the *okyeame*, the spokesman.

Attobrah repeated, quietly, 'I told you already: I am a Christian.'

My mother went to sit next to him. '*Me srɛ wo*, I beg you, Papa.'

I hated it when she begged, clapping her right hand, palm up, into the palm of the left, the edges of her mouth turned down in supplication. *Me srɛ wo, Papa.*

She called him Papa even though his soul was not made of gold, even though he was willing to give up his claim to the stool and all the wisdom that had come before.

Yet still my mother was entreating the young man in glasses, more accountant than king; giving him praise appellations he was not worthy of.

My uncle got up and left.

The men followed.

The door to the hallway stood open.

I followed my mother out, and looked for Kojo.

He was sitting on the bed in Uncle Guggisberg's room, holding a book.

All around, piles of books stood on the floor underneath pictures of my grandfather.

Kojo opened his shirt and tucked the book he was holding into the top of his trousers.

'What are you doing?'

He walked past me, not looking up, and when I went to stand by him, he moved away.

By the time we left, it was already dark outside.

We were staying with Auntie Eastham, christened by us after the area of London where she lived.

When we got to the semi-detached terraced house, Kojo went up to the room he was sleeping in and sat on the pink *Frottee* bedcover with the open notebook on his lap, marked by stains and holes, sheaths of papers stretching out of its depths.

'What is it?' I sat next to him.

Kojo said nothing.

I put my chin on his shoulder and read:

You were born a silent child.

For a moment there was a gap in the noise of the world, that perfect peace that usually follows death rather than birth, so that when the women began to scream as I listened from the stone courtyard outside the Council Chamber, which the courtiers had converted into a maternity ward, once your birth became imminent, I mistook the cadences of joy with those of horror. Your mother too was silent…

'Who is it for?' I asked.

Kojo turned to the last page, where parts of the writing were illegible.

I wanted to return to you.

Here the streets have numbers. Nobody knows whose mother's father or father's mother lived in the house on the corner. Nobody knows my name, my past, my forgotten future… If only I knew how to pray for your freedom from this inescapable absence… Use my mistakes, my memories, as markers. As I did my father's wisdom. And then forget as I could not…

I looked at the concentration on Kojo's emptied-out face. 'Is it your father, Kojo? Is it *The Book of Histories*?'

He closed the book. 'It is not ... enough. It is not what we have been looking for.' His voice was hoarse, like a grown-up's. 'We will have to change it.'

'Change it?' I asked, but I was knocking on a closed door, and my mother was already coming up the stairs.

Kojo hid the notebook underneath the mattress. 'Go to bed,' he said.

———

I left the room, and lay down next to my mother. I was already falling asleep, despite the fast beat of my heart, when something dark flew into my side of the bed.

I tried to scream, to move, but could not.

I tried to call my mother.

I concentrated my power.

'Mummy,' I repeated silently, again and again, until soundlessness became voice.

'Yes?' She sat up at once. 'What is it?'

I told her of the thing that had flown into the bed.

She put her hand on my forehead and began to pray. 'Cover this child in the blood of Jesus, protect her.' She lay back down. 'I knew she was a witch.'

'Who?'

'It does not matter.'

'You mean Auntie Eastham? How can she be a witch? She's your sister… You think everyone is bad.'

'There are things you cannot and will not understand. That is why I am warning you and your brother. You don't know what you are dealing with.'

I turned my back to her.

I thought of the book under Kojo's bed, of deciphering its codes, and those of England too. I thought of

63

the pictures of my grandfather and longed to be in the certainty of his presence, to sit at his feet, lift the arm covered with gold so he would not have to exert himself, hold the umbrella that would shade him from sun's harm. I thought of my uncles' laughter, of how they could not know or see my strength and of how it did not matter, because here and now, it was not they that had to.

IO

My mother sat in the front of the car, shouting at us in the back seat.

She always shouted now.

Kojo shouted too.

Out in public they tried on their new voices.

My mother, a charming closed-mouth laugh.

Kojo, a low-whisper voice, so contrary to the one I knew that each time it took me by surprise.

I put my cheek against the window.

Kojo was talking at me, but it did not seem to matter whether I was listening.

I turned to him.

He was wearing his new navy-blue trousers, corduroy jacket and striped tie.

'...even put coins in the meter for electricity!' It was his at-home loud voice. 'As if *they* are the Third World country. And look at these small, small houses, squashed like *kenkey*. This is the Empire they've been talking about? All their *petey-petey* old furniture. You wait till I tell everybody at home...' He leant against my shoulder, and began whispering in my ear. 'Remember what I told you. I won't

always be there with you, so you've got to remember, do you understand?'

'Yes,' I pushed him away, 'I understand.'

'What are you two talking about, hmm?' my mother said into the rear-view mirror, a small silver trunk on the passenger seat next to her.

We were drawing up to grand, Gothic-looking buildings, boys jostling like a corduroy army through the spired courtyards, wearing woollen scarves in different coloured stripes, and the same blue uniforms as Kojo's.

Their fathers and mothers, tall thin and expensive, in blazers and Barbours, were moving slower, almost still.

I wanted my mother to keep driving, but she had already stopped.

'Kojo…' I held on to his arm.

'What?' He had his hand on the door handle.

'Be good. Don't get into trouble.'

He opened the door. 'What are you even talking about?'

'That sometimes you are a hundred … and sometimes ten.'

He lunged and pushed against me with his full weight, then left the car.

I closed my eyes, felt the cold window against my cheek, the imprint of his body against my side, and knew I would feel it, still, even after he was gone.

'*Oh-ho, wo pɛ saa dodo*,' my mother was shouting at me from outside the car.

I opened the door and got out quickly to make her stop.

'You wait for me by the car,' she said, and began to run, as if for an audience, throwing smiles at the tall blonde neat parents as she went, her scarf flying behind her, her handbag open in her hand.

'Come on,' Kojo said.

'Where are we going?'

He shrugged. 'I don't know.'

We walked through the quadrangle filled with boys, past pillars, a large wooden door.

'What do you think is in here?' I said.

'Look!' He was pointing at boys clutching handfuls of sweets. They were coming from an archway to the right of the courtyard. Inside, there was a chalkboard over a counter with the words 'Tuck Shop' written on it. Behind the counter were jars of labelled sweets, with names and colours I did not know.

Hard aniseed Black Jacks in black and white wrappers, caramel-brown Highland toffee, large chunks of golden, airy honeycomb, acrid-pink Wham bars with bursts of green and yellow.

'What shall we have?' Kojo's eyes were moving back and forth.

'Do you have any money?'

'Of course I do.' He pulled back his shoulders and pushed into the crowd of boys, pointing at different sweets as if he had been buying these for years, and not *Violetten* and *Weisse Mäuse*, all these years.

We went to the end of the quadrangle, past a long stee-pled chapel with painted windows, and sat at the edge of a vast white-paint-marked lawn.

Kojo poured the sweets into our hands.

Sherbet powder-filled flying saucers melted in our mouths like thin paper.

We dipped liquorice sticks in white sherbet dust and licked the dust off our hands.

Gobstoppers stopped us from talking until we had sucked the colourings far into the recesses of our mouths.

I laughed at Kojo's concentrated face.

'Shh, do you hear that?' he asked, the gobstopper extending his cheek.

'What?' I listened to the noise of the boys in the quadrangle, quieter now. Beneath them was the voice of an organ and a single thin high voice. I stood up. 'Let's go and listen.'

We went up the steps of the chapel. 'Don't go in,' Kojo said.

'"I vow to thee, my country…"' the voice sang.

'Is it a boy or a girl?' I asked, then remembered there were no girls.

Kojo said nothing.

'"…all earthly things above, entire and whole and perfect, the service of my love…"'

The boy's voice was clear and strong, and I thought of Dr Lartey's son in his red and white choir gown.

'"I heard my country calling, away across the sea, across the waste of waters she calls and calls to me."'

'Did you hear that?' Kojo asked, pulling me down the steps. '"My country calling" … it's a sign. I told you we have to get close to him now, before he ascends the stool.'

I stopped myself from saying what I thought of Attobrah, and followed him back through the quadrangle, emptier now. 'We should get back to the car.'

He opened the large wooden door we had passed earlier, and went in.

I followed. It was the single biggest room I had ever been in, the ceilings stretching far up, wooden beams running across them, meeting at the centre.

Kojo sat down at one of the long benches next to the tables that lined the length of the hall. 'It's not the history we were looking for,' he said. 'He speaks only of his own life.'

I waited. 'So what's missing?'

'Everything,' Kojo said. 'And at the end—'

'At the end, what?'

'I don't know what happened – he gave up.'

'So what now?'

'We change it.'

'What do you mean, change it? What happens once we have?'

'We show them.'

'Haven't they read it already?'

Kojo looked at me. 'Have you not learnt anything? We just tell them what is true, and they will believe it.'

'How will we tell them we got the book?'

'We tell them the truth. We tell them we were looking through the books in London, that we found it, and took it.'

'When will we do it?'

He shrugged. 'Your handwriting is better than mine, and you're better at copying.'

'What do you mean? Better at copying what?'

'Everything. Their accents. Their ways.'

'That's what we were supposed to be doing. That's what you said.'

He was looking up at the walls, covered in wood rather than paper, lined with the portraits of old men, each one lit by hallowed light. 'One day, it will be our faces we see.'

'Here?'

'Everywhere.'

'We should go.'

He nodded, but did not move.

Behind him a man appeared below an arch at the back of the hall. 'What ... are you doing here?' He moved quietly, but his voice was sharp.

Kojo turned, then stood up straight. 'Sorry, sir. We were just looking.'

'And who are you?' He wore a green tweed jacket and had a whistle around his neck, his brown hair combed into a stiff side-parting.

'Sorry, sir?'

'Name. House.' His voice drew my ribs together.

'Kojo Agyata. Hallows.'

'My patch.' He stood and looked at Kojo, then turned to walk away.

'Sir, sir, before you go…' Kojo walked towards him and stopped. 'I was wondering, sir. I know the rules say we have to ask if we want to have exeats, I know it's soon, sir, but I was wondering if I could ask for one for next weekend.'

The man smiled before he turned to walk back out of the hall, and I knew, even though Kojo did not, that his smile meant Kojo would not be coming home that weekend, and I hoped, even though the smile said otherwise, that it was the worst he would take away from us.

'Let's go back to the car, Kojo.' I went towards the door.

Kojo was still standing in the middle of the hall. 'You know it'll be all right, don't you?'

I shook my head. 'No.'

'When my father left, we knew he would not come back, but we did not know my mother would give up too, that my sisters…' He looked again like a little boy and not the commander of a vast invisible army. I knew it was not the end, that things would be better even than before, but I could not tell him.

'Come on.' I took his hand. 'It's getting late.'

At assembly in my new school, the headmistress told us in her Margaret Thatcher voice how fortunate we were, not only to be the top minds of the country, but to be sharing our quality with one another.

The older girls showed us the tennis courts, netball courts, hockey fields, swimming pool, science blocks, art block, and auditorium.

They touched my hair and stroked my skin and passed me round on their laps like a doll.

I watched them for the codes they did not pass on, and saw that the girls that were good at games were the most popular.

I watched their studied insouciance, the girls they laughed at, the way they wore their uniforms with their buttons open, ties loose, skirts hemmed up.

I could not feign their passion for pushing a ball round a field with a hooded stick, or getting a bigger one into a net, or for beating a rival school, and yet I was picked first for every team.

I longed to be invisible, but was too conspicuous not to stand out, now by curiosity; later, perhaps, by ridicule, or by regard.

After lunch, the boarders in our class showed us the boarding houses.

I looked in the kitchen for signs of midnight feasts, but saw only vast grills, blackened from centuries of girls making cheese on toast. The upstairs rooms had slanted roofs with two single beds, desks, an orderliness that spoke of comfort. The downstairs dormitories had twelve narrow beds, some bare, some housing families of stuffed animals.

The girls took us out onto the fire escape.

I looked down at the grounds.

I closed my eyes.

What if I fell? What would catch me?

The other girls were chatting and laughing.

I felt the edge of panic, put my hand against the wall, held on to a hook.

There was a chain on it that was attached to the escape.

My back pressed against one of the other's.

I looked around; it was Lucinda.

She was small and thin and not especially good at sports, but still somehow commandeered the power to bestow the less popular girls with titles like 'scrubber' and 'minge'.

She turned to look at me. 'Careful,' she said, pointing at my hand.

I looked into her eyes. They were clear and blue and hard and steady.

'Careful,' she said again.

I began to ease the chain off the hook. Something in her uncertainty was making the panic subside.

'What are you doing?' She looked at my hand, then back at me.

There was a crash as the iron ladder reached the ground.

The chattering of the girls gave way to intakes of breath. 'Oh my God. Why did you do that?'

I turned to look down.

An arm pulled me off the fire escape and back through the window. 'Here, put this under your eyes.' It was Lucinda's voice, something in it that was either camaraderie or mirth. She held a small jar in her hand.

'What is it?' It smelt of Vicks Rub.

'Tiger balm, quick. It will make you cry.'

Flat, heavy footsteps neared the door.

I put my finger into the red container and rubbed the ointment under my eyes.

They smarted.

I rubbed it into the skin around my cheekbones; stood, blinking, to face the door.

Miss Hunter, fat-ankled, limp-haired, entered. 'Who is responsible for this?'

The girls watched me.

I had almost missed my cue.

I rubbed the greasy tears from my face. 'I don't know what happened, we were just standing on the... And then ... then ...'

'You had better come with me.' The door shut behind her.

I looked around.

Most of the girls covered their mouths with their hands. Only Lucinda did not smile.

I followed Miss Hunter down to her study.

She closed the door hard behind me. 'Well?'

I opened my mouth.

'There's no use in lying. I can smell the Tiger balm from here.'

I wanted to laugh at her policeman stance, tell her that she should give up teaching English, because she murdered words and sentences and paragraphs just by reading them out loud, but I said nothing.

She came close to my face, and told me that she knew what I was up to.

I crossed my arms.

There was nothing she could do. However much she shouted, however much she goaded, however red her dry-skinned face became, I would not shout back.

She opened the door, and looked back before she slammed it.

I sat down.

A little later, a bent-over wrinkled woman with a hairless dog, dragging its testicles across the floor, came in. 'You'd better go now,' she said.

I nodded, got up and walked past her, not smiling, as she held open the door.

12

At home, I dialled Kojo's number. 'How are things going with the book?'

'They're going.'

'Have you made the changes yet?'

'Not yet, I'm preparing.'

'Do you need my help?'

'You know what all of this means?'

'What does it mean?'

'That we have to listen and look closer than before. These people are the masters of the story.'

'Which people?'

'Look. This is nothing but a small shitty island that doesn't even work properly. It's a cold wet Third World country, but they made us think they were all powerful. We have to see how they did it.'

'When do you think we'll go home?'

'When we've learnt enough,' he said.

I wondered which home he thought I had meant.

'*Veni, vidi, vici.* Remember that. I came, I saw, I conquered.'

'You're shouting,' I said quietly. 'How is it there?'

'They call me Master Kojo and I'm a fag.'

'Translate?'

'We have to run around for the older boys. The ones that don't move fast enough get their heads dunked in the toilet or get showered down with a fire extinguisher.'

'Sounds like a really nice place.'

'It's all right. They like me. I'm good at things. They want me on their teams. I'll be king of this place in no time.'

'That's nice.'

'Nice, is it? What's happened to your vocabulary? Have you even read any books since we arrived? You should get out of bed more often, you lazy coon.'

'You know that's a racist term, don't you?'

'That's more like it, my pedantic little worm.'

'Coon? Really? Did you learn that there?'

'No, it comes straight from the mother country, colonial hang-up.'

'I thought this was the mother country.'

'Depends where you're standing, Maya. We'll be fine. We have to keep what we're doing at the front of our minds at all times. They were messed up, our parents, they've internalised a lot of crap. Once we put things in order, it will fall back into place.'

'You don't really believe that, do you?'

'If you keep staying in bed, you're going to get meaner, as well as dumber and uglier.'

'Thanks.'

'You don't have to like it, though you might. We came to bury Caesar, not to praise him.'

'What does that even mean?'

'Why don't you figure it out when you're smart again?'

'I got invited to Lucinda's birthday party... It's next weekend.'

'Eureka. When you get to her house, watch everything. Especially their rituals. If you can, take notes.'

'What am I supposed to be looking out for – the code to some secret safe?'

'Lucinda is the one whose mother's a Lady? And her father's a politician in the House of Lords?'

'And?'

'These are the people we have to watch and learn from. They understand how it works.'

'You mean you want me to learn to colonise others?'

'No, it's sorcery I want you to learn. How to make people believe you have something when really you have nothing.'

'And then?'

'Then you're protected, then people can't take away from you any more.'

'And how do you take away from nothing?'

'It's not us that have nothing, it's them.'

'So if we become takers, we'll have nothing too, but at least we can pretend we have something, to the others?'

'Stop being so obtuse. You know what I mean.'

'I'm not sure I do. Aren't we already trying to be like them too much? Can't we just stop and get on with our own path?'

Kojo started shouting. 'Maya! That's what we were doing when they came.'

I held the receiver away from my ear.

'That's what we were doing. This is not that kind of world. Things don't work that way. It's not a world where I can play with my toys in peace, and you with yours. You want my toys, and if I'm not prepared, then I will lose them, and be left with nothing, whilst you tell me that you taking them was the best thing that ever happened to me. Nothing's over, Maya. We will go on losing our toys again

and again and again, if we don't learn to protect them, do you understand? Do you understand that, to protect ourselves, we have to learn how the toy-takers operate?'

I wanted to drop the receiver, but instead put it back to my ear. 'Tell me more... Are you happy?'

'It's OK. The boys are good sports. I'm closest with a boy called Peregrine and one of the Kennedy clan. We play rugby, get all the girls at parties.'

'What girls?'

'Pretty English schoolgirls. They're mad as hell about me, which Sergeant doesn't like much.'

'Your housemaster? What does he have to do with it?'

'He's scared I've come to steal their wives and daughters, sit at the head of the table, put my feet in their slippers, warm them by the hearth.'

'And haven't you?'

'Only temporarily.' He laughed, but his laugh was not real.

'Are you OK, Kojo?'

'Yeah. I miss home. It was easier. I didn't feel like I had to be on my guard all the time like I do here.'

'I know what you mean.' I thought of Saint Martin hiding alone in the pen with the geese. 'At least we have each other.'

'And Ma. She understands too, in a different way. That's why she makes us do tennis and piano lessons, and buys all those clothes. She understands.'

'And Pa?'

'He's more afraid. I think they'll get to him.'

I said nothing.

'Kid? You OK? I've got to go. Don't let them get to you.'

'I won't. I'm much stronger than you anyhow.'

'That's why you always run crying to Mummy when I sit on your head?'

'It's a tactic. You should learn some one day.'
'Said the pupil to the master.'
'Said the birch tree to the stump.'

I noted that Lucinda's house had turrets, and a long grav-
elly path to its entrance, that her parents talked of wings
instead of rooms, that her mother said 'ooofully', instead
of 'awfully', and fed her dogs smoked salmon and roast
chicken from the same plates and weighted silver cutlery
that we ate with.

The wings were cold and smelt of wet dogs, even though
large fires burnt in every one. Rugs and books were strewn all
over the deep sofas and surfaces, and the walls were painted
dark rich colours, blood-red, yolk-yellow and olive-green.

We sat in the sofas and on the floor of the children's
drawing room and watched a film starring a horse that
was bred for racing. In the last race the jockey drove the
horse so hard that its hoof came half off, and yet it still
ran and won.

Lucinda's father, wide-bellied in tapestried slippers and
an assured deep shout in his voice, switched on the lights.

Everyone in the room was crying, except for me.

That night, we all crowded onto the bed in Lucinda's
room, even though we had been assigned rooms in the
various wings. I watched how Josephine knelt on the bed,
brushing and braiding Lucinda's hair.

'I notice you talk to Anna a lot,' Lucinda said to me.

I said nothing.

'I feel really sorry for her,' she said. 'That hurts!' She
elbowed Josephine and yanked her hair away, then turned
back to me. 'She's always inviting herself to our parties,
and turns up to things even though no one told her to

come. She almost invited herself to this. And have you noticed that she says really stupid things? Like "toilet" instead of "loo", and she calls a sofa a settee…'

Josephine laughed.

I looked at her, wishing Lucinda would elbow her again.

Josephine looked up at me and took one of my braids between her fingers and pinched it. 'Hey, how come your hair's always different every few weeks? It's much longer suddenly.'

'We have this special ointment in Ghana,' I said slowly. 'It makes our hair grow really long, really fast. It once went from here –' I put my hand by my chin '– to here –' I touched my right shoulder '– in a week.'

'Really?' Their voices were high in amazement. 'Wow.'

Kojo was right. It was possible to change stories and still be believed.

———

I went through all the motions of talking, eating, laughing, sleeping, and, while waiting, perfected the mantle of their ways. I learnt to stand in the woods at the back of the school while Charlotte, who was repeating our form for the third time and was tallest, smoked; and while Juliet, who was already beginning to grow breasts, talked of boys. I learnt to sit on the floor of the 7-Eleven shop on Sunday mornings, skiving church with Sarah, who was pretty, clever, good at sports, and whose parents lived in London. I learnt the choreography of slipping food from my plate into paper napkins under the table, of being excused, of flushing it down the loo. In class, I still could not find my way into the mannered indirect world of Jane Austen, of all that tea-drinking and people not saying what they meant. I missed the clear direct words of Rilke

and Goethe. Even the floweriness of Balzac and Zola in French class did not compensate, and all the teachers seemed intent on deadening the things you hated, as well as those you loved, except Mrs Lilley, with her long chestnut hair that she held back with thin Alice bands in blue velvet or brown tortoiseshell, her line-straight skirts, cowl-neck blouses and matching high-necked jumpers. She did not metaphorically pat us on the head or shake hers patronisingly when we spoke, but nodded seriously and sometimes smiled a little at the edges of her mouth. We read excerpts of the Bible-sized tome by Simon Schama on the French Revolution as homework. In his pages, it was as if each turn, each power struggle, were playing out in the room, and I was anxious for each day to pass, so I could come alive through his words at night, learning the secret passion at the back of each player's heart. I saw how the past could come alive and be relived through words.

When I presented, the other girls complained at my high marks even though I had not learnt a single date. For all their 'top minds', only few of them could see we just had to make sense of the story, learn a few facts to throw in for good measure. It would not work for everything, but it was not in everything I had to succeed.

Still the story I told was not good enough for what we were planning. I had to learn to create images with words.

During art class, I looked through the shelves for books titled 'revolution' and opened one.

Camilla Gray was twenty-one when she began her pioneering research on Russian art, it said. *She published the book five years later and died tragically at the age of thirty-five…*

I took the book to my table, turned to the last page.

For the first time since the Middle Ages, the artist and his art were embodied in the make-up of the common life, art was given a working job…

I looked for a picture of her. There was none, though it said she had been a ballerina before she had written the book. I looked at an image of huge crowds in a square…
A Re-enactment of the Storming of the Winter Palace.

'What are you doing?' Miss Pettisome, our art teacher, wore uniforms of black scarves layered with primary-coloured coats, like shapeless dressing gowns, their sleeves much too wide and hollow.

I closed the book. 'Just looking.'

'You should be getting on with your project. Not looking.'

The art block was filling with copies of Monet's *Water Lilies*, da Vinci's *Mona Lisa*, Rodin's *Kiss*.

Miss Pettisome had told us to find an artist to copy. 'That's right. Find an artist who inspires you, and copy their work, forge, plagiarise, steal. If you would like to add your own little twist, by all means do.' She said that the philosopher Plato regarded art as just a poor copy of the object world, which was already only a shadow of the real. 'Mimesis, he called it. Poppycock, I say.' She looped her arms theatrically in the air when she spoke. 'Copy away as much as you want and don't be afraid that you're stepping away from "the real", whatever that means. Copying gives you mastery of form.'

'Do we have the Plato book here?' I asked, as she stood over me.

'You're too young to read Plato, my dear.'

'Can I go to the library? Everyone's already doing every-one else.'

'Don't you have enough to distract you with here? … I suppose so.'

I got up, Camilla Gray in hand.

'Uh-uh-uh … where do you think you're going with that?'

'Can I? I'll bring it back.'

I rushed out before she could say no, through the grounds, past the girls in short skirts playing hockey, and into the library. I sat by the window and reopened the book.

A Re-enactment of the Storming of the Winter Palace.

They had recruited thousands to restage the storming and decorated the square with giant sculptures.

I turned the page. There was a structure, lopsided, but upright, made of iron poles reaching up and up, spiralling round and around: Tatlin's *Monument to the Third International*.

It was like the festivals that Kojo had told me about in which they acted out events from the past to recreate order.

It was what we had to do. Recreate what had happened; not just on the pages, but in life too.

'What are you doing in here, weirdo?' It was Josephine, with Lucinda and Charlotte.

'I'm looking for something.' I put my hand over the book.

Lucinda picked it up. '*The Russian Experiment in Art.*' She threw the book back onto the table. 'Come on. It's lunchtime.'

'I can't. I have to do this. We have to … in our spare time—'

'You know where to find us if you get bored.'

'Yeah, I'm bored already…' I shrugged, watching them leave, though it was their world, which from the outside looked so expensively wrought, and which was really ridden with holes, that I was bored of.

I got up, scoured the library for Plato's *Republic* and looked for the section of which Miss Pettisome had spoken.

The sun was the light of truth, it said, and the everyday shadows on the walls of the cave in which we were trapped, and to which the sun gave form, were what we thought of as truth.

The philosopher kings could climb out and see and pass on to the others, who were either too dense or lazy or afraid to climb out, their wisdom and clarity.

The philosopher kings, who had gold in their souls, just like my grandfather, Kojo and me.

Miss Pettisome had told us that, in Plato's Republic, artists would be banned, because they made copies of objects that in themselves were copies of the real.

But, for Camilla's artists, naturalistic trees and landscapes were reduced to three or four colours, and then to lines, as if to remove all that was superfluous to life, to retain only what was necessary and true.

It was like our stories, which only passed on what was essential.

Kojo had told me they collapsed time, that in them the past and the future were pulled into the present so that it did not matter what age or date something was; they all collapsed into one which contained them all.

He told me that the way they told stories here, with one thing after the other, and one date following on from the next, was all wrong.

It was not really how it worked, they had got it all confused, but we knew better.

I made a sketch of Tatlin's *Monument*, then looked out of the window.

The girls in their hockey skirts came into focus, running and hitting at the ball.

What if we did it? What if we really did manage to climb out and there was nothing there except the climb?

The girls began to stream in; lunch break was almost over.

I walked along the aisles, opened books, traced the flatness of the pages with my palms, inhaled the familiarity of bound paper.

I picked up a book on Van Gogh, his thick, tortured, almost chaotic strokes applied layer over layer, in a way that was still strangely serene.

I traced the swirls and curves of his suns with my fingers, and closed the book.

This would do.

13

I waited outside after school for my mother's car, though I knew it would arrive long after everyone else's.

I looked at the brick-red wall of the school building keeping out the world, and wondered how it would be if I climbed it and closed the distance.

I thought of Kojo and of all the secrets he was discovering in the notebook that he was keeping from me, of how I could now tell him what we must do.

When my mother's yellow Golf pulled up, there were two heads in the car instead of one.

It was Kojo.

I went towards the car, but I did not open the door.

My mother was shouting.

Kojo was shouting too.

But not in their usual shouting for shouting sake's way.

'I didn't do it!' That was Kojo. 'I said I didn't do it.'

I got in and closed the door; their noise was forming layers in my head.

'He said he didn't do it,' I yelled. 'Didn't you hear him?'

My mother's fury turned on me. 'You think because you have big schooling now that you are better than me,

heh? Now I am a foolish woman? Now I am stupid? Who pays for that school of yours, heh?'

I had tears in my stomach and in my throat.

My mother's voice was so loud now that people driving past looked out of their cars at us, even though the windows were shut. She shouted all the way home, and kept shouting even when Kojo and I went up to my room.

I sat on the floor and told him about Simon Schama and Plato and Camilla Gray, of how we would be able to change the past, because the future was so clear to us; of how our words and those in the notebook would make the past come alive again, and thus change the present.

Kojo shook his head. 'It doesn't matter,' he said.

'You have to tell me what happened, Kojo. If you don't tell me, I can't help.'

'Someone wrote "Sergeant fucks Jane" all over the Junior Common Room wall,' he said.

Jane, the pretty school nurse.

Sergeant thought it was Kojo. In the middle of the night, he had got him out of bed, told him to get dressed quick smart.

It was still dark outside and some of the other boys in the dorm had looked out from their striped pyjamas and scratchy blankets.

Kojo's shoes creaked on the wooden floorboards, and they were the only sound as Sergeant stood in the lit doorway, arms folded.

Sergeant was holding in his cheeks the same way he did on those days he told Kojo what to do and Kojo didn't.

Roll down your sleeves.

It's hot where I come from, sir.

Spit out your gum.

I can't, it's like sacred tradition in my country, sir.

Sergeant dragged him down to the running fields, pulling him by his woollen hair, and Kojo said he knew Sergeant could not bear to touch it, because of the face he made, and he hoped the dirt in his hair and the Dax wax was slipping off onto his fingers.

It was raining, the soft unyielding rain it rained in England, not the forceful kind from home that announced its coming with flashes and sky rumbles, and he was already slipping in his regulation shoes.

The stiff first discomfort of his cricket whites and rugby stripes was nothing compared to the sodden sagginess of long navy corduroys, shirt and jumper sticking to him in the rain.

Sergeant stood and looked at him and shouted as if he were on a Combined Cadet Force drill. 'Say it…' he said. 'Say it…'

But he could not, Kojo said, first of all because he did not know what Sergeant wanted him to say, and secondly because he wouldn't.

They stood like that forever, Sergeant and he, both getting wet, and then Sergeant blew the whistle, the one that hung around his neck like a dog tag, even when he was in his speckled green tweed on Sundays.

Kojo knew he wanted him to run, so he ran, slipping in the mud.

Sergeant blew the whistle again, and Kojo skidded out onto the grass as he stopped and ran back. When he reached Sergeant, the whistle blew again.

He was hardly running because he was slipping so much, so he bent to take off his shoes, and Sergeant blew his whistle hard and quick again and again.

His shoes were off. He ran. Back and forth, back and forth, and still Sergeant was blowing his whistle.

It was almost like he was moonwalking.

Sergeant was shouting now. 'Run, you bloody wog. Run.'

And Kojo knew he was not allowed to say that, the 'bloody' or the 'wog', but he was not one to point it out.

Sergeant was running beside him now and he was blowing the whistle in his face and he turned back and ran, back again, ran, back, ran, back again.

Sergeant did not know that every night Kojo beat his head against his pillow, that at home Mum used to hold his head down and blow *shhs* into his ear, that at school the boys had laughed at him, until he showed them what was what, that then they stopped. That he kept beating his head. So he knew about endurance. He knew how to keep going.

'You won't break me with your whistling and your insults,' he was saying to an invisible Sergeant, and his face was more closed than I had ever seen it.

Sergeant. Fucking Sergeant. Fucking Jane. It was raining like a rhythm through his head. He wished he had written it, because it was so good, and he smiled as he thought that.

Sergeant saw, through the rain pouring down, and through his sweat. 'Down on your hands and feet,' he shouted.

Kojo stopped. He felt like passing out.

'Down on your hands and feet. Now.'

He did not know where he found the strength, but he thought of prostrating himself as a child in front of his father in Kaba.

Of lying face down in the imported gravel at the palace, waiting until he was given permission to get up.

He thought of his sisters.

Of coming out of the bathroom and ripping off his towel and doing a dance and wiggling it at them.

Of them chasing after him and catching him and holding him down.

All three of them holding him down and laughing at him as he struggled to get free.

He was still on his hands and feet, but the sound of his sisters' laughter was deep in his ears, and the sight of his father's callused feet and snakeskin sandals was in the back of his eyes.

He felt something come up and he had to lie down or he had to get up.

His hands were slipping and something was struggling in his chest.

He wanted to get up, but Sergeant pressed his great walloping foot on his back.

Sergeant pressed his face into the mud and, right there and then, something in him broke.

Something broke and he was crying and he was hitting Sergeant, punching him with the strength he had left, and he didn't know if he was crying because Sergeant had won or because of the thing that was broken.

14

After Kojo had gone to bed, my mother came into my room. 'Maya, I have to tell you a secret,' she said, amnesiac as always of her mood earlier.

The last time she had told me one, it was of her affair with the Ghanaian ambassador in London, whom she had known since she was young and who she insisted had stayed unmarried so he could marry her. I did not want to know any more secrets.

She began to tell me anyway. After her father died, she said, the other wives divided his treasures so they could gain education and come back to lead.

There was a turn in the fortunes of the family, of the kingdom, as if her father's passing undid not just the balance of the kingdom, but of the whole country.

'I know this already,' I said.

But she went on.

When Nkrumah came into power, he gave scholarships to the young and promising to go abroad, so they could gain education, come back to lead.

One of her brothers, not liking the company she was keeping, helped her be chosen.

Before she left, she went with her mother to a prophet, who told her that one day she would come back as First Lady all in white, but she already knew.

She knew that when she was born she was the only one of her siblings to be outdoored in the palace, in white lace and red velvet, and that it was because she had been born with the mark of greatness.

She knew, while she sold oranges on the street, and helped out in the homes of her older, wealthier brothers, that she would one day be the wealthiest, the grandest of them all.

And now a man who had been looking for her had found her.

Nii Tetteh, a friend of her brother's, the former finance minister, was trying to gain access to all the money they, the founders of the nation, had put away for the country, and he needed her help.

They had been to the banks in Switzerland, were going to the Caymans; and very soon she would return home as the First Lady she was born to be.

'And the ambassador?' I interrupted her.

'Oh-ho, you too.'

'What does it mean?'

'I'm going home.'

'As First Lady?'

'Not yet. We're going to prepare.'

'And us?'

'You'll stay at school. Kojo will go to your father and you'll stay at boarding school here.'

'Why here?'

'You like it, don't you? You have friends.'

I shrugged. 'I guess I do.'

———

At school, I piled layer upon layer of paint onto card, adding silver, blue, green and bronze to the barks of trees; planted yellow-, violet-, ochre-hued soil.

'Not quite there, is it?' It was Miss Pettisome.

I put down my paintbrush.

'Wash.' Miss Pettisome was pointing at the brush.

I held it in my hand, wondering whether to fight. I went to the sink.

'Helloooo.' Anna, bouncing as she always did, just like she brayed when she laughed.

I looked at her, big-boned and good-natured. 'Anna … I wanted to tell you something …'

'Yes? Isn't this class magic? I love what you're doing, by the way; it's so … thick.'

'Thanks. Anna,' I put the brush down, 'you know how … how you sometimes invite yourself to things … even if someone's having a deep meaningful, you just kind of come and sit with them…' I looked at her; it was not registering. 'The others, they don't like it. They talk about it. I thought, maybe someone should tell you, so you know, so you don't… Everyone really likes you, it's just that…' I stopped.

There had appeared on Anna's face, so suddenly, a look I had not seen before, a look so distracted that I longed for her to hee-haw, or come and stand too close to me.

'I'm sorry. I didn't mean to hurt your feelings. I thought you'd want to know. It's just … I would…'

'Thanks, that's really sweet.'

'I didn't mean…' I did not want to look at her any more. I took my paintbrushes half-washed of their yellow-blues, put them in the glass jar, and left the class.

By the time the bell rang for the next lesson and I went to the homeroom to get my books, the others were already there.

I opened my desk.

'That was really mean, what you did to Anna,' Josephine said, putting the lid of my desk down. 'Who do you think you are?'

'You think you're special, don't you? You think you're someone?' Lucinda's face was tight and hard. 'Well, you're not. You're not anything.'

I felt hot in my stomach, under my skin. 'I thought … I thought…'

Her English-rose face came close to mine. 'What did you think?' I noticed how well she spat out the 'th' … when I still mixed up my s's and th's.

'Maybe I should tell you something too… You know the only reason everyone likes you … is because you're black.'

They walked away.

I sat down at the closed desk.

What if you managed to gather all you could, all your strength and sight, climbed out of the cave, and when you got out, all you wanted to do was lie down and die?

Lucinda's cruelty. Charlotte's smoking. Juliet's ribaldry. The boys at Kojo's school.

They could all afford to play the fool, because it was still the muted portraits of their ancestors that lined the oak-panelled walls of the great hall.

They would be all right.

They had been for centuries and would be so for centuries more.

But at least I knew, now Kojo was going back to Germany, I would go too.

PART THREE

15

My mother left for Ghana. Kojo and I were both sent to Catholic schools. Kojo to a monastery in the countryside. I, to a convent in town.

Every week our history teacher picked three of us from class – Angelika, Zinaida and me, perhaps because we challenged him most often on the vagaries of history – to come to his house and stand at either end shouting out loud the lines of Goethe's three Fates, Atropos, Lachesis and Clotho.

His plan, he told us, was for us to swing, clad in white sheets, from the chandeliers at school.

The house was large with tall ceilings.

I was alone in one of the rooms, empty except for a wooden chair and table.

From one of the other rooms, Angelika's voice came, shouting, '*Des Menschen Seele gleicht dem Wasser, Vom Himmel kommt es, Zum Himmel steigt es.*'

'*Lauter,*' Herr Geissmann's voice was shouting back from the other side of the house.

'*Und wieder nieder Zur Erde muß es! Ewig wechselnd!*'

'Zinaida…' he summoned.

'*Seele des Menschen, Wie gleichst du dem Wasser!*' Zinaida's voice, accented, replied.

'*Lauter!*'

'*Schicksal des Menschen! Wie gleichst du dem Wind!*'

I walked down the stone steps of the house. It would be my turn next, and I did not want to shout. I was not sure what broken thing would emerge from my depths along with my voice. I opened the heavy door and went out into the street. The autumn air hung dark, cloaking whatever hope summer had wrought. The house was in the old part of the town, the roads cobbled and uneven. I looked back to see if he had followed me out. People moved towards me, threatening to come too close, but Herr Geissmann was not among them. He was too tall and thin and ancient, too storybook-like to be over-looked, his thinning hair combed back in a way that was endearing rather than ridiculous, his yellowed false teeth jostling around in his mouth, baptising spit soaking the front row ceaselessly as he taught.

He spoke to us of Goethe's idea of a *Weltliteratur* in which all the literatures of the world stood equally side by side.

I wanted to tell him it implied that all the stories of the world matched each other, and did not take into account that some were stopped in their tracks or usurped or deemed primitive; or that some were written and others told or drummed; or that sometimes the change across boundaries, of colour and tone and rhythm, affected how those stories were received once they arrived.

My kingdom's story had been told largely through its objects; its narratives of performance, their meanings, distorted, neglected, lost along the way. It was up to us now, to Kojo and I, to restore them, to craft stories that could stand side by side with all the others.

I sat down on the stoop of a doorway. I had one hour before I was due to report back. Herr Geissmann would not tell them I had left early. He dreamt of a future for me as an ARD presenter, reading the news, in a *Hochdeutsch* even more enunciated than that of the Germans themselves, but I could not think of much that was more frightening than fitting into this pinched-in, sterile world.

I thought of the stories my mother told me of my birth into this pale-moon world: white-blonde nurses, white corridors, white walls, white floors in the children's ward of the *Marienkrankenhaus* in Bad Godesberg. And amongst all the harsh whiteness, the soft brown skin, dark brown hair and brown screams from my brown-pinkish mouth. The relief and happiness that shone through my father's glass-framed eyes, as he held his newborn baby, as he handed it to the sweat-soaked blood-streaked woman lying on the bed who was laughing, always, despite all the pain.

I imagined how he walked to the bathroom through the white-tiled corridors, the dark brown man with a white smile between his lips. Past the German doctor, who later often visited our house, and who had a hospital in what he described as German Togoland, where they still spoke German. Into the bathroom where all too was white; my father, gripping the sides of the basin, wanting to go down on his knees, but afraid, always, of what the Germans would think of him.

I opened my rucksack and took out my uncle's book. Kojo had finally let me have it.

The parts he had highlighted, the hard facts of things:

Our grandfather's death, arrests, a court case, the war, a freedom-fighter friend called Felix, politics in London.

I skipped over these, like I did the war scenes in *War and Peace*, and opened to those that spoke of our family:

Of our grandmother, of my mother whom my uncle called Yaa, of my father whom he called Kwamena, and of Kojo's mother Amba...

I looked at my watch. It was long past time. I would get in trouble. I put the book in the rucksack and ran. I got to the gate and stopped. There was someone outside. It was Zinaida.

She had arrived only a few months ago, dropped off by her mother who wore tight leather trousers, a red bolero jacket and a short dark-blonde bob the mirror of Zinaida's. She looked younger than the rest of us, so frail and thin that I wondered if she would be anorexic like Mariana, chew only on gum, occasionally eat soup, and grow hair all over her face and body, but she was not; it was the nervous energy inside her that seemed to consume everything that went in. Her constant painful laugh pulled on my sinews and in her high-pitched vulnerability, in the edge on which she balanced, sharply, precariously, she held something singular, something that did not close itself to life. She had wondered about me too, she told me later; had heard from someone that my father was a plastic surgeon, that I had had surgery to perfect my skin and cheeks.

'And you believed that?' I asked her, laughing.

'Come on,' she said now, 'I've been waiting almost twenty minutes.' She told me Angelika hadn't wanted to wait, but that she had not wanted to go in without me.

I took her hand and pressed it.

We went past the nun at the *Pforte*, holding hands; past one of the nuns, less fierce-looking than Schwester Maria Amabilis, our housemistress who, in her black habit, patched white and pink skin and stomping sandals, led us all, eighteen of us boarders, single file every morning into prayer, while we fingered our rosary beads – *Heilige*

Maria, Mutter Gottes, bitte für uns Sünder, jetzt und in der Stunde unseres Todes – prayed for our sins, prayed for forgiveness, prayed for the filth that coated us even before we were born.

I closed my eyes, and every morning tried to feel myself into my sin, but instead felt empty and bored, by the lack of sanctity, of beauty, of mystery; by the nuns, the other girls who, though still skilled choreographers of food, lacked the imagination of their counterparts in England.

The next morning was Saturday. We were allowed out into the main streets of the town. We stopped in the only shop where the clothes did not look like they were made exclusively for women in their fifties. The eyes of the sales assistants travelled us up and down. We pulled out clothes and held them against each other. Zinaida wanted to try one on, but the woman told her its price and she put it back.

Outside, she showed me the leather bracelet she had hidden in her hand. In the next shop, she nudged me as she slipped a thin necklace up her sleeve.

I tried to walk slowly as we left the shop, but we both skip-ran as we got further down the street. We turned the corner into another shop, tried on T-shirts and jeans, piled our own clothes on top of them. My legs and hands felt bloodless as we went up and down the escalators, holding up items, nodding or shaking our heads, finding more and more brazen ways of hiding things we did not need: a writing pad, a letter opener for my father, a bracelet for my mother, playing cards for Kojo.

Back at school, we stripped off to our jeans, and ran up to the bathrooms. We locked ourselves in the only cubicle with a tub, sat face to face in the hot water, and waited for our jeans to shrink to our size.

There was a knock on the door.

Then Schwester Maria Amabilis's voice with a shriek in it: '*Ich weiss was ihr dadrin macht. Ich weiss es.*'

We let out the bathwater, holding the plug in place so it would seep away quietly. We stripped off our wet jeans and put on our dry clothes, laughing silently, as if gasping for air, until our stomachs hurt with anxiety.

But she kept knocking.

We waited, listening, until all was quiet, then signalled each other. I would go out first. We opened the door slowly, no creaking.

Her wide ugly black sandal was in at once, jamming the door. Her veiny pink hands, like octopi, reached for our arms. She pinched each one of us hard, and the pain was like being punched.

'*Aua*,' Zinaida said, telling her she could not do that, spitting vengeance high-pitched in her face.

Still she held us, and told us in a voice which slapped that we were wicked dirty girls for what we were doing, and despite our unshrunken jeans lying sodden in the corner, I felt ashamed.

16

I climbed out of the window of the apartment and lowered myself onto the ground below. I walked in the dark the steps I had walked many times by myself, but only occasionally at night, and always then with my father or Kojo. Even though I felt afraid, I walked head up, staring defiantly back at the Germans who stared at me, as if a young Ghanaian girl out alone at night, in the streets of this *Kuhdorf*, this small semi-urban town on the border of industrial heartlands, were a perfectly normal sight. I stood at the bus stop in the market square – in front of the pizza van that sold powdery Italian pizza; next to the chicken joint that roasted sweaty whole chickens on a rotisserie; opposite the bakery that sold seed-strewn breads, sugar-coated Berliner, icing-glazed Amerikaner – and waited.

The bus was almost empty. My heart beat fast as it now did constantly, as if the pulse of life itself had become irregular.

I thought of the version of my father that Kojo's father had described in the book and could not reconcile him with the man I knew, the one whose promise of light had dimmed into shadow. I got off the bus, followed

Zinaida's instructions, through the dark empty streets of meticulously manicured gardens framing meticulously structured houses, towards the sure arrogance of Jamie, as he sat under trees, reading books, while the other boys played ball.

At the end of the cul-de-sac stood a white-bricked house, the kind you used as the facade, waved goodbye in front of when your friends dropped you off, praying their parents would drive away before you reached the door.

Downstairs French music played from the film *La Boum*. I knew the boys and girls would be dancing what they called the blues, in an approximation of French sophistication and laxity.

I pushed open the door and walked down the darkened staircase looking through the bodies for the safety of Zinaida's form.

She was there on a chair leaning over Sebastian, whom she liked, but who, whenever I was around, made it clear that he liked me. It was usually Zinaida, with her light-coloured bob, complexion, her already ripened experience of the other sex, whom boys yearned for. I did not know where outside or within myself to place his affection.

I looked for Jamie, blue-eyed, Aryan poet-prince, who had the familiar assurance, the nonchalance I knew from Kojo's friends that allowed him to say, as we sat outside the ice-skating rink, which on Sundays was a daytime disco, that when he was older he would never employ black people in his company.

Zinaida looked at me. 'Maya's black,' she said.

'That's different,' he said. 'My father doesn't employ black people either.'

Sebastian was next to me and bumped his shoulder against mine. 'Would you like to dance the blues?' he asked.

'No, thank you,' I said, walking towards the gap he had left beside Zinaida.

She put her mouth close to my ear. 'He asked for my number.'

I looked at her, wanted to ask, 'Sebastian?' but was too surprised.

'We're both going to Mallorca, for the holidays.' She put her arm through mine.

I looked at her. Who was she talking about?

She nodded in Jamie's direction.

I made my arm go lax, so she would no longer have anything to hold.

Sebastian was walking towards us, his mouth a wide, uncomfortable smile.

I felt Zinaida's energy move in his direction.

I willed myself up the stairs, onto the street, towards the bus stop I had walked from earlier with an expectation of some kind of release, trying all the time not to burst the capacity of my constricted lungs.

The apartment was quiet. When I unlocked the door, slowly, noiselessly, my father stood, as if he had been waiting, in the darkened corridor.

'I told you not to go out. You still went,' he said. There was no shout in his reprieve.

I said nothing, turned and walked into the bedroom, stood behind the closed door, holding in my stomach, my arms, my fists.

I lay down on the bed, reached under the mattress for my uncle's book and opened one of the pages I had marked, looked for clues of how to survive.

He did not know.

I got up to go to the living room. It was not yet light. My father had left for the clinic. I turned on the television.

There was a film of a group of French men, bon viveurs and gluttons. They had shut themselves up in a large house in order to eat and copulate themselves to death. I turned the volume down; the noises of their perversion, excess and physical combustion threatened to escape the boundaries of the television.

I switched channels.

On ZDF, a group of very straight-looking German men showcased their inclinations; a man in his fifties, dressed in a baby's all-in-one, sat in a giant cot, sucking his thumb, wailing, until he was spanked.

On RTL 4, chubby teenage boys ran around beaches, Benny Hill-style, trying rapidly, with accompanying music, to sleep with as many girls as they could.

On ARD, a close-up of the face of a beautiful woman, black and white, the wind tussling her blonde hair as she stood on a gorse-scattered cliff. I watched her beauty, the movement of her body, and looked down at my breasts that were beginning to make mounds under my T-shirt.

I went to the bathroom and filled the tub with hot water, lay in it until the skin on the tips of my fingers paled and webbed, filling and refilling the water; savouring the endless efficient flow of German heat; driving out memories of British finiteness, cold-running baths, early-morning hockey practice, holey cashmere jumpers that signified wealth and abandon, self-inflicted stoic suffering, Kojo, my mother. I got dressed and walked to the same marketplace I had walked to hours before. In the telephone kiosk, I dialled her number. I was not meant to give her our number at home, so she would not bother him, my father said.

There was no need for hellos or how are yous. 'Call me, Mummy. I'll be home in ten minutes.'

'Darling, what's wrong?'

'Nothing.'

'Oh-ho, I can hear it. Have you eaten?' she asked; eternal concern which posited that everything, even a sore heart, might be mended by a meal.

But I knew that there were some things that could not; some things I could not explain to her.

In England, my mother had brought over Kwame, one of the many cousins she took into to our homes: in Germany, in England, later in Ghana; arranged passports, visas, flights, clothes. Some stayed weeks, some months, some even years, though it was only Kojo who really became one of her own, her god child, her protected one. Kwame, arrived in Michael Jackson tendrils, white vests, a leather jacket, a cross around his neck, a burn on his hand from a childhood accident and a deep, Barry White-like, almost sarcastic, laugh. He began working at McDonald's and, in the evenings when my mother stayed late at the lab, looked after me with television, crisps and Coca-Cola. It was one evening like this I lay next to him on my mother's bed. He put his hand down his trousers and with the other touched me, held me closer and closer to him until I could no longer breathe, until it stopped. He moved away soon after, and I dreamt the dream of forgetting, but the wound in my stomach grew so that my skin hurt from breathing. I hugged myself in to contain it, bit on my tongue to stop it from seeping, drowning me out.

I walked home, heard the phone ring even before I had unlocked the door.

I told her of a friend whom I loved, who had tried, for reasons I could not explain, to take something away that I loved, and how it hurt.

'Darling,' my mother said, in a voice that was calmer, lower, than the one I knew, 'what God has given to you, no one can take away.'

I nodded and held the phone next to my cheek even after she was gone, so that the sound, which came from behind the closed front door, broke into silence.

I got up and opened it quickly so as not to be afraid of what lay beyond.

My father and I were both surprised to be standing, suddenly, face to face.

He, with a look of intent listening; his eyes deep with hurt and betrayal.

I, trying to blink away the confusion that flushed my body hot.

17

I managed to avoid Zinaida for days, missing classes we were meant to be in together by feigning illness, pretending not to hear her when she spoke.

But still she came into my room as I lay on the bed with my uncle's book, holding a gift wrapped in crumpled tissue paper. I hesitated, holding in my head the story of pride that forever cast her asunder, then reached out and took it.

We grinned widely, stupidly, for a few minutes and even though I had other friends, Zinaida was always in my mind the first. It was not just that we coordinated our clothes or were so elated in each other's company that our voices were often a chorus of high-pitched rush, breathlessness and laughter; or that we had an elaborate handshake that was ours alone. I had had friends like that before and would after. It was that in her refusal to let me go she created a home that was forever mine.

She leant over and whispered to me, even though there was no one else in the room. She had asked for an exeat. She was going to meet Max. She had referred to him before as a boyfriend, but he was always away at boarding

school, and I had never met him. She would arrange it so that I could come and Max would bring Sebastian and we would all have so much fun.

She seemed to have forgotten already her former affection for Sebastian, and wished him on me wholeheartedly.

I had promised Kojo that I would soon be finished with the book. He was right, it was one only of personal defeat. What we needed was a book of victories.

What would we do with our story once it was written? I asked Kojo again and again. Rewriting was only the first step.

'Wait and see,' Kojo always said, as if he were centuries older, 'wait and see.'

The boys picked us up outside the heavy door of the back *Pforte*.

Max was tall and lanky and spotty. She ran to him, jumped up and wrapped her legs around him, like a Monchichi. Her lips stuck to his and he tussled her hair like in one of the frisky films they showed late at night on TV, emulating people in love.

I did not look at Sebastian though I could feel the heat of his energy radiating towards me.

We walked around the town for hours, stopped for ice cream and McDonald's, until it was time to go back. We stood outside the door he had picked me up at; he in a large hoodie that swamped his frame, and green jeans, and I wondered if the boys dyed theirs together like we did, or whether they did it at home alone. He wore the Vans trainers they all did, and there was a chain around his neck. He looked only half himself, without his skateboard in his hand.

'Goodnight then,' I said. I could see in his eyes a mixture of anxiety and excitement that filtered back into my own.

He leant towards me, until his body was hard against mine.

My heart beat in my throat.

His lips were dry.

Back at school, the phone rang almost as soon as I reached the top of the stairs.

Someone called out my name.

When I picked up the receiver, it was his voice, already, on the other end.

'Just a minute.' I called Zinaida. I cradled the phone between the two of us so she could hear.

He was stuttering something.

We both began giggling, silently.

There was a pause. 'Is someone else there?'

I had my hand over my laughing mouth, gesticulated for her to take the receiver.

She opened her mouth. Laughter spilled out. She held her stomach. 'He's hung up.'

I kept laughing, as loudly as I could, imitating the cadence of hers, hoping she would not see through the hollow tone.

When the phone rang for me again, I thought it might be him – like her, not willing to give up – but it was not.

'Hello?' Instead it was my father's voice, cautious.

'Dad?'

'I trusted you,' he said. 'I told you not to give her our number. I know what I am doing.'

'She is my mother. I am still only a child.'

He paused. 'Something has happened with Kojo. He has gone missing from school. Your mother is on a flight. I will go and pick her up from the airport.'

'Kojo's gone? Gone where?'

'We don't know.'

'What happened? Are you going to pick me up too?'

My mind was still ringing with the feeling that had opened up between my legs.

I had neglected Kojo for Zinaida, had skipped pages in the book, had not paid enough attention.

I sat, paralysed by the knowledge that it was all somehow my fault.

18

My father and I did not speak on the way to the airport.

Once there, I stood watching the planes arrive, as he stood at the gate.

I heard my mother's voice before I saw her.

'Is this my daughter? Aaa! What is she wearing? Is this how she has grown? In these jeans? Aaa! And her hair?'

Hello Mother, I said in my head, not looking at all the German people looking at me.

She put her hand through my hair; I pushed it away. She smelt of Chanel perfume, powdery and sweet. She had gold bracelets on her wrist and a gold watch with diamonds. She was wearing a black-and-white chequered suit with patent black flat shoes and gold buckles. Even now, she somehow trapped the sun beneath her skin.

In the car, my father showed my mother Kojo's report. I took it from her.

Despite the fact that Kojo's group tutor, housemaster
and subject tutors have done their very best this term to
persuade and coerce him to work, their efforts have been

*in vain and he has made minimal progress. This is a
summary of the present situation:*

*English, O level – comprehension good, essays spoiled
by careless spelling and punctuation. He could pass but is
likely to get a D.*

*Mathematics, CSE – very easily distracted. Has made
some effort in the last few weeks.*

Physics – far too casual.

Art – lacks concentration.

Engineering – has potential but will not use it.

*Electronics – does the minimum of work necessary to
keep out of trouble.*

*There is the faint possibility that through revision
during the holidays, followed by great and consistent
efforts next term, he may partially redeem the situation,
but I do not feel optimistic.*

*In view of this I feel that I must repeat the statement
that I made at our last meeting.*

*Kojo has failed to take advantage of the academic,
sporting or social opportunities of the school and, as there
are no signs of a radical change of heart on his part, his
future here must be limited.*

*It would be a wise move on your part, therefore, to
give written notice of your intention to withdraw Kojo
from the school at the end of the spring term.*

*I have talked to our Careers Adviser about his pos-
sible future. Like me, they feel that there is little point in
continuing with Kojo's education in view of his present
attitude, for no progress will be made until he realises the
necessity of education and hard work.*

*We would suggest, therefore, that you should put Kojo
out to work in a rather lowly capacity, which is all he
is at present fitted for, under the supervision of someone
you can trust, and being paid the appropriate salary, in*

the hope that this rather harsh treatment will bring him
to his senses and force him to realise that it is up to him
to make the most of his undoubted abilities to under-
take courses of further education of a definite vocational
nature.

If he were to realise this in the next year, it would
not be too late for him to make a fresh start at a new
establishment.

I regret having to write this letter, but assume that
under the circumstances you will wish to send the
customary term's notice and make the appropriate
arrangements for Kojo's future.

'Is this why he disappeared?' I asked.

My father shook his head; it was because one of the assistant teachers had slapped him, and he had slapped her back.

'Too right,' my mother said.

I looked at her.

We arrived at the Catholic boys' boarding school that was also a monastery. There were llamas grazing in the field outside and the sky was dark as octopus ink. Kojo was already back in his room, where cards of NASA astronauts plastered the wall.

'No child of mine is going to work in – what do you call it? – a lowly capacity. Pack your things.'

They had already been packed.

———

At home, there were now everywhere suitcases of clothes, the yams and plantains and snails she had brought from home. I lay on the sofa amidst half-empty pots of cream foundation and face powder, blunt eye pencils and skin-brightening creams.

I took the book from my bag and opened it almost at the end.

There was a black and white photograph of Kojo inside.

He was with his sisters, and smiling with all his teeth, as well as his eyes.

It was so different from the picture of him I had seen at his school, shoulders hunched in his uniform as if to guard from the cold, or some even bigger threat.

I heard through the closed door the sound of my parents' raised, syncopated voices.

I finished the last paragraphs and went into Kojo's room.

'Why are you always getting into trouble?' I slammed the door.

'Why are you?'

'At least I'm going back to school.'

'I want to go home,' he said.

'You *are* home.'

He shook his head. 'No, I'm not. Will you come with me?'

In my mind I shook my head; I was not ready. 'Do you think we've done enough?'

'I think so,' he whispered. 'Come with me.'

'Where?' I snuck the book with the pages of my rewrite under the mattress.

He held up my mother's car keys. We had both thought her story a fairy tale until she bought a BMW on the day before her birthday.

We put on our coats.

'Where are we going?' I asked.

Outside he unlocked her new car.

We got in.

He turned the ignition.

'What are you doing?'

'Don't you trust me?'

'Of course I do.'

He stop-started the car down the road. 'Which way?'

'Straight,' I said, praying we could drive away and not come back.

'Let's go and get some sweets.'

The car was jumping ahead. There were no other cars.

'We should go back, Kojo.'

'We're almost there.'

'We should go back. I don't have a good feeling.'

He looked at me, then started reversing the car in the middle of the road.

It stopped.

He started it again.

It sped backwards – flattening a fence – into a neatly planted flowery garden, almost hitting the house.

He put the car back into gear with both hands.

We stop-started again towards the apartment.

We left the car in the car park and went back up in silence.

Upstairs he lay on the bed, playing Dungeons and Dragons.

I looked at his hair, his head, his hands.

I looked at the loose pages of the book sticking out from under the mattress.

I looked out of the window, not really looking, so that even though I saw the blue lights flashing through the glass and into the room, it was not until the siren stopped that I realised what it was, and the panic that was now constant in me, the scream that was a lake that was the feeling that we were only just surviving, widened up to take me over.

PART FOUR

19

I lay on my bed as the anaemic London sun shone through the red and gold sari cloth I had hung for a curtain. I looked at the books stacked in piles around the room, the pastel drawings and magazine cut-outs on the walls, newspaper fragments listing jobs, aborted attempts at essays spread out over the large wooden desk; the rail at the end of the bed, hung with printed, patterned, knitted, gold-threaded clothes, bought with the proceeds of my mother's borrowed dreams.

It was not so long ago that I had looked at my clothes with the excitement of an artist choosing the right palette, or like the Black Barbie doll someone once called me. Now I lay still as a corpse on display, the teak of my arms against the creased white of my sheets. The zebra-patterned bag I had carried my belongings in from flat to flat when I first arrived in the city lay crumpled on the floor by the clothes rail. My mother and I had bought the bag in a small shop near Harrods, where wealthy ladies went to sell hordes of brand-new, still tagged, clothes to make room for more.

The shop was close to one of the apartments in Knightsbridge or Mayfair, which she rented in the school

holidays, all with the same anonymity of opulent rented spaces, that rose higher on the gradient of grandeur as my mother and Nii Tetteh flew back and forth from Switzerland to the Caymans to Ghana; from hotel rooms to banks to Ghanaian courts, fighting for the release of the money they were adamant was locked in their vaults, as investors poured money into the promise of endless returns.

Kojo and I had made sure the book was found, then stopped talking about it, even amongst ourselves, as if its provenance had nothing to do with us.

It was now a mythic story of a kingdom, a nation that rose, smoothly, united, despite the things that tore at it, and in which the future was foretold as one of glory and global dominion. Whole extracts were dedicated to the objects Kojo knew had been stolen, vanished or sold. We had not held back, but amplified each impression, every goal, just as my mother did not hold back in her enthusiasm, manifesting at each turn the billions that would soon be hers.

There were several missed calls from Kojo.

I dialled his number in Accra.

'You do not have enough credit to make this call,' a helpful woman intoned.

I got out of bed and looked through the pockets of my dark pink suede swing coat. I emptied the zebra bag, put my hand through a hole in the quilted gold lining, went into the small kitchen, its yellow walls warming the incoming rays of the sun. I emptied the pot of change by the gas cooker: one pound thirty-six pence. Three pounds and sixty-four pence more and I could call Kojo back.

I sat down at the small wooden kitchen table and picked up the packet of Marlboro Reds that Zinaida had left.

The day before, I had gone to the cinema on my own, used my last money to watch Antonioni caress Monica

Vitti on the screen, needing to escape the constant fullness of my head, the emptiness of my stomach.

I had imagined another life for university, a search for meanings beyond words, long conversations about Plato and Tolstoy and truth and art, but had found it a conveyor belt of hollow pretence, until Zinaida appeared in London, wearing a leopard-skin coat, bright red lipstick, and alligator-skin high-heeled boots that made her walk fast and at a bit of a stoop, as if slowing down would make her fall. She looked now like a young Cruella de Vil. Mirroring, as she had before, whichever boy she was dating. She had gone to live on an island in Goa before university, started following the precepts of the Indian guru Osho, had taken an HIV test on arrival, slept with fourteen other people in the spirit of elevated love, posed as a nude model for extra money, and lay in flotation tanks in the gaps between lectures for balance and serenity. We coordinated outfits, running down daffodil-covered hills in North London to watch silent films like *Man with a Movie Camera* and reading Chekhov to each other in Café Rouge, laughing at our own pretension.

I took out one of her cigarettes, and put it between my lips. I had the urge to make myself feel sick, though I did not smoke. I walked to the little mirror we had found on a wall in the street and hung in our narrow corridor. I held the dead cigarette in my mouth and inhaled, then exhaled. Monica Vitti, I thought, narrowing my eyes. No, Romy Schneider: I pulled back my hair with my left hand and inhaled again. I parted my hair to the side and over my eyes, ruffled the back and pouted. Brigitte Bardot. I walked with a slow deliberate hip-swing to the window, leant out and tipped my imaginary ash. I fluttered my eyelashes at the wind and looked down at the bench opposite the terraced building. Someone had left a large blue

Ikea bag there, brightly coloured clothes spilling out of its neck like the curdled brains of a man shot in the head.

You are never poor. I heard the echo of my mother's voice in my head.

I put a coat over my blue-and-wine striped pyjamas and the Green Flash plimsolls that still had my name tag stitched into their tongues and thought of all the unopened bills in my mother's house, and of the wardrobes stuffed to overspill with clothes. I walked out of the door, down the four flights of steps and along the side streets parallel to Ladbroke Grove which began to get wider as the houses grew taller, towards the second-hand clothes shop that I hoped would buy what I had.

As I went, I looked into the windows of the perfectly arranged kitchens and front rooms. I knew that behind the facades lay messy imperfection, but wanted to glut myself on the fake perfections until my head hurt in the same way it did when I looked through the pages of *Vogue* magazine.

I walked to the Notting Hill Exchange, looked down at the Vivienne Westwood platform shoes as I went in. They were selling for £250. The peroxided leather-jacket-wearing sales assistant looked into my bag full of designer treasures, wordlessly took out five dirty ten-pound notes, and put them on the counter.

Back home, I did not take my coat off to dial Kojo's number, but sat on the bed in my pyjamas, held my breath at the familiar drawn-out ringtone.

'Hello? ... Maya. Is that you?' Kojo shouted from the other end. 'Maya, I need your help.'

'Of course, of course I'll help you.'

He laughed. 'You haven't even heard, and you're prepared. You're either very trusting or a fool.'

I bit my tongue. Since his return, Kojo had found his place, his calling, his person, when I, in staying, seemed

to get more and more lost in the seeking. 'Tell me,' I said.

'I can't, not fully, on the phone. We have an election coming. Do you remember, Maya, all the treasures we used to talk about? Those sold off?'

I said nothing.

'We have finally found the places they were sold to. Even the golden crown, Maya. Even the golden crown… Next year, before the election, we will have a grand exhibition, a festival, a museum, an Odwira here. On home soil. All the world's leaders, everyone will come and see how deep our history is. You have to come. I asked your mother to book you a ticket, to come for Christmas.'

'Does she want me to come?'

'She wants a Christmas tree,' he laughed.

I said no to my mother's demand to bring a Christmas tree with me from England; until Ben, who always wore patterned woollen jumpers and whose smile when he saw me was that of a child, asked me what good a Christmas tree would be in Africa. I told him it was Ghana, not Africa, and asked him why it was we couldn't have Christmas trees if we wanted them, aware that I was sounding spoilt and unreasonable, and that he did not deserve my wrath; but there was something in his voice that reminded me of the line in the song heralding that there would be no snow in Africa this Christmas, the pop stars singing with their mouths downturned at the thought of snowless children in over forty degrees heat.

My mother not only expected me to drag a live Christmas tree halfway across the world on a plane, as bulk luggage, but on her last visit to London had, as only she knew how, charmed a man the local taxi company had sent, whom we later baptised Uncle Matthew, into being her personal chauffeur, and had no qualms enlisting him to scour London scouting for just the right one.

I was out of the bath, standing wet in the kitchen, when I heard the sound of a loud radio come up from the street, then that of a car horn. I went over and looked out of the window. Uncle Matthew's car was dwarfed by a gigantic fir tree.

Oh no! I went into my room. Bags had to be closed. Papers still packed. Passport found. I stood at the doorway, wondering where to start. I went towards the suitcase, then back to the papers on the floor, then towards the desk. I stood still and looked from one to the other.

'Here, you sit on it and I'll zip it up.' Zinaida was in the doorway. She knelt and tried to press shut the bulging suitcase.

'My oh my,' Uncle Matthew said as we went up and down the stairs, clutching suitcases, bags and notebooks.

'That's it.' I looked up at the house. 'Wish me luck.'

'You don't need it. You're going home,' Zinaida said.

'I'm so nervous.'

'I know you are, darling, but it will be all right. Your mother will be fine. Kojo will be there. And Saba will be … Saba,' she said, as if Kojo's sister's presence could do anything but make things harder.

'Thank you. Give my love to the others. And thank you.' I drew back, clenched my fists and squeezed my shoulders up to my ears. 'I am so excited.'

The taxi crawled up Ladbroke Grove as the intensity of the cars beeping behind us grew.

'It might help if you took your sunglasses off, Uncle Matthew. It's actually quite dark.'

'No, no it's all right.' He turned round and slowed down even further. The sunglasses had large white frames and, if he hadn't been so old, he might have looked like a

seventies pimp. He had found the sunglasses in the back of the taxi, he said, and lifted them up onto his fore-head with a trembling hand to show me his smiling eyes underneath.

Cars were overtaking us. Drivers shouted swear words as they passed by.

Uncle Matthew waved his hand at them as if swatting off mosquitoes.

I leant back for the snail-ride to the airport, ignoring the background sounds of horns and expletives. When we reached the roundabout that led to the different terminals of Heathrow, Uncle Matthew drove round and round at walking pace, leaning over the steering wheel and indicat-ing for each exit before changing his mind, the orchestra of horns behind us a discordant symphony.

We got to Terminal Four – I was late. My heart beat hard. I was going to miss the plane. I was my mother's daughter after all. I lugged suitcases onto a trolley and ran.

Uncle Matthew was behind with the Christmas tree.

We drew all kinds of curious looks as we ran past German travellers with their compact Samsonite suitcases, Italian travellers with their matching leather ones and Americans with their rucksacks, or so it seemed. One of my suitcases fell off the trolley. 'Damn them all for look-ing at me,' I cursed. 'May their stares turn back on them and into flames.'

I saw the Ghanaian travellers with trolleys piled with bulging brown Sellotaped boxes and bound-together suit-cases and washing machines and children's bicycles and huge red-and-black chequered Ghana Must Go bags. Ghana Airways.

I ran to the check-in. A man was pleading with the airline staff as he pulled item after item from his suitcase. People were giving large suitcases to relatives to hide so

they could take them on as hand luggage and everyone was looking at my Christmas tree.

I asked a harried-looking woman at the counter in a British Airways uniform if she had seen Mr Omisah. She looked at me, Uncle Matthew and our trolleys and said that Ghana Airways had overbooked; there was no time to check in people arriving now.

'But I have to get on the plane,' I told her.

The woman had already turned away.

'Uncle Matthew, wait here. I'm coming.' I took the trolley and ran through the mass of people to the Ghana Airways counter.

There were two women in charge. One was trying to calm the madding crowd, the other had turned to face the wall and was silently holding a telephone receiver in her hand.

I went round the counter to the woman on the phone. 'Please, Auntie,' I said, taking her arm, 'please, I'm looking for Mr Omisah.'

Uncle Matthew had followed me to the counter with the tree. I felt a surge of guilt for making the old man rush with me, but I knew he would not leave even if I told him to. I went to stand next to him and put my hand on his shoulder.

The woman refused to look away from the wall and I tried again. 'My mother is Yaa Agyata, she told me to look for Mr Omisah when I came.'

The woman turned to me for the first time and took the receiver from her ear. 'Who?' She looked at me with bullish annoyance.

I balked slightly at the woman's hostile glance and at the realisation that I was now no longer just another African girl in London, but in territory in which the mention of my mother's name could get me onto a plane.

'Sister, you dey fo take this home?' the man next to her asked, pointing at the tree just as I spotted Mr Omisah walking past the counter.

I ran towards him, motioning at Uncle Matthew. 'Mr Omisah,' I shouted, as I reached him.

He saw me, smiled at first, then looked alarmed when he spotted the Christmas tree. I felt flush with embarrassment, then remembered that my mother would reward him. I looked up at the display board for the first time – four hours' delay.

Mr Omisah took the Christmas-tree trolley from Uncle Matthew and led me to the front of the queue. I was getting my mother's treatment.

———

We were held up in Rome for two hours with no explanation, until a murmured chorus rose from the passengers. 'What nonsense is this…? Why are they treating us like animals?' Still, when the plane landed in Accra, everyone cheered and clapped like it had been a first-class journey. I sat in business class and had been refreshed by orange juice on a regular basis. Those in economy had none. It was now one of my mother's pretensions to sit herself and her children in business class, wherever we flew or however little money she had. It was like the way her accent changed when she left the house. Or her voice rose when she wanted people to hear what she was talking about – her large house, her Jaguar, her royal lineage. Once, when listening to her boasting of our enormous television, I interjected, 'But we don't have one,' and had been clipped for my troubles, learning to wince silently at the excesses.

I stepped out of the plane onto the top step of the ladder. The hot muggy air swept over and into me. I

closed my eyes. Home. We were herded into a bus and, when we got to the terminal building, the first thing I saw were the familiar gold-rimmed smiling eyes of Kojo. I ran into his arms.

'*Akwaaba*, welcome.' He took my bag from me. 'You have grown into a beautiful young woman.' He looked at my tight curly hair, misshapen from the journey, my pink crumpled flower skirt, white vest top and platform shoes.

I smiled into his admiration. He whisked me past the passport control, throwing waves and smiles as he went. On the other side, a man in a white-shirt uniform, with a blue beret, met us with a trolley and asked me to describe my bags. The arrivals hall was small and matt compared to the glossiness of Heathrow. There were only two conveyer belts and a small wooden counter with 'Bureau de Change' written in black on yellow above it. Why French? I was wondering, when I saw my mother rushing towards me in a sumptuous long green, gold-dusted dress, gold slip-on shoes and matching bag. I had forgotten how beautiful she was. She was laughing, with her arms outstretched, her bag falling from her shoulder to her elbow. Her diamond-encrusted glasses hung diagonally across her face. She took me in her arms and kissed me hard on the cheek. I drew in my head at her effusiveness and looked up at her. She smelt of powdery luxury. Her arms and chest felt like butter and as always there was gold trapped beneath her skin.

'Your hair looks awful!' She put her hands through it. 'And what are you wearing? Terrible!' Even though I was next to her, her voice rang out to the walls.

We had to pick up other boxes. My mother had demanded Christmas-tree lights and decorations from Switzerland and Lebkuchen biscuits, Dr. Oetker juices

and a Christmas cake from Germany. I did not know what imperative drove her to have things sent from abroad, when she could readily buy them from the supermarkets and shops in Accra, but it was the same one that made her bring pineapples and mangoes and yams to me when she came to London, shirts and suits and dresses to relatives when she came back to Accra, and kente and Adinkra cloths when she visited friends in Europe. It was as if she always wanted to bear gifts with her from foreign lands or pass on the excess of her own rare, precious essence to those less well imbued, like the Three Magi bearing frankincense, gold and myrrh. The uniformed man came back with my luggage, followed by three other men in white shirts and blue trousers, pushing three trolleys piled high with boxes. They all walked towards customs. A man with a stern face and a blue customs suit beckoned them towards him.

'My little girl,' my mother cooed at him, 'she has just come. Books. Only books. Her food will get cold.' She tickled the custom man's cheek and waved the men pushing the trolleys on.

We went past the thronged mass outside, waiting for the returnees; past the porters and taxi drivers sidling up for custom; past the suited men wanting to shake Kojo's hand, to the waiting car.

The driver got out of the four-wheel drive and nodded at me. 'You are welcome, madam.'

I smiled, uneasy with this form of address, not least because he was much older than me, my senses filled with the pulse of the airport, the frenzied shouting, the closeness, people holding hands and embracing and approaching as if there were no boundaries.

We got into the car, to the loud chattering orders of my mother and the quieter efficiency of Kojo.

At the traffic light, girls and boys selling 'pia water', pure water in sachets, plantain chips, portable radios, windscreen cloths, watches, mops and buckets, magazines and chewing gum, crowded round our air-conditioned car.

My mother opened the window and let the warm air in. 'Mummy, Mummy, Mummy,' they shouted, as she bought toilet roll and joked with them about the prices.

I sat in the back seat looking out at the legless men rolling past the cars in front of them.

There was a knock on my window. A young boy was holding out his hand. A blind man leant on his shoulder.

I tugged at my mother's arm.

She looked across at my side of the car and beckoned them over.

'Please,' the boy said, 'my father is sick and we have no money for medicine. We have no money to go home. Please, Mummy, help us.'

My mother took a 10,000-cedi note out of her bag. I looked at the boy and his father and the gauntness of their cheeks.

My mother touched my cheek. 'Don't be sad, little girl. You don't know if it is the Lord himself come down to test us.' She pressed my hand.

We passed women selling mangoes, pineapples, sweet potatoes and yams on their trolleys on the sides of the streets. New shopping centres stocked with high-end clothes, toys and household goods had sprung up since I had last come. In front of an aluminium-roofed kiosk, a young woman sat on a stool as another one braided her hair. A small fat-bellied boy ran naked and wet out in front of them, did a dance and ran back in. The tarmac turned into red earth where nascent concrete shells of houses stood. At the side of the road, a man lay on a bench with a radio beside him. The warm evening sun seemed

to slow everything down and my heart struggled to settle into its pace. We pulled into the gates of a large peach-painted house that from the outside looked like any of the villas we had passed in the area. It stretched almost to the extremes of the compound.

My mother shouted, 'Charles!'

Out of the annals of the house an echo answered, 'Madam!'

'Charles!' my mother called again.

'Madam!' the echo responded once more, this time accompanied by a rush of feet and a smiling shirt-clad young boy.

'Where have you been, stu-pid boy? Sleeping? You damn fool! Hurry up! Hurry up and get the things out of the car!'

'Yes, madam,' Charles answered, still smiling through the storm of insults.

They all seemed bemused – Kojo, the driver and Charles. Only I was mortified at my mother's tone. I stood with my arms folded, scowling at her.

'But, madam. Where is the tree for Christmas time?' Charles asked, and in all innocence pushed a nuclear button.

'*A-wu-ra-de! Aich!*' My mother was waving her arms. 'Oh Lord!' She clutched her head. 'Jeeee-sus! You damned fool!' Her drama turned to the driver, John. 'Id-iy-ot.' She stood in front of this grown man shouting him down to his face. 'Why did you not think of it? You, with your face like a goat! What do I pay you for?'

John looked out at the gate through which we had just driven.

'It's not his fault,' I said to my mother, arms still folded.

She turned her attention to me. 'How dare you talk to me like that in front of these people? What do you think I am? A damned fool?'

I walked into the house. On the cold marble-flecked floors stood plush yellow embroidered sofas and a glass gold-encrusted centre-table underneath an ornate crystal chandelier. In the dining-room area, there was a lacquered dining table with eight chairs and a glass cabinet filled with the expensive plates and crockery that had caused my father to finally leave.

I went up the stairs: more sofas and a large television. Aha, I thought, the mythical TV, at last. My mother had a disarming knack for turning dreams into reality. I opened a door to her powdery perfumy smell. In the room stood a large golden bed with a gold eiderdown cover on it and another, smaller TV against the wall facing it. The walls were lined with gold-handled wardrobes and in the corner were a golden chair and an ivory dresser, littered with perfume bottles, make-up, keys and papers. For comfort I touched the dresser before I closed the door.

In the next room, there was a smaller cream-coloured gold-edged bed and a similar dressing table, but empty, and a cream wardrobe. My room. Princess-sized to my mother's queen. I went in and lay on the bed. I looked up at the air conditioning, blowing cold air above my head, and switched it off with the remote.

There was a knock on the door.

'Come in,' I said after a pause.

It was Kojo. 'Come,' he said, so much older than me now. 'I called for someone to bring the Christmas tree from the airport; it is here and up, and I am leaving.'

I turned to face the wall.

'Come, tomorrow Ma will bring you to my house. We will go to Gyata, and we will do all.' He pulled me up and put his arm around my shoulders as we walked down the stairs.

The Christmas tree stood tall in the garden; Charles was up a ladder hanging the decorations and lights on it. I

watched him clumsily draping tinsel on pine. My mother in turn barked orders and laughed. I rolled my eyes at Kojo, who came and squeezed me, kissed my mother on the cheek, shook hands with the driver, and reached a cedi note up to Charles, before going to speak to the gateman.

'Nobody has eaten. Kojo, come back,' my mother shouted to his departing car. 'Charles, have you eaten at all? Security. Who in this house has eaten this evening...?'

We all piled into the kitchen. My mother delegated tasks and set to making plantain and yam and green *kontomire* stew in palm oil with boiled eggs. She made everyone – John, Charles, the cook – laugh with her stories, and I thought, not for the first time, as I sat on the counter, what an actress she would have made, as she rushed from stove to fridge, dealing out portions of food for all in the house.

With Charles, I laid out the costly plates for the two of us in the dining room.

20

I woke up the next morning to the absence of the mechanical noise of London and began to make out the rhythmic strains of someone pounding *fufu*, the distant echo of a radio. I opened my eyes, saw that the sky was covered in a fog-like cast; the harmattan was blowing in from the Sahara, its clouds said to carry disease and misfortune along with their dust. Catarrh clogged the lungs. Grit stuck in the eyes. Its still wind dried out the mind. There was a knock on the door.

'Yes?'

Charles came in. 'Madam. Fine morning.'

'Good morning, Charles. Call me Maya.'

'Yes, sister. Maya. Please, I would like to bring the breakfast.'

'Breakfast in bed?' I smiled, thinking of the very recent scrimmage for coins.

'Yes, sister, please, sausage and eggs.'

'Mummy asked you to make this? I've been vegetarian since I was eight.'

'*Bejtan…?*'

'I don't eat meat…' I had stopped eating red meat at school when as teenage girls we had been given the option

of what and how much we wanted to eat. And yet still my mother told me there was no meat in dishes in which there was, or that corned beef was not really meat. 'Never mind. Where is she? Is she up?'

'Please, Mummy has gone out.'

'She will be back soon?'

'This night.'

'And there's no car?'

'No please.'

I fell back into the pillows. I remembered now how hard it was to be independent here, with no car, no local phone, how my mother seemed to make sure I could do nothing alone without a driver, without her, and how easy it was, when you were not with Kojo, to lose him in the constant stream of engagements and meetings and busyness he was now engulfed in. And yet there was so much to do – the museum we were building in Gyata with all the goods that had gone missing, all our powers returned, and we now did not have much time.

'Charles,' I shouted, sitting up.

'Sister,' he replied quietly.

'Sorry … I thought you'd gone. Is there a telephone?'

'They have disconnected it.'

'Of course they have…'

'I bring break fast?'

'No, thanks, I will come.' I got out of bed, ran my fingers against the walls as I went down; the hollowness of empty rooms, empty apartments, empty houses, its reson-ance an old friend. I went into the kitchen. Charles was eating *gari foto* with stew. It was the one dish I had never taken to, the coarse grains sticking in my throat. I stood and watched him and he stopped eating. I looked around at the large bare kitchen completely stripped of herbs, condiments, oils and trimmings, unlike our kitchen in

London with its olive oils and teas and paper cut-outs of roses and passport pictures on the cupboards.

Charles had begun eating again.

'You should sit down when you eat, it's better for you,' I said to him.

He looked at me. 'I know where there is telephone.'

'What? What did you say?'

'There is a man who sell the unit. He has mobile phone.'

'Charles, you are amazing.' I ran up to my mother's room and stopped. I did not have Kojo's number. I looked around at the coloured woven cloths my mother had tried and discarded onto the bed and chair. I opened the bedside table that was attached to the large ill-shaped bed-board. Among the scribblings of Bible passages in my mother's address book, I found the number I was looking for. It was underneath my own. Above a prayer my mother had written out for the protection of her children. *Let no harm come to them*, she had written, her writing spilling diagonally across the lines. I ran my fingers over them and closed the book.

I went through the door between the wardrobes that opened into the bathroom. I turned the taps of the large amoeba-shaped sunken bath with holes in the bottom. Hot water. The luxury. I let the water run over my fingers, until it began to burn. I looked at the cosmetics on a trolley next to the basin. I began to straighten out all the powders, creams, ointments, oils and perfumes. I turned the labels outwards and picked up a facecloth and rubbed the dust off the Dax hairwax and the pink oil, the sticky heavy medicinal-smelling ointments I had put in my hair when I was little to tame its rebellious kink. I polished the Nina Ricci, the Diorissimo and the Chanel No5 bottles and smelt each one for my mother. I opened the blue-and-white tub of Astral cream and dipped my finger into its marshmallow whiteness and

picked up a white blue-lettered container – skin lightener, as advertised on CNN. I opened the jar and the chemical aroma filled my nostrils. My mother was always telling me I was too dark. Once, I had tried it, but it had left dark patches on my temples and I could not stand the smell of limed poison on my skin. My mother was more expert and mixed it with less harmful creams and somehow achieved an even glossy hue. Not like the women you saw with large dark blotches, beige-coloured skin and down growing on their faces and arms. I got into the bath and pushed the button so that air came up out of the holes at the bottom. I closed my eyes and thought of how difficult life was in London and how often my mother had told me to come home. And yet, on my last visit to Ghana, when I had woken up one morning and put on a thin kaftan over my naked body to go down to breakfast, she had looked at me and hissed, 'Are you wearing pants?' I ignored her loud-whispered, 'There are men in the house ... that's why no one respects you.' In England I could be free, unrestrained. Here there were safety nets, but also rules, mores alien to me. And in both, it was a daily struggle to master the tightrope of existence, or risk falling. I stretched my head back into the soft bubbling water, held my breath.

Outside the Christmas tree was beginning to go brown with the heat. Charles and I walked down to the bottom of the untarred cratered lane. There was a half-finished house, unpainted and scaffolded. Men were sitting in a group around a small radio; a woman with a baby tied to her back was rhythmically lifting a long stick up and down above a bowl, pounding *fufu*.

'What are they doing there?'

'They sell yam.'

'Do they live there?'

'*Ai*.'

'Does the landlord know?'

'Pardon?'

'The master of the house?'

'Yes. Maybe they rent from him. I think he does not have enough money to finish so he is selling yam.'

We walked on along red-earth lanes and past half-finished shells of houses and finished ones with basketball courts and pillars. We stopped at one house that had been made to look like a castle: turrets, golden lions and all.

'My God. Who built this?'

'It is a lady. She de come from Europe.'

Of course. She was one of the been-tos who went to Europe and worked as doctors, lawyers, nurses, taxi drivers or cleaners, and returned with the same qualification of the school of over there.

'Will you take me to Aburokyire, sister?'

'To Europe? It's not that great there, Charles. It's very difficult and cold and people don't talk to each other.'

'But everybody is rich?'

I laughed. 'No, not everybody.'

'I would like to go to America.'

'What would you do there?'

'Play football. Buy a mobile phone. And a car.'

'You think it's easier there?'

'Yes, sister.'

We walked on in silence, towards the main road.

'You marry an *oburoni*?' he asked me.

'I don't know,' I said. 'I don't think so. There are so many differences, but Ghanaian men think I'm funny.'

We had reached the main road. In front of us was a kiosk selling household goods and refreshments and a two-storey-building with an ice-cream parlour, dressmaker and Internet café.

'Why? Because you are too small?' He pressed his arms to his side to show my thinness. 'I will show you how to pound *fufu*, Sister Maya. Then we will find you a husband.'

I smiled and pinched his nose.

'*Aich*,' he said and laughed. It was deep and boyish.

'Where are your parents, Charles?'

'They have passed.'

'Your brothers and sisters…?'

'In the village. Mummy came to get me and now she is sending me to school … sister, the number.'

There was a man sitting on the edge of the road, with a wooden table and an old-fashioned handset, rather than a mobile phone. I wondered how it connected. I handed him the number I had written on a piece of paper. He dialled several times, but Kojo's number was unresponsive.

'Try again,' I urged him, until he shook his head and gave me back the piece of paper.

There was only one thing left to do.

'You have a number for Saba?' I asked Charles.

'Yes, please. You want make me fo call am?' He looked at me, sensing my reluctance.

I nodded once, twice.

Speaking to Kojo's sister was as hard for me as swallowing *fufu*, but I had no other choice. Saba agreed to come over. We walked the red-dusted road towards the house in silence, passing by the shoeshiners ringing their bells and street traders with goods piled high on top of their heads as they went.

A car was driving up to the gate when we got there and the elderly gateman slowly opened it. He was tall, stooped and very slender. A Volkswagen Golf pulled in and Saba stepped out. She was leaner and many shades lighter than Kojo. Her hair was scraped back, Sade-like,

from her rounded forehead and she was wearing gold heels and a short aquamarine dress with a looped halter-neck encrusted with what looked like semi-precious multicoloured stones, which on anyone else might have looked tacky or overblown.

'Maya, dah-ling. Mu-wah, mu-wah. How absolutely dah-ling to see you. What a dah-ling Christmas tree. Back in a mo.' She swept into the house.

It was still a source of amazement to me that Saba, having never really lived in England, affected the intonations of a Chelsea mum. After their mother's death, Kojo and his sisters were shared between their mother's siblings and Saba was the only one to have stayed in Ghana. She looked out of the front door. 'Get changed, Maya, we're going to a wedding!'

'Saba,' I followed her into the house, 'I'd love to go, but I'm looking for Kojo.'

'I thought you might be.' Saba stood on the staircase with her hand on her hip. 'Mummy tells me of you and your cousin's aspirations. He'll be at this do, so get dressed.'

I went up the stairs behind Saba and turned into my room. I emptied the contents of my suitcases onto the floor – vintage frocks, skirts and tops that all looked fine on the streets of London – and pulled out a short black fitted dress. Downstairs, Saba was getting into the Golf and motioned for me to do the same. She began to beep her horn.

'He's already on his way to the gate, Saba.'

'More like on his way to the grave. I don't know why Mummy insists on employing these good-for-nothings.'

'Hasn't he been in the family for years?'

'Exactly.'

'They are human beings too, you know.'

'Oh here we go. Please spare me your First World guilt.'
She turned up the song playing on her car radio: Mariah
Carey's 'All I Want for Christmas'; Saba sang along at the
top of her voice, shimmying her shoulders. I looked out
of the window as we drove out of the dusty drive and onto
the main roads of East Legon. Half-built houses nestled
alongside ones with basketball courts. Areas of land were
being cleared for more houses and luxury estates. Accra
was expanding ever further outwards to accommodate its
growing moneyed classes. We joined the slip road that led
onto the motorway. I saw an enormous pillared building,
the size of a stadium. There were empty flagpoles outside
and a huge billboard of a smiling well-fed smooth-
skinned man wearing a white Mao-style shirt and black
suit jacket.

'Whose wedding is it?' I asked Saba.

'Michael's. He's David's friend.'

'Is that where you were when I arrived, with David?'

'None of your beeswax. We're picking him up in Osu.'

'Lovely,' I said. I had met him many years ago, after
Saba had divorced her first husband, and my memories
of him were not rainbow-rimmed. We drove down the
37 highway and onto Oxford Street. The streets bustled
with energy, music and honking cars. We passed tall girls
in hotpants and short dresses, boys in baggy low-slung
jeans and baseball caps, red-faced tourists wearing batik
and printed dresses, neon-signed nightclubs, Chinese
restaurants, fried chicken joints, an ice-cream bar, shops
selling cards, wrapping paper and mobile phones, hawk-
ers holding up Ghana football shirts, flags, masks and
alligator-skin handbags. We stopped at a bar with an
outside terrace and got out of the car. Saba went and
whispered in the ear of a stocky dark man sitting with a
group. Everything about him signalled wealth. His gold

watch. The crisp white of his polo shirt with the small blue horseman above his nipple. The sunglasses perched on his head. The BMW key ring he dangled from his middle finger. I walked slowly towards them, looked round the patio with its tiled floor and shiny black tables. There was a shy-looking couple waiting to be seated. The girl whispered to the boy, who smiled up at her and put his hand on her back. A large, red-faced man in an open crumpled shirt pushed past me.

I turned. 'Excuse me.'

'Give me a table,' he said to the waitress in a white and green African-print shirt-dress who was clearing plates.

A wiry floppy-haired blond man came out and led the red-faced man to a table.

The girl who had been waiting with her boyfriend whispered into his ear again.

'I think they're being racist,' I said, joining Saba.

'Stop being so sensitive,' Saba said, with her hand on the back of David's chair.

'Hey, little sis.' David had an American accent at the edge of his voice.

'We'll see you there.' Saba started walking away.

I followed her to the car, and we waited for him to get into his.

'That was fun,' I said.

'If you stopped being so mealy-mouthed, you might enjoy yourself. Isn't he handsome?'

'Not really. Where to now?'

Kojo had wanted to go to Gyata today; it was getting late.

'Michael's fiancée's. David's pulling some strings for him to get a diamond concession in the Upper East.'

'You mean his father's strings? Isn't that called corruption?'

'I think it's called making the best of your opportunities, sweetheart, and it's a universal phenomenon. Besides no one here makes enough.'

'He certainly doesn't look like someone who doesn't.'

We trailed David's BMW, as he stop-started rhythmically to the sound of some hip-hop tune.

'Why does he only stop at some traffic lights?'

'No point stopping when there aren't any cars.'

'You can do that here?'

Saba shrugged.

We were driving into the streets of Airport Residential Area, next to the airport, giving rulers past and present quick access to the shops of London, Paris and New York, and a ready escape route should the masses revolt. It was developed for colonial officers and now housed Accra's most established residents. Its streets were wider and cleaner, its trees taller and fuller, its houses larger and fatter. We pulled up at a house with BMWs, Mercedes and Range Rovers parked outside.

'I don't understand why any of these people would have to take something that's not actually theirs.'

'It'll take you a while to figure out how things work at the top, my bohemian princess.'

'I'm not sure I want to.'

'Enough of this posturing and pouting. If you behave, you might even find yourself a husband,' Saba said, putting on lip gloss in the rear-view mirror.

'I'm not looking for one.' I got out of the car.

'Uh-huh.'

'Not everyone's like you, Saba. Some of us want to be our own—'

'Shh…' she said, as a young man with grey-white hair in a dark blue suit and blue shirt walked past. 'That's your cousin's business associate. Now, he'd make a good match.'

David stood in the entrance with another man, and had taken off his polo shirt; they both wore long blue *boubous* over their shorts and went in at the gate when they saw us. We followed the men – like good wives, I thought, and stopped.

'What are you doing?' Saba asked.

'I'll catch you up.' I looked at the large garden, with its flamboyants and frangipani, banana, mango, palm and pawpaw trees. Everyone, young and old, in varying shades of blue and white, looked smooth-skinned and shiny-haired. To my left, there was a large clear swimming pool; to my right, a long white-cloth-covered table with platters of *jollof* rice, spicy chicken, *fufu*, soup, *kontomire* stew, *apim* and fried plantain. A Lebanese man in a white gold-embroidered *boubou* came out of the house. 'My brother,' he was saying to David, opening his arms. They bumped chests.

'Is that Michael?' I caught up with Saba.

'No, it's the bride's brother.'

'Does she have a name?' I asked, but Saba was already in the house.

I entered the large box-shaped villa, draughty with air conditioning; it had the gold chandeliers, stone floors and silk sofas of affluence that could have been in Abu Dhabi or Hong Kong. Everyone was dressed in blue-greens and white here too. The blue-greens were mostly Ghanaian, sitting on the left side of the room, and those in white, mostly Lebanese, were on the other. Against the blue and white, my little black dress felt very short and very black. After all these years, I was still the outside-inside girl, still getting things wrong. I pulled the hem down towards my knees.

'Do you know where Kojo is?' I asked Saba.

'Will you shut up?' Saba turned and saw me tugging at my hem. 'Oh, for God's sake, let's find him, so at least I can have some fun.' She walked towards a group of

146

middle-aged women on the left and started shaking each one's hand. She stopped at the end when she got to a stern-looking woman with a very glossy wig. I followed suit.

'Auntie Oti, how are you? This is my sister from London.'

The woman looked me up and down. 'Why is she wearing black? Does she think she is at a funeral?'

I looked at Saba. 'I wasn't told, Auntie.'

Auntie Oti closed her eyes. 'You girls have plans to marry soon, I'm sure.'

'Yes, Auntie,' we said in unison.

'Well, your weddings will be grander than this, your mother will make sure of that. They've ruined everything. They had the knocking this morning.' She shook her head.

'How would it normally be done, Auntie?' I asked.

She looked around the room. I was used to having my questions ignored. 'Auntie, what's a knocking like normally?'

She closed her eyes again and opened them, then sighed. 'The groom and a delegation from his family come to the bride's family home to knock. They wait to be given permission to enter. They bring schnapps.' She waved her hand.

'He says he's seen a beautiful flower that he wants to uproot,' Saba said, 'and make it his own…'

'Yes, yes, then the bride's family,' Auntie Oti leant forward and lowered her voice, 'is supposed to have time to investigate the groom's background, his family history. Only then should the rites be performed. It is never done on the same day. Never.'

The sound of loud drumming from outside interrupted her, and the doors opened. Men and women entered the

147

reception room with wrapped goods on their heads. They carried whisky and kente and lace and wax prints and paraded them in front of those sitting on the right-hand side of the room.

I crouched next to the bewigged woman. 'Auntie, have you seen Kojo?'

'He was here for the knocking this morning.'

I got up. Saba had disappeared. I went out into the garden, where mostly young people sat at white-clothed tables under white-and-blue striped awnings. Saba was with David and others, who all had the same air of affluence. The drumming started again and I walked towards the pool. The cameras rushed towards the gate. The bride was coming. I craned my neck to see her. She was young, picture-book beautiful, eyes large with cartoon eyelashes.

'Is this your bride?' a man was asking the groom, shorter and darker than the bride, well-chiselled to her gloss.

I looked at the clear water in the pool. Across it, on the other side of the garden, I saw the man Saba had called Kojo's business associate standing apart from the crowd, texting.

I walked round the pool towards him. 'Hello.'

'Hello.' He looked up, put his phone in his pocket.

'Do you agree to marry this man?' The MC was holding the microphone too close.

'I'm Maya. I'm Kojo Agyata's cousin.'

'Pleasure to meet you. I'm Gideon.'

'Do you agree to marry this man?' the MC was asking again.

The bride's answer was inaudible.

Perhaps the MC could not hear her either, or she was losing her nerve. 'Do you agree to marry this man?' The question hung in the air a third time.

'How long does this go on for?' I asked Gideon.

'I'm not sure. I think it's over,' he replied. 'Isn't that one of your uncles?'

A man with a kente cloth of white and gold wrapped around him like a toga, wearing large gold wristlets, sandals and anklets, was walking towards the stage. Another was twirling an enormous velvet and kente umbrella over his head. There were drummers drumming ahead of him and a procession of young men followed.

'Looks like it. What's he doing up there?'

'I think Michael's from your region.'

The richly dressed man put some schnapps into a glass and began pouring it onto the ground. 'Grandfather Kuntunkunku drinks for you,' he said in Twi.

'*Ampa, ampa*,' his spokesman interjected.

'Yeboa of Adanse drinks for you,' he shouted, with the same projection and rhythm and flow of an actor reciting Shakespeare, pausing for effect.

'*Ampa, ampa*.'

'Grandmother Musa drinks for you,' he said, calling on our first ancestress.

'*Ampa, ampa*.'

'You descended from heaven by golden chains.'

'*Sio, sio*.'

'It was through perseverance, unity…'

'*Sio*.'

'…and wisdom that you became…'

'*Sio, sio*.'

'…the first builders in Akanland.'

'The Asante would squabble with that one.' Gideon leant sideways towards me, almost toppled.

'If people actually learnt our history instead of second-guessing, there wouldn't be any squabbling,' I said to him.

Gideon's mouth twitched.

I bit my lip. 'Sorry. It's the weather. It makes me hot. You're working with Kojo?'

'That's right,' he said, taking his phone out of his pocket and looking at it.

'So am I.'

'Wonderful.'

'Will you help me find him?'

'I could call him.' He looked bemused.

'Oh, could you? Please, I've tried and tried and I can't get through.'

'Your cousin has four phones, only one of which he answers.'

My uncle had invoked God, the earth, my clan and the groom's family ancestors. '*Yen nyinaa nkwa so*,' he was concluding, 'may we all live long.'

The guests responded: '*Mo ne kasa*.' He had spoken well.

'Yes, hello there,' Gideon said into the phone. 'Yes … I have your young cousin here. It seems she is looking for you, rather desperately … yes, still here … right…' He hung up. 'We'd better go.'

'Where?'

'I'm going to drop you home. I have to be back before the groom notices I'm gone.'

As we went out of the gate, a priest and an imam were getting onto the stage to give their blessings.

'Do you have to tell anyone you're going?' Gideon asked.

'No.'

We got into his new-looking, racing-green Range Rover. He told me that he too was Lebanese, though not like the bride's family, born and bred in Ghana, but in London. He had been sent by his father to lead the

construction company he had built; first in Senegal, now here. He had tried multiple other businesses of his own, he said, succeeded, then failed, but this, helping Kojo to build the museum, was by far his favourite. Kojo had never mentioned Gideon in our conversations. I looked at him.

'You can drop me off here,' I said when we got to the top of our lane. 'Thanks a million.' I was out of the car almost before he had stopped it.

They were still pounding next door and playing High-life from a transistor radio. I looked down at the red earth coating the platform of my shoes, did not at first see the Terrano jeep that stood outside the door. It was only when I reached the porch and heard a male voice – 'And what kind of greeting is this?' – that I saw Kojo. I ran to where he sat on the sofa and put my head in his chest.

'I brought you something.' He picked up a hamper wrapped with a big red bow. Inside were packets of spaghetti and cans of concentrated tomato paste, choco-lates, and a bottle of sparkling wine. 'For the vegetarian,' he said.

I put my face in his chest again. 'Thank you,' I said silently, to the rhythmic pounding of the *fufu* in the half-house next door.

'Get dressed, we're going to the Odwira.'

'The what?' I asked, knowing, but reluctant to move my face from his chest.

'Odwira. You English call it black Christmas. Do you have any traditional cloth?'

'No…' I looked up at him. 'I'm not English.'

'Then wear something smart. No black. Hurry. It's already late.'

I ran up and changed into a pink 1950s-style cocktail dress with a silk strapless body that went in at the waist,

with chiffon shoulder caps. I almost tore it in the rush to get it on. I put on my platforms and grabbed a beaded black clutch bag. I had a smile on my face that shrank when I came down. Kojo was sitting on the sofa with his head in his hands, his shoulders hunched.

'Are you OK?' I asked.

He looked up. 'Let's go.' He stood almost painfully.

'What happened?'

'I … I have many things on my mind.'

We drove down the Legon road past the white-walled, red-roofed university campus. The dense exhaust fumes of blue-and-yellow painted taxis and *trotros* mingled with the stifling dry dust of the harmattan winds.

'Are you going to tell me?'

'Tell you what?' Kojo looked straight ahead of him as we passed a truck turned over on its roof.

'Kojo, what's wrong with you?'

He didn't answer. Maybe the harmattan had entered his bones. We drove past large black gates that seemed to stand all alone amidst the thick green foliage.

'Did you know that Nkrumah built all this?' he asked.

'What?'

'The university. The atomic power station. And still we hated him.'

'Nkrumah, the first president? I don't hate him,' I said. 'He's my idol… "Free us from the shackles of neocolonialist tyranny… Lead us from Babylon to the promised land…"'

'I think you've got your Kwame Nkrumah and your Bob Marley mixed up.'

'Same difference.'

'I wouldn't let your parents hear you talk like that.'

'About Bob Marley? Why, because they'll think I'll grow dreads and develop a taste for marihuana?'

Kojo laughed. 'No. You know that Nkrumah might be even worse for them than that...'

'Worse than that? Isn't he the reason they went abroad in the first place?'

'Yes, but he also killed their uncle, and my father.'

I looked at him, and thought of the two of us weighed down since childhood, by centuries of legacy and obligation. I followed his gaze, past the cocktail of trees spread out on the hills. 'You're driving very fast, Kojo,' I said.

'How is your father?'

'I don't really know. I haven't seen him for a long time. He calls every so often to give me advice that's meant for some fictional daughter.'

'You and your father used to be inseparable, you know. You used to follow him everywhere he went. The two of you would go on secret trips to museums ... he's a good man.'

'Yeah. He still left, though ...' I stopped myself, looked over at him. 'I'm sorry.'

'It's OK.'

We were driving through a town. There was the sound of drums and people shouting. We drove through the throng of people wearing printed cloth and kente, their narrow strips catching the sun in their greens, whites, reds, yellows, oranges and blues.

'What is going on?' I asked.

Kojo stopped the car behind others, crowded with people. He got out. I wanted to reach out, pull him back in, tell him that it was still possible to escape this path, to walk our own. I stared at the people surrounding the car. I looked down at my pink vintage cocktail dress and pulled at my chiffon shoulder caps. I wished I had worn sandals instead of platforms. The sound was deafening. My heartbeat sped up to match the sound of the drums beating their rhythm of welcome. The energy of the

people jostling, dancing and laughing, waving their white handkerchiefs in the air, seemed to come from a different plane. I opened the car door, and stepped out into the crowd.

The women had undone the top layer of their cloths when Kojo got out, and were waving them in front of him, as if clearing a path for a king.

Kojo smiled, lifted his hands and moved his hips in a subtle dance.

They raised two fingers above his head.

I knew that crowds at festivals and gatherings made this kind of display for anyone who carried the aura of importance in the air around them, but there was something more in the way they treated Kojo, and in the way he stopped and greeted them; in the way he danced and in the way they danced in response. He was himself again, weaving his stories silently, carrying all along with him.

'Come,' he said, leading me through the jostling crowd.

Three drummers came to our side and played in short rhythmic bursts, until Kojo pulled some cedi notes out of his wallet and plastered them onto their foreheads. They stopped drumming to catch them before they fell to the ground.

'Where are we going?' I asked.

He put his arm around me. 'To the palace.'

I had not been to this hillside town before. As we approached, I saw that the palace was not as large as the one in my hometown, and that its once-white paint was peeling. Two men holding gold-handled daggers between their teeth, wearing dark red mudcloth tops with leather pouches sewn into them, guarded the gates that blocked out the crowd. I knew that in the past these men had some special function, that each pouch and stitch and colour of their costume meant something, but I did not know what.

I looked up at Kojo, his face stern and concentrated. When the men saw him, they soundlessly opened the gates; he took out more notes and handed them over. Outside, the throng was heaving, but inside the walled courtyard all was quiet. I stood and looked back at the dense crowd, through the gate that made me feel safe, as well as sad at the separation. My mother and Saba took it for granted that they were special. Even to Kojo, it was natural and unquestioned, though he tried to bridge the gaps. Only I seemed to feel the strangeness at being so through no merit of my own. It rattled me as much as when people told me I was beautiful, then gave me access to things and places I felt I had done nothing to deserve. I had become accustomed to people treating me according to the way I looked. It no longer burdened me. But this other privileged access was still weighted with my ignorance.

'Come, Maya.' Kojo's voice was impatient. He was standing looking down at me from a balustraded landing.

Outside a large door stood two men wrapped in toga'd cloths.

'*Ohenenana Ohene*,' they greeted Kojo. I knew this meant 'grandchild of the King', and I stood up straight in my platform shoes and smiled at the two men. The men looked back, unsmiling.

Kojo took my elbow as we went in. 'Do as I do,' he said to me.

Inside there were mostly men, wrapped in royal kente togas; a few women with the sumptuous cloths, head wraps and beads of queen mothers. At the front of the room was an old man, the King. Everything around him was gold: his brocade cloth, his crown and stool; the amulet around the neck of the small boy in white cloth sat by his feet on a leopard skin; the long staff topped by an egg. Again the signs of histories I did not understand.

Kojo had started to the right of the room and was shaking hands with everyone, bending down and whispering to some.

I watched him, aware that a natural move on my part could easily be taken as transgression by the others. I followed, shaking hands, nodding and smiling as he did.

Some of the old people put their heads together and said to each other, '*Yaa ba*, Yaa's daughter,' pointing at me as if I was not there.

I was no longer I, but a small girl, the daughter of Yaa, granddaughter of the Gyata and cousin to Kojo, the family's rising, most important star. As I went, shaking hands, I tried to play the role this particular history had picked for me, knowing that those I greeted were looking at me; as one of them, one who inherently knew the hierarchy of rules and mores; and as an outsider, ignorant of their deeper meanings. When we reached the King, my cheeks were stiff with smiling, the corset of my dress tight from the constant bending to greet. The room was hot and muggy with stares; I longed to be swimming in a clear cool stream. Kojo said something to the man with the golden staff, who bent over to the King and whispered.

Kojo said, louder now, so I could hear, 'This is Maya, daughter of Yaa, granddaughter of the lion, our sister.'

The man with the staff bent down again, said something quietly in the King's ear.

The King nodded slowly, imperceptibly.

I stepped forward and curtsied. Was this what you did? I turned to Kojo.

'Take off your shoes,' he whispered.

I slipped off my platforms and bowed my head. When I looked up, the King was smiling.

'Our sister,' he said quietly.

'Our sister,' the man with the staff repeated.

I looked up at Kojo, who took my elbow, pulling it slightly. I slipped back into my platforms and we continued with the handshakes. I looked into the faces of the men and women I shook hands with. Some smiled at me, some seemed bored and barely acknowledged me, some looked at me with disdain. I wondered at the histories that linked us, at the hostilities between our mothers and our mothers' fathers and our mothers' fathers' mothers that now manifested in a smile, a nod or a frown. Even though I did not know their faces, and despite the strangeness, I felt somehow safe in the knowledge that they knew my ground.

We got to the end of the semicircle. I was about to shake hands with a man bent and withered as the trees that lined the palace courtyard, when the horn players in striped togas began to play in short bursts, as if talking. The drums behind the King echoed the horns. Back and forth. Horns to drum. Drums to horn. Until he rose. And the whole room rose with him. The withered old man, who was wearing large red-and-black leather bracelets on his arm, pulled me in next to him, out from the middle of the room. As the King walked out, the gold on his arms clinked, the horns and drums played, the assembly followed.

I looked at Kojo.

He was looking at his watch. 'Stay here,' he said.

'What? Where? Who with?'

'Wɔfa, Kwame Asiamah,' he said to the withered, braceleted old man, whose skin was the colour of burnt umber, 'look after our sister. I will be back.'

'I want to come with you,' I said to Kojo, suddenly afraid, but he ignored me and followed the throng out.

I looked over the balustrade after Kojo and saw him talking to Gideon. I was surprised; he had not mentioned him once.

Kojo was waving his arms. I could hear the edges of his anger all the way up on the balcony. His face was close to Gideon's, who had his arm on Kojo's shoulder trying to calm him down. Kojo threw him off and walked away. A young woman with a long Afro wig followed close behind him. I had seen Kojo's wrath before. It was deep and rumbling and epic, and it was usually directed at his wife. Gideon pulled up his left sleeve with a sharp efficient tug, looked at his watch. Its platinum reflected the naked sun and reminded me of how uncomfortable I was in my tight chiffon sleeves. A crowd of people was pushing past him, and he had his arms held in front of him as if he had been asked to hold them up by the police. He was standing almost flat against the wall, but not quite touching it, as if not to sully himself with it or with the people around him. I watched him walk out of the gates, his hands held above his head now, weaving and wafting through the crowd like a man hula-hooping or playing a strange game of pass-the-people-but-don't-touch. I watched him until all I could see were the gleams of sun bouncing off his platinum watch and off the beads of sweat on his hairline head-high above the rest. He reminded me of English comedians playing at the colonial tourist in far-off places. I laughed and heard the echo of a chuckle next to me. The withered man. I had forgotten him.

'You are ready?' he asked.

I nodded.

'Then come.'

'But Kojo—'

'He will find us.'

He led me out of the back of the building and away from the crowds, through the quiet, paved streets, into the compound of a one-storeyed white-painted house. There were children playing *Ampe*, jumping up and down

rhythmically, clapping on the third offbeat, tapping one leg forward to the ground. We walked to a building at the far end of the compound, where the old man lifted the curtain and looked in. It smelt of food – *fufu* and *abenkwan*, palm-nut soup. In the dark room, my eyes adjusted, I was able to make out a woman, with layers of fat rolled over the cloth she had wrapped around her, eating out of a large black bowl.

'Good afternoon,' she said, 'you are invited.'

I shook my head. 'Good afternoon. Thank you. I am full.'

'This is Yaa's daughter,' my guide said.

The woman put her clean left hand to her head. '*Aich*,' she screamed, 'is this Maya? Little Maya? Whose hair fell out until she was naked like a coconut. *Yesh*.' She got up, still screaming, enveloped me into her folds.

'Kwesi, Abena, Afia, Kofi,' she called out into the courtyard and the children came running in. 'This is your Auntie Maya from Abrokyere. Say good afternoon.'

'Fine afternoon,' they chorused.

I turned to the old man. 'Ofa, Uncle, I don't remember.'

He laughed. An old-river laugh. 'No matter. You were younger than this one when we last saw you. You were like this.' He put his thumb to his forefinger.

'You are my uncle?' I asked him.

'Yes, yes, something like that.' He waved his arm. 'Go and get some Pepsi-Cola for your auntie,' he said to the oldest boy, taking some cedis from the shorts under his toga.

'Sit down. Please.' He beckoned to me.

I sat on a chair. The room was bare except for a plastic table and chairs and some aluminium cooking pots. In the room next door I could see a large bed covered in clothes.

I turned to the man. 'Where did he go? Kojo.'

He wiped his hand over his face, as if cleaning it with water. 'Your brother is very troubled. Very troubled. He is taking some very unnecessary measures.' He looked out towards the curtain through which the children had disappeared again. 'Did you see the men wrapped in white, whose heads were marked with chalk lines?'

I shook my head.

'They are *osofo*. Fetish priests.'

The woman had come back; she was holding a bottle of Coke.

'He is in turmoil, and he thinks they can help him,' he said.

'When he should be putting himself at the mercy of the Lord Jesus our Saviour,' the woman said, clapping her hands to punctuate her words, 'washing himself in the blood of Jesus. Oh help us, God.'

'He thinks he is being attacked.'

'Attacked? Kojo?'

'Spiritually attacked. He had a dream that affected him, of a lion ripping his body. You may not take these things seriously. You, from Abrokyere with all your science and book learning, but there are some things that cannot be explained by the book alone. Watch over your brother.'

'There are so many things I don't understand. Things about the festival. About Kojo. I came here to learn, I'm just getting more and more confused. I—' The curtain moved and Kojo walked through. The children had followed him. One was clamped on his leg and three others were jumping at him shouting, 'Bra Kojo-o, Bra Kojo-o.'

'Good afternoon, Wɔfa, maame. We must go, Maya, the curfew will begin soon and we will be stuck.'

'Eh, Bra Kojo, will you come to my house and insult me like this? The *Aburokyire*, the white girl, will not eat

my food, but you –' the woman clapped her hands, as if rubbing flour off them '– never. Never.'

'Oh,' Kojo said, regaining his smile. 'How can I say no to *fufu*? How? Quick. Quick. Give me my bowl so I can eat before I go.'

The woman giggled and ran out into the courtyard, her fat jiggling as she went.

By the time we drove out into the streets, the town was deserted. Every light in every house was extinguished, and there was silence, except for the noise of the gong-gong being beaten.

'Why so quiet?' I whispered to Kojo.

'They are washing and feeding the ancestral stools and no one must be on the streets.'

We left the town behind. Kojo was driving more reck-lessly than before. I shut my eyes. When I opened them, what I could see of the road looked unfamiliar.

'Where are we going, Kojo?'

'We will spend the night in Kaba. Did you bring a toothbrush?'

'No, you didn't tell me to.'

'We will buy one at the petrol station.'

'Was he related to us, the King?'

'Mm-hmm. He is our small brother. Our King sent his younger brother to help the Akwapims fight the Akwamus. When he defeated them, they asked him to stay and protect and rule them. Since then, he has been our younger brother.'

'And the old man you left me with?'

'One of the court drummers. He is a great historian and traditionalist.'

'Is he our small brother too?' I asked.

Kojo did not smile, but only shook his head.

'Why were you so angry with Gideon?'

Kojo looked at me, smiled slightly. 'Always so many questions, Maya.'

A car behind us tried to overtake, but Kojo accelerated, driving almost in the middle of the road.

'It was with him we were planning to restore the kingdom to its former glory, and put Ghana at the centre of the world.' He said this as if repeating something he had learnt off by heart. It had always been his way, to reel these lines off as if he were playing the part of Conscious Rememberer in a play, but this was now more pronounced than ever. Underneath, I could see in his eyes a turbulent, raving pain that threatened to spill out, and which he struggled to contain.

I laughed.

'You laugh, but it is no laughing matter. Our most important sword, our crown, our stool – all the keys to the power of the kingdom – have been rotting in the dungeons of museums, of collectors, somewhere in Abrokyere with no notion of their spiritual value. And you think it is any wonder that our power has dwindled? That our country is chomping on its own tail?' He was shouting now and the level of his voice and the speed of the car was making me nauseous. A pair of headlights came towards us, one much brighter than the other. The oncoming vehicle blew its horn in one incessant beep and Kojo swerved to the side of the road.

'God,' I said.

'You are afraid?' he asked. 'With me?'

'Tell me again about the Odwira, Kojo,' I said now, wanting him to calm down.

He pressed his back against his seat. 'The *Afahye*, the festivals, mark the end of one period and the beginning of a new one. Their rites cleanse the state of all the disorder and chaos of the year before, restore all balance and harmony.'

And yet, underneath, I could see in his eyes a turbulent, raving pain that threatened to spill out, and which he struggled to contain.

'Do you still believe that?' I asked, to lead him back to the surface.

'The world in which you grew—'

'You grew there too.'

'—teaches you that the material world around you is all there is. Here, we know our forefathers live with us, that the line that separates the living and the dead does not exist.'

'And you don't think it's a bit old-fashioned, all the bowing and kowtowing to one person?'

'Old-fashioned? You think history is old-fashioned? You think foundations are old-fashioned? You think cultural legacies are old-fashioned? People come home. They resolve their arguments. They meet and begin to know themselves, and each other, again. They learn. The elders pass on all their knowledge to the young. I learnt almost all I know at *Afahye*. You know this. They tell us we have no history, that we are trees that grew from the earth with no roots, and here we are declaring it to the skies, stretching our branches to where they should not be able to go. You call this old-fashioned?'

In the distance, I could see and feel the stillness and the dark outlines of the tree-covered hills and dense forests. 'Do you know why we don't perform Odwira any more if it's so important?'

'We see new ways of being, forget our old gods, forget our old ways. When you are told again and again that your origins are the making of the devil, you begin to believe it.'

We were driving into Kaba. I had missed talking to Kojo. I looked up at the coconuts clustered in the eaves of the tall palm trees that my grandfather had planted along the main road of the small town.

Kojo looked at me. 'Our grandfather fought hard to align the new Christian ways and our old Akan ones, but today people see them as incompatible, but they still believe. They are so confused in their self-deception.'

I said nothing. Unlike my mother, Kojo drove with the air conditioning off and the windows open. I felt a calm breeze from the mountain plains and the deep wet green from the rainforests around Kaba.

A chalky silence hung in the air. The sky was almost black. I looked out at the one-storey houses that lined the streets. Kojo pulled in at the Total petrol station to buy a toothbrush and paste. As he came out, those walking past on night-time errands stopped to greet him; it was twenty minutes before he arrived back at the car. We drove the five metres into the family compound. Since the last time I had visited, two more houses had gone up in a semicircle next to the small one my grandmother had built.

'*Akwaada Nyame*,' Kojo said, 'welcome home.'

I nodded.

'This is my house,' he said, pointing to a raised white structure with a balustrade running the length of it. 'You can stay with me or in your mother's house, as you wish.'

'With you, of course,' I said. 'Whose is the other one?'

'Your auntie's,' he said, 'the witch.'

'You're becoming more and more like our mother. And the King. Is he here?'

'No. The King has deserted his palace. And prefers to stay in Accra.' He was already unlocking one of the doors of the house. 'This is your room. And that door is mine. Goodnight. Tomorrow is an early start. Tomorrow we will talk, and we will reveal all to each other.'

The night was quieter than any night I had known, so that I fell into a dreamless rest. I was so used to dreaming that, when I heard the screams, it was a while before I realised they were not a part of my sleep. I sat up with a start and listened into the silence the screams had left behind. I put on my pink dress and walked out onto the verandah. A grey-blue haze hung over the rainforests in the distance. There was a crash from Kojo's room. 'Kojo? Was that you? Kojo?' I listened at his door. I could make out gasps and strangled breaths. I opened it. 'Kojo?'

He was lying diagonally across the bed his left arm dangling down.

'Kojo!' I rushed across, put my ear to his chest. His heart was beating, quick and irregular. I ran out into the court-yard and tried the doors of the other houses. They were all locked and there was no answer when I knocked. I was finding it hard to breathe. I knew there was a hospital nearby, or should I run to the palace? Would they recognise me? I looked across at the Total filling station. It was closed. I bent over, my hands on my knees. There was a high-pitched sound floating through the air, the sound of birds or of the bats that congregated around the palace. I stood up straight and strained my ears to the sound, then ran across the court-yard and through the long grass towards the small church not far from my mother's house. Inside there was a man on tiptoes with his back to me. He was pulsing his body and waving his hands above his head. Facing me was a group of young children dressed in light-red pinafores. Their singing was high-pitched and unnatural.

166

'Help me,' I said as I approached them.

The children began giggling behind their hands.

The choirmaster still flailed his long arms across his torso.

I tried hard not to cry. He could not hear me. I got to the front of the church and one by one the children stopped singing, until finally the choirmaster turned around.

'Kojo,' I said. 'He is not well. Please help me. I need a doctor.'

He looked for a moment as if he had not understood, then went to shake a young boy who had fallen asleep by two large carved wooden drums and told him something. The boy began to beat the drums in a way that did not sound church-like at all. The children clapped in time and began to sing more tunefully.

'Come,' he said. 'We will go to the hospital.'

'Should I stay with him?' I asked as we were running down the main road. I stopped. 'I'm going back. Please hurry.' I turned just as a car behind me blew its horn.

'Mind yourself,' the driver shouted.

I ran into the grass, but the horn kept blowing. The headlights were stinging my eyes. I ran past the oncoming car. A door was opening. I did not want to hear their insults now. I kept running. The car was reversing back. I ran faster, until the car caught up.

'Maya. What are you doing running around the street in that dirty dress at this time of night? Have you gone mad?'

'Mama.'

She had come to look for me.

'Kojo. His heart hurts. He was holding it. He was sweating, Mama—'

'Get in. You go to him,' she said to the choirmaster. 'To the hospital. Now,' she said to the driver.

I was holding my breath.

'You see what happens? You see? You don't understand what you are dealing with. Oh God.'

We pulled up at the brown concrete hospital. My mother got out of the car. I followed in her wake.

'I need a doctor immediately,' she said as soon as she entered, announcing it to the receptionist as well as the few people waiting to be seen, 'by heaven or hell. I am Oheneba Yaa Agyata.'

'Madam, please sit down and wait. I'll see what I can do.'

'I will not wait. You will not see. A doctor must come with me now!' My mother banged on the reception desk. 'My son is dying and you want me to wait? You damned fool.'

The receptionist pursed her lips and went into a closed room.

'As long as my name is Yaa Agyata, I will not wait here for some shabby, shabby nurse to wipe her nose before she calls a doctor. I said I need a doctor now!' She was shouting, and I could see it was not just her usual dramatics. She leant on the reception desk, groaned as if she had a stomach ache. She was trying to stop herself from crying. She pushed herself off the desk with both hands and headed towards the closed door.

A young man in a white coat came out into the corridor.

'Oh, Doctor. Thank God. You must help me. My son is dying. I am Oheneba Yaa Agyata. His name is Kojo Frempong Agyata. You must come with us now. In God's name, I beg you.'

'Please, madam. Oheneba. Please, calm yourself.'

My mother fell into the doctor's arms. She was shaking. The doctor tried to lift her back on to her feet.

'I will come. Please … wait.'

The receptionist reappeared.

'Please wake Dr Nketia up,' he said to her. 'Tell him I will be back soon. I will get my case.'

'Hurry,' my mother said. 'Oh God. It is not time for him to go. Deliver him.'

At the house, Kojo was still on the bed. The choirmaster was holding his hand.

'*Awurade*. My son.' My mother held her stomach when she saw him.

'Please wait outside.' The doctor closed the door.

My mother walked up and down the courtyard. '*Ha ba la sha ka fa sa ta re di ka re fa la sha mi ka sip o ta ra ke si me fa sha bi do ke ra mi so la ki ra bo la shi fa la so.*'

I could not normally take her seriously when she spoke in tongues – her pacing and delivery were too dramatic for my own more muted idea of the sacred – but I paced too, focusing my energy on her supplications as she fell down on her knees with surprising dexterity, her arms skywards. 'Jesus,' she said, 'save my son. Jesus, it is not time for him to go. Jesus, you have said that by your covenant all my children are protected. He is no son of my womb, Jesus, but he is a son of my heart. Protect him, heal him, save him.'

I walked out onto the street and looked at the palm trees my grandfather had planted. 'Make him all right, Grandfather. Who else will carry on your fight?' I touched a tree trunk and closed my eyes.

There were voices behind me. It was the doctor speaking to my mother.

I ran to where they stood.

'You must take him back to Accra. He has suffered some kind of nervous attack. He is very agitated. He needs rest now. I have given him a sedative. Please—' He beckoned towards the room.

My mother went in first. 'Don't worry … God is with you.' She put her hand on Kojo's damp forehead and began to pray.

'Madam, one more thing,' the doctor called into the room. She followed him out.

Kojo held his hand up towards me, and I knelt by the bed. 'I am so scared, Maya. I am so afraid.'

'What are you so afraid of?'

'I was attacked, in my sleep, by three people – two women and a man. He had a gun. He shot at me. My heart stopped.'

I had never seen Kojo look frightened before; the fear that laced his eyes shook into me.

'Do you believe me, Maya?'

'Of course I believe you.' I held his hand, which was dry and hard. 'But you're all right now. Nothing will happen to you. You have to rest.'

He lay back. 'I have so much to do. This evening I must drive to Kwahu. Will you come with me?'

'I don't think you should go tonight. Rest.'

'I must. In the next election I stand for MP. You will support me, won't you?'

'You know I will always be your biggest cheerleader.'

He smiled. 'Yes, I know. We must go on with our project now before they try and stop us.'

'Who will stop us…?'

Before he could answer my mother came in, shouting orders at the driver to collect all our things and put them in the car.

I sat next to Kojo in the back of the Terrano jeep as we drove along the windy roads to Accra. He had his eyes closed. The mist over the mountains was beginning to clear. He opened them when we drove through the town where the ceremony had taken place, as if he had been

tracking our path unconsciously, and told the story of being shot in his dream to my mother.

'This is what comes of going to all these juju ceremonies. Your head fills with nonsense.' She held tightly to the handle above the car window, then turned and said with the tone of wisdom that sometimes coated her words, 'They cannot harm you, Kojo. You are protected.'

'You of all people call them juju ceremonies when you know of their importance? You wonder why misfortune rains on us when our ceremonies are neglected? We are all running, towards a time that will never stand still, as if it has not all been before. And our souls are covered in dirt, but we will not stop to wash them.'

'It is all in God's hands, Kojo,' my mother said quietly.

'Your God that serves whose purpose?' Kojo replied, looking out of the window.

The trees were growing denser now. Their different shapes and sizes stepped up the mountains like green curtains; above them hung the clouds that signalled the beginning of the rainy season. I put my head on the shoulder that I had known and loved since girlhood.

I woke up outside the yellow-painted bungalow that was Kojo's house.

The blond dogs slowly circled the car. Dogs always kept their distance from people in this country where they were never treated with the care reserved for humans.

Kojo's wife Araba came out. She straightened her hair against her head and retied the crumpled wrapper covering her kaba and slit.

Behind her came Yaw, pushing at her mother's calves, and Abena, quiet, with the same deep eyes as her father.

Kojo opened the door. 'You have been sleeping in the day again? You good-for-nothing woman. Take my

things out of the car. Hurry up.' He waved the dogs away.

'Good morning,' my mother said, looking Araba up and down. 'How can you greet your husband like this? Just because you are married does not mean you must lay waste to yourself. Aah. Look after him.' She patted her on the cheek through the open car window. 'He has had an attack. We will pass by after church.' She turned to Kojo. 'As for you, I advise you not to do anything foolish or hasty in this house. I will come after church to see you both.'

'We're going to church, Mum?'

My mother ignored me.

'What's going on with Kojo and his wife?'

'He wants to throw her out of the house, because of that small girl he is running around with. Araba is a foolish woman – she lost money for one of his businesses – but she is his children's mother.'

'I'm sure Kojo has his reasons,' I said, and crossed my arms. I always defended Kojo, even if his behaviour towards women was inexcusable in anyone else. I remembered now the young woman, with the skin colour they called red and the large Afro wig, whom I saw him disappear with at the ceremony. I only caught her from afar, but from her shape and walk she was probably in her early twenties. 'Is she nice, Mummy?'

'The last one was better,' my mother said, meaning the last girlfriend had fawned over her and this one did not. She took out a hairbrush from her bag, turned to the back seat, and started pulling at my hair.

'Ouch. What are you doing?'

'You cannot enter the church looking like that. It's shame enough that you have not had your bath this morning.'

'I don't have to go.'

172

'We have to pray for Kojo. If you knew how serious this was, you would not be smiling from the side of your mouth like that.'

'I wasn't smiling,' I said, and took the hairbrush. I gently pulled at my hair with it and looked out of the window as we drove past the open shacks that sold plumbing goods and soft drinks. Women wearing white lace and kente were walking to and from church, and young children ran in the street through the traffic-locked cars. We pulled up to the large half-finished building. It looked more like a stadium than a church. The sign above it read 'Christ the Mission International Gospel Church'. The congregation were waving their white handkerchiefs and swaying to the slightly off-key band. '*Efi se*, oh yeah,' they sang as a man on the podium waved his handkerchief above his head.

It was the man from the billboard, wearing a white Mao-style shirt and black suit jacket. He was singing with his eyes closed and was short, like the Wizard of Oz.

My mother stepped, in her gold-slippered feet, across the red earth. Gold shimmered in her long sheer coat as she walked through the crowd towards the pulpit, parting the sea of common worshippers, just like Jesus himself. She walked with her chin jutting out, her lips curved downwards at the edges, her gold-coloured handbag jammed in the crook of her arm. She waved at people as she went, and they waved their handkerchiefs at her in time with the music. When she reached the pulpit, the band had stopped. I bowed and hid behind her just as the priest bent down to lay his hand on my mother's head.

'Jee-sus, let your daughter grace us with her blessings. Let your spirit move in her. Jee-sus.'

Before he had time to start speaking in tongues, she opened her golden purse and laid out the notes in his hand. Not Ghana cedis, but crisp new American dollars.

With every note, the priest prayed more fervently, '*Mabalakatasatema.*'

The congregation waved their handkerchiefs higher, like groupies waving their mobile phones at a rock concert.

He held the white-and-green notes above his head. 'Be-hold,' he shouted in a high-pitched voice, 'the spirit is moving within us.'

'Amen,' the congregation shouted back.

My mother danced as the drums and guitar began their high-pitched serenade.

Two men in suits, and a woman with the face of the priest printed onto her kaba and slit, rushed to get two empty chairs.

'Anyone bringing dollars for offering, come and receive your blessings,' the priest was shouting. 'Let the Holy Spirit take control.'

My mother opened her bag and gave me a note.

'No, Mummy,' I said, but she pushed me forward.

She nodded to the front, and was beginning to look embarrassed.

I joined the line of dancing people before the pulpit.

When I went to hand over the note, the priest bent forward.

'*Habaklashatimakafalasakabramkatosi,*' he began. 'Jee-sus,' he put his hand on my forehead, 'Holy Spirit. Enter your child. Jee-sus.'

I could feel the laughter rising inside me. I pressed my lips together as the priest pushed his hand harder and harder against my forehead.

'Jeeeee-sus,' he shouted loudly.

I covered my mouth to stop from laughing out loud, but the priest had already opened his eyes with a look of surprise. I turned around and walked back towards my mother. She shook her head. I buried my head in her arm.

The priest now prayed for a large woman in a long lime-green dress. She fell onto the floor as soon as he touched her forehead. Two suited men ran up to catch her and held her as she flung herself across the ground, covering her green lace with red earth, like someone in the throes of an epileptic fit. The band played even louder and the man next to us started jogging up and down in tune with the rhythm. I looked over at my mother. She had her eyes closed and was dancing to the music, mumbling prayers under her breath. I swayed with her, closed my eyes and prayed silently. 'Please God. Let Kojo be all right.'

After the priest had asked the congregation to come up for their hierarchy of blessings, we went to his office. The waiting room was crowded with people, queuing for more absolution. My mother marched straight to the door, and opened it.

'*Oheneba*, princess.' The priest stood up as she walked in.

The person who had been sitting in front of the desk also stood, and waved my mother into his seat. I sat down next to her. There was a gold-framed picture of the priest with his wife and two children on his desk, and a glass-covered bookshelf, with books on business and scripture, behind him. On the wall hung framed certificates commemorating the priest's international achievements.

'Papa, you know of my brother's son Kojo, the politician. He is not well. He has had a spiritual attack and I need him to be covered with the blood of Jesus.'

The priest nodded. 'Let us pray.'

We got up and held hands with the priest as he prayed forcefully for Kojo's soul, and this time I did not laugh.

When we got home, I lay down on the bed and must have slept into the night, because it was dark when I opened

my eyes, and I was still wearing my pink dress. I did not know at first what had woken me.

'Maya. We must go now,' the voice was saying. 'It is Kojo.'

I sat up. 'What is it?'

It was Araba, Kojo's wife. 'There has been an accident. Your mother is waiting downstairs.'

I put on the platform shoes I had discarded earlier and ran down to the car.

'What happened?' I asked my mother.

'Your mother came to the house earlier,' Araba answered. 'After she went, Kojo left for Kwahu, he had an accident on the way.'

'Is he all right?' I asked.

'We have no information.'

We drove back the way we had come earlier that day. I held my breath, tried to contract my heart, silently repeating the mantra, 'Please God, let him be all right,' doing my best to empty my brain of all but its power. Even though there was pain, there was no emotion in me. We drove until we reached the blue-and-white police station on the road to Kaba.

It was still dark.

My mother went inside.

We waited on the side of the road.

I held Araba's hand.

A policeman came out with my mother.

'What happened?' I asked. 'Is he all right?'

'Where are the men?' He looked at us.

'He is all right, isn't he?' I asked the policeman again, just as my mother smashed to the floor, like a stack of gilt-framed mirrors.

I ran to her and bent down. 'Wake up, Mummy, he's all right. Wake up,' I said, my voice coming from a strange place in the back of my throat.

My mother opened her eyes and let out a wail.

'Don't cry, Mummy,' I said. 'Please don't cry.' I held her close to my expanding, hurting heart, looked at the gold slipper that had come off her foot and now lay abandoned on the mud-coloured earth.

The police said nothing, until the men came.

It was Uncle Kwabena, who had said libation at Michael's wedding, and Uncle Kwame Asiamah, the old withered man, who came.

Even after it had been said, I still closed my eyes, imagined Kojo well.

We got into Uncle Kwabena's car and drove to the scene of the accident.

I watched calmly, as if it all were happening in a story somewhere far removed from my core.

Kojo's Terrano jeep was on the side of the road.

It was upside down.

It no longer resembled a car, but a squashed soft-drinks can, or sardine tin.

All its innards – the seats, the steering wheel, the engine – were visible.

My uncle was holding my mother, who suddenly looked very old and very weak. Even her hands had aged.

We stood by the wreck.

The day was dawning.

There were bits of debris splayed all around the car: his brown dusty leather sandals, the white-and-black cloth he had worn to the Odwira the day before, his gold-rimmed glasses, yesterday's newspaper and, in the grass, a woman's curly Afro wig.

He was overtaking a car.

A lorry came from the other side, and neither he nor the lorry driver pulled back.

The impact had dragged them ten metres down the road, before they came off it.

The lorry was undamaged.

We drove to the mortuary.

I stood outside for a long time before I could go in.

I could hear my mother's screams from inside.

It was a bare white-painted room with a stone floor.

He and the young woman were laid side by side.

Kojo's body had shrunk.

He too had been squashed.

His arms and legs and chest were criss-crossed with cuts and slashes, so that his red flesh pushed out of them.

I remembered how the old man had told me about the dream of the lion attacking him.

The top of his head was open and a dark grey substance was visible within it.

Bits of it were on the floor.

Uncle Kwame Asiamah picked a piece up and put it in his pocket. He rested his hands on the metal bed where Kojo lay. He stemmed his spindly legs into the floor. Silent sobs rose up, and his withered body succumbed to them.

I felt as if emptiness had entered and was lifting me off the ground.

I swayed.

There was a pressure in my ears.

I held my hands over them.

I began to scream, but could not hear myself.

The inside of my skin was cold.

I screamed and screamed, until my mother came and put her arms around me and led me away.

A tide was coming from the town, wailing and screaming and singing. A chorus of pain. There were women, old and young, beating their chests, holding their heads, running up and down. Some of them knelt on the floor

when they got to the mortuary and cried into the dusty ground. Some sang Kojo's name. *Adɛn?* They sang again and again. *Adɛn?* Why? The men cried too, but wet, quiet tears.

One woman, a cousin, rolled round and round in the red earth, crying out as if someone were pressing irons against her skin, beating herself on the chest and face. I watched as the tears fell down her face. I wanted to join her. I wanted to cover myself with the red earth. To roll and roll and beat myself, until it all went away. Until it had never happened. Until he was standing next to me with his gold-rimmed glasses and his ever-kind eyes and smile, asking if I was all right. Until he was happy. Until he was putting his arm around me, saying, 'Sister, all will be well.' I wanted it to stop.

22

When I went home again, my mother had grown so weak that she had collapsed on the one-year anniversary of Kojo's death, I had not been there.

Kojo's death had made her need stretch out over its edges, encompassing every space in which she was and which she was not.

Nii Tetteh died a few months after Kojo. By now, the case had become so fractious, and they had quarrelled so much, that I did not know which version of her truths to believe.

She was adamant that the billions, so far-fetched, were still within her reach; that until his death, despite the headline stories that he wed another, Nii Tetteh was still close to marrying her; but her tone was now full of hysteria, full of shout.

She picked me up from the airport. Her glasses sat askew on her face, the buttons on her dress were done up wrong. The curtains in her new house were raggedy. She had done nothing to do it up.

Hardly anyone now came to see her, she whose house had always been host to weddings and parties, endless lunches and dinners.

My mother held a picture of her father to her face and cried bitterly.

I went to hold her, but there was nothing I could do to comfort.

I remembered what my father had once told me:

It is the king alone who dreams dreams.

My grandfather had chosen all forty-three of his wives of royal blood.

It was their bloodlines that gave their children the authority to represent towns and villages on the state council and tribunal.

It was the education their father sent them far and wide for that gave them mandate.

He knew that not only he, but also his children, would have to master the old ways alongside the new, yet in that short space between death and entry into Asamandeefoo, the land of the ancestors, fate had usurped his plans, and it was as if it was up to us – all of us – to realign them.

My mother felt that she had failed not only him, but the markings of her birth.

In every generation of our family, there was always one anointed to knowledge from the earliest stages, to see what others could not: an *Akwadaa Nyame*, a god child, one who could hear the universe's whisperings more clearly than the noise of the world around them. She or he travelled the ages, making right at each turn, the things that had formerly gone wrong.

Kojo and I wanted to bring *The Book of Histories* into reality through our retelling, to create structures to support its meaning; until its truth filled the place of all memory.

The libraries that Kojo had talked of were filled with our external stories of wars and victories and defeats and

ancestral stools, but before these were our internal stories of becoming, and it was these we had to master before all else.

My mother asked to hear something of what I was writing.

'Really?' I said.

She nodded.

'I have something. It's called "*Pièces d'Identités*":

'*So many of us were sent. Sons and daughters,*
grandsons and daughters of kings and presidents,
bank owners and freedom fighters.
Within the confines of England's finest and grandest
* boarding-school institutions.*
They herded us.
English Africa's noble future.
With a pat on the head and a whisper of our intended
* paths,*
They left us. Alone.
The most robust of us fulfilled our obligations, returned
* home*
as lawyers, doctors and bankers. Ready to rule.
With our Queen's English and our Bond Street tailored
* shirts.*
So well equipped.
We who were trained as monkeys
to teach the way to civilisation. Follow suit.
A few of us tried our best to be strong,
to follow the path set out for us,
to become what they wanted us to be.
So hard that our softness cracked
at the effort, and we were left
floundering like fish out of water.
We are now lost in the big cities of Europe and America.
Great children of great leaders,

who have lost their way home.
And finally, there are those of us who could see clearly
the lie that they were selling as truth.
Could not blind ourselves to the pain of separation.
Separation from our utmost selves.
We locked what we could away. Built shells, barriers,
* fortresses. Closed the door and locked it tight.*
On the outside we learnt their ways. Talked the talk.
But refused to walk the walk of life they had set us.
We cannot.
Pieces of identity.
Kept hidden away.
Safe.
From all you
parents, teachers, educators.
Friends.
We thank you not for your guidance.
We thank you not for forcing us to live out your dreams.
Not for your selfish blindness to your children's needs.
We do thank you as we pick up the pieces.
Reshuffle, keep and throw away.
And for setting us on this path of the cycle of freedom.'

'It's about you,' she said. 'I'm so happy nothing happened
to you, that you did so well, that you didn't turn to boys,
or smoking weed when we left you alone. You did well.'

I had not thought she had noticed.

When she brought me back to the airport, she said, 'I'll
be alone again now.'

'Not for long,' I told her.

The text came a week later.

It was from Saba. *Mummy is very sick*, it said.

There was no finality in the message.

Neither she nor my mother picked up the phone.

A call came hours later.

She had had a severe stroke and was unconscious.

I lost my ability to breathe.

Zinaida shouted at me, 'Breathe, breathe. You're hyper-ventilating. You are scaring me.'

I brought back my breath, because I did not want to scare her.

I booked a flight to Accra.

As I was landing, President Obama was leaving.

We were held in the air for two hours. I arrived too late to see her in the Intensive Care Unit.

She still had not woken up, but I knew that, now I was there, she would.

I went to the hospital at six the next morning. There were tubes coming out of her nose and IV needles plastered over the veins of her hands.

'Wake up, Mummy, I'm here now. Wake up. Wake up, Mummy.' I put my mouth to her ear and promised that I would not leave her again, and that everything would be all right now.

She did not stir.

The nurses told me to stop crying.

My mother, smelling of hospital creams and shiny with Vaseline, moved her arm to remove the tube coming out of her nose, tried to speak, then was immobile. There was an almost imperceptible tremor in her head.

I put my hand on her head to calm the shaking.

My mother collapsed at her brother Guggisberg's wake; her brother who, like her, loved society more than anything else. Who, like her, loved to laugh and entertain and feed.

She always boasted to me that she had no friends, because the Agyatas were only friends to each other.

She woke up once more. Her nephews and nieces and brothers and sisters sitting on the bed around her.

'I am so glad you are all here,' she said. Then, 'You all love me, after all.'

The doctor looked into her eyes with a torch. 'Her pupils are not reacting,' he said. 'It's not good.'

The life-support machines in the hospital were all taken. The doctor called all the hospitals in Accra to find one. He tried to steer me towards the consultation room. 'Sit down,' he said.

I shook my head. I could not stay away from her side. She needed my strength.

The doctor said to my cousin: 'There is nothing you can do here. Go home.'

At home, I looked for clues on the Internet, as I had all along. First, subarachnoid haemorrhage, Glasgow Coma Scale, hydrocephalus, extraventricular drain, now fixed pupils.

I could see, but not feel; everything in me was contracted. I lay on the bed, closed my eyes and focused health into my mother's heart, into her mind, into every cell of her body, dreaming her well.

When he called us back into the hospital, my tears came before he opened his mouth. 'The brain is dead,' he said. 'It is your choice, whether you want to keep her on life support.'

'We only know five to ten per cent of the brain's functions,' I said. 'It is still possible she will come back.' I quoted my Internet findings. 'People have been known to come back from brain death. There was a woman whose breathing tube they had removed, a boy who woke up just as they were about to disconnect his life-support machine.'

'Not in this case, Maya,' the doctor said. 'In those cases, the brain was frozen.'

I knew what he said was not true. The woman had had a cerebral haemorrhage. The boy was in a car accident. Their brains were not frozen. *In this case*, I answered him silently.

The image of her body lying under the frayed thin sky-blue sheet bearing the faded stamp of an East German hospital.

Of her breath leaving that body.

Of the male nurse pumping life in and out of her lungs from a picture-book sun-yellow hand-held oxygen pump, because there were no life-support machines available in all of Accra.

Of the question: Shall we stop? How could we say yes? How could we deny life to the woman who embodied life and all it meant, all that it stood for, even at the expense of a young man's persistent, futile effort?

A memory of running through the hail beneath my mother's pea-green silk raincoat, of feeling safe despite the empty streets and the hard, unforgiving rain.

A memory of eternal protection.

Memories of piano lessons, tennis lessons, swimming lessons; of watching Doris Day, Sophia Loren and Elvis Presley; of lying in the bath with her as she told me stories; of standing on the toilet lid as she slathered me with cream; of her powdery perfumy smell; of the snippets of the bouffant wig I took to bed with me at night when she was not there; of lying on the bed watching her in the dressing mirror.

My mother is the most beautiful woman in the world and I am her daughter.

PART FIVE

23

There was our country, ringed by mountains and topped by mist, through which a river, dry in the middle months, wound its way.

Now the absence of her permeates that country's air, and the future is a place in which you can receive a text that changes your definition forever.

Before, the truth was instinctive. Then, all the trust of things being as they should be went away and there was no more knowing.

Only the visceral understanding of the suffering and unreliability and ephemerality of all things, including the ones we love; of the spectre of death there, always, constant, as true as life, maybe even more so.

Instead of inherent order, there is chaos and the mistrust of it, and I think that it is her that I am missing, but I know it was there, hedging, even before she left.

I am tempted to pick up the phone and call a man, who loved me as a boy, whom I reconnected with, but the love we have now is not the one we had before.

Connecting as adults does not reconstitute connecting as teenagers; fresh, untainted, open, and even then it was not what it was.

When he called me again after all those years, just as I was readying myself for the kind of love that he was open to then and I was not, I thought perhaps that it was life making patterns in the snow.

But he is not the same and neither am I. I wonder if all the people we hurt change in the same way or if we all change differently.

Life is not making the patterns I want it to make, but its own.

When I reach for the phone, it is not him as he is now that I am wanting to call, but the spirit of love, complete and answering, and I no longer know if it exists.

I am in Norway as I write this, where you have to seek out alcohol in special shops, and I am a little drunk. I bought some wine, which is very expensive here.

It is strange to be in a place where I do not speak the language. I must have mastered the gestures of understanding, though, because in the shops, at the tills and counters, they assume I speak Norwegian and are surprised, annoyed almost, when finally I confess I do not. What am I shut out of, not knowing the codes and rhythms and nuances by which these people understand each other and themselves?

I have never been to Norway before and my impressions are of the empty streets of this large town, the shut doors and windows, the doll-perfect pastel-painted frames, the white-washed wooden houses, with bursts of red and yellow roses, the muggy muteness, the nothingness of it all. It is indecipherable to me at first until I begin to see in these impressions Henrik Ibsen's play *A Doll's House*, Knut Hamsun's book *Hunger*, Edvard Munch's painting *The Scream*.

Books, art and films, as always, are beginning to do their work on me, forming a bridge of understanding – even if not of things the way they really are, at least closer.

A man keeps sending me pictures of himself or, rather, he has done so twice.

He is a man in Senegal and I wonder why he is doing this.

I look at the emails telling me how 'they' miss me in Senegal, and at the pictures, and even though they are of a handsome man I feel nothing and have no urge to reply.

I do not remember that, only two months ago, I was taken by a passion so deep for this man that I spent days and nights imagining our life together, with an obstinacy matched only by the instinctual knowledge that it would not work out.

What is this emotional amnesia? This ability to forget people so completely once I have left them? Will it always be this way? Even when I have children?

Will I leave to go somewhere and write for a few months, as I am doing now in the bus, past the tree-stepped sun-hallowed mountains and fjords, the grassy roofs of multicoloured slatted wooden houses in south-western Norway, and when the telephone rings, and someone – their father, maybe, or nanny – says to me on the other end, 'Your children want to speak to you,' will I be jolted? Will I think, *children*?

Will I struggle to draw their blurry faces into something tangible? Will I wonder in the brief moment that it takes them to reach the phone what resonance their voices will have in me? Will I be that kind of mother?

These recurrent memories of the future can be just as real as those of the past.

And yet, her voice.

There is something of its essence that remains.

In my heart, I feel the timbre of her laugh, the back notes of it, like a formless echo.

I struggle to remember the things she said to me, and how.

How it felt when she put her hands into my hair and I drew away, annoyed.

What it was like to lie on her breast and have her heartbeat deep in my ear, almost in my throat.

The author Paul Auster, writing of the loss of his father, quotes the poet Wallace Stevens: 'in the presence of extraordinary actuality, consciousness takes the place of imagination'.

Our bus waits in line to get on to the ferry and cross the fjord. Next to us, a swarm of cyclists in tight shiny shorts and tops, mostly men. I look at their legs and backsides and cannot decide if the body is beautiful or ugly.

Does anyone ever leave a shore by boat and not think of death? Or is it only those of us for whom the door has been opened?

And yet, even amidst its presence, it is hard to fathom that these lakes, this patch of sunlit mountain, will continue to exist when this body does not.

Would I have lived differently if I had carried this awareness from birth? Will I live differently now?

24

One night, not long after his death, I saw Kojo looking down on me from the mezzanine in my mother's house.

My mother told me that I should pray, protect myself.

'Why should I be afraid?' I asked.

She did not say.

I was afraid, of the unknown force which had killed him, and which accompanied me on the plane as I flew home, and which eased as I headed to our corner of Ladbroke Grove, which was no longer what it was before.

All our friends were moving piecemeal to East London, where large, high-ceilinged warehouse spaces were still cheap enough to allow us to live off temp jobs and short-term grants.

After months, I too got a grant, for research on Gyata's looted, stolen, sold objects, and moved to a two-bedroom apartment near Old Street.

Ben, one of a group of misfit friends who wore their privilege and dysfunction on their skins like beautiful armour, was twenty years older than me and young and playful in the way only those free of obligation could be.

He took me to smart restaurants, art-show openings, houses in the countryside, insisting that I held his hand, which I refused, having heard that I was not the only girl he was squiring around.

He sat outside in his black Mercedes below a sign that said 'No Waiting'.

I looked at the softness of his hair, his eyes, his face, the openness for which it would be so easy to fall, and braced myself.

'We'll pick up a friend of mine on the way,' he said.

'What kind of friend?'

'She's called Bernie. She's one of the Randolphs. I've known her for years.'

I had already heard from our friend Tatyana she was the other girl he was seeing. I looked over at him, his face a picture of easy unconcern.

'She's not as beautiful as the rest of you girls, so she gets left out,' he said, feigning charity; he was stopping outside Tatyana's house, an old converted working man's club off the Harrow Road.

Bernie came out with a smile that dropped when she saw me. As we drove off, I looked at her in the rear-view mirror. She was sturdy, her hair dishevelled, and her cheeks flushed. She was biting her nails now and, despite my rising irritation, I felt protective of her. I had known she was young, but the stories of her fixation with Ben had led me to think she was sophisticated.

I turned to face her. 'Have you met any of these people before?'

Bernie shook her head and looked out of the window.

'I'm intrigued,' I said and turned back round.

When we got to the restaurant, I flirted with the host, who sat next to me, to distract myself from the discomfort. He was a film producer, an old man surrounded by

young; he wore an open shirt and a mischievous look. He was telling me about the last film he produced, an enormous hit, he said.

'How lovely for you.'

He raised his eyebrows, not used to being unimpressive. He leant over and pointed to the brown-haired woman on my left. She was the real-life princess of a European country, he told me. She even had 'Princess' written in her passport.

'Really? As in her first name?'

He laughed. 'You are silly.'

I could feel Ben looking at me from across the table. I looked down the end at Bernie watching him. I could see from her eyes that he was everything she wanted, and envied her the solidity of wanting something so tangible, so reachable. She was red in the face and her blue eyes seemed ready to wash out.

I looked at the producer and Ben who had put their heads together and were talking about me.

'Quite wonderful,' the producer said.

I wanted to shoot them both. Instead I got up to go to the bathroom.

After Ben dropped Bernie off, we drove back east on the flyover past King's Cross and the new British Library, through the still-Dickensian streets of Islington, past the Old Street roundabout, into the heartland of abandoned warehouses.

At Mungo's warehouse building, the sound of music and voices reached down to us from the fifth floor. People piled through the open door, and up the stairs.

I turned to Ben. 'How could you be so cruel?'

He was silent for a while. 'I think she had a good time.'

'She is in love with you.'

'So? I'm in love with you.'

'It's not the same. She's only eighteen. You are twenty years older than her.'

'She's only a couple of years younger than you.'

'I know, but she's so much younger than me.'

'She's a country girl, who wants to get married.'

'And you are a dirty old man.'

His hands were gripping the steering wheel and he was frowning.

Good, I thought; I wasn't finished. 'She couldn't even look at me.'

'That's because you intimidate her.'

'I intimidate her? Why on earth would I intimidate her?'

'Because you're beautiful. You're clever. And you don't doubt yourself. That gives you power.'

'Do I intimidate you?'

'You scare me shitless,' he laughed.

How could anyone who laughed so limitlessly be so callous?

'Can I kiss you?' he asked.

I said nothing.

He leant over and kissed me. 'Can I come up?'

I shook my head, looked at how his open heart came through in his face, thought of how I liked how he kissed me, of how I wanted to journey with him, but of how my power, what I had of it, would be squashed under the weight of his money, houses, cars and his ready-made place in the world; of how I was still an unborn foetus to his grown boy-man.

'How's your work going?' I asked him.

'Sometimes I wish I hadn't been given all this money. I would have made it on my own.'

'I know what you mean,' I said. Not about the money, but the weight of obligation. To have been given, and to

feel the need to give back. To have to be bigger than your-self, even when you needed to be small.

'Why don't we drop all this? The rat race. Trying to be like everyone else. Let's go away. Go and live in the sun somewhere. You'll write. I'll make art…'

I smiled. 'It's easy for you.'

'I'll look after you.'

I shook my head. 'No.'

The look in his eyes made me hurt for him, and for myself.

I wanted to tell him that I would never be like him, that my obligations were deeper, and the wounds far harder to quell.

Death is an absolute necessity, because it defines life. The writer and film-maker Pasolini said this in an interview shortly before his own.

The loss of connections we fight all our lives to find.

The inevitability of death. The necessity of it as it defines life. If time is linear, the possibility of growth. If it is cyclical, the continual realisation of our smallness in the face of all things. Fragments of time. Glimpses of knowledge through that love which illuminates us and makes us known. Consciousness in the place of imagination.

If different deaths define a life to differing degrees, then my grandfather's defined my mother's the most. Kojo's caused a visible weakening. My uncle's wake brought about her final collapse.

Then: 'You all love me, after all.'

Hope of a reality, as the philosopher Walter Benjamin describes, in which succeeding generations wake into more and more profound levels of awareness. Our continual striving – towards knowledge, towards connection, towards sight. Our eternal ignorance in the face of life and death.

'I am so excited,' I said to her on the phone the day before. 'I can finally work on the book.'

'Do you have enough money to go?' she asked, as she always did.

My last ever words to her on the phone, as always: 'I love you.'

Still, the paradoxes and imperfections of love. The mistakes we learn from, the pain we do not forget.

Out of the window now, velvety moss on craggy mountains and trees that grow out of the rocks as in my grandfather's appellation, *oboo petepre ma nase apom*, and all those flowers and all those shrubs for which I have no names.

I read of the love the Greeks called agape, described as the highest known to humanity, as self-sacrificing and all-encompassing. It reminds me of my mother and the space her love gave me to define myself.

It was also stubborn and tempestuous. Often it shone so loud, I had to escape its noise to find my silence.

I think of the man my mother wanted me to marry, whom I could not even try to love however much I wanted. Of the coldness I saw in him that she did not.

How still my wedding day was always to be hers.

Her dream of a bombastic glamorous affair, instead of mine, candle-lit, with only the most cherished friends and family. A bargain for her happiness.

A dream I dreamt when my mother was still alive, the man I love dancing with her, holding her hand as he walks to our house framed by mango trees and frangipani. We live on one side of the courtyard, she on the other.

My life inextricably entwined with hers.

The bus halts; a mother and her teenage daughter get on. The evergreens spread up and out like fish spines,

and I no longer feel the life-stopping pain I did when I watched a mother and daughter's mutual tenderness not so long ago. The only comfort then being that soon these mothers too would die, and leave their daughters.

26

Ben announces his engagement on Facebook. There is an album full of pictures of his new fiancée, Bernie – the very same girl who was in love with him when he was in love with me. They are happy, as evidenced by a series of photographs for public private consumption. I feel a sepia-coloured joy for them; envy for the lives I have chosen not to live, for those girls at school named Lucy, Diana and Chloe, who saw their fulfilment so early, in the dream of marriage, children, a house in the countryside. 'Let's give up this race,' he said to me, 'and run away.'

But it has never been enough.

I wanted this happiness.

Of trying to find truth through words on the page.

Nothing else, however hard I have hidden it, has ever mattered as much.

———

I have come to this small farm on a mountain alone; the nearest person is a twenty-minute hike through the forest. Before the owner of the house leaves to go back down the mountain, he installs a projector with a large screen, tells

me in the winter he will project films from Africa onto the snow.

He has restored the house so that it is just as it was when the farmer who last lived here died; so that the memory of him lives on in its patterns.

Why do we hold so keenly on to the past; build museums, write books, preserve? So as not to die? To look back and have something alive of that person? When I read *A Portrait of the Artist as a Young Man*, do I think of Joyce? *The House of Hunger*, of Marechera? *A Room of One's Own*, of Woolf? Yes, but not of their corporeal forms, not of what they had for breakfast, who they loved, how they hurt.

The light comes in now, and it is dawn. I put on a long cardigan over my white nightdress, the blue wellington boots I got from Portobello Market in London, the blue-and-white printed scarf from a market in N'Djamena in Chad. Outside, the lake, rocks and trees stretch away as far as I can see. I crouch down from the strange painful numbness inside, unable to uncoil.

The truth is, I do not know: how to remember her, or where in the world to look for her, or for the essence of what she left behind.

I walk up the mountain to escape myself, past the bluebells and daisies, past the carcass of a sheep tied to a rock with blue string, and feel a type of madness setting in.

The invitation read:

Tribal Gathering and the British Museum invite you to
Disappearing Africa:
Tribal Portraits

On the back of the postcard, in a black-and-white photograph staged in a pseudo-*Vogue*-like composition, were five young women with geometrically patterned materials wrapped around their waists, intricately twisted headscarves, large round collars of powder on their shoulders and bare breasts, with '*Dahomey Girls* by Irving Penn' written in the right-hand corner.

The supervisor for the grant I received, James Murray, had given it to me. He had helped me look through shelves and shelves of boxes in the British Museum's cold storerooms in Orsman Road, through the indexes of museums in Paris, Brussels, Berlin, New York, until I had finally found what I was looking for.

One *abusua kuruwa*, the brass pan at the foot of the bed into which all the children and grandchildren cut

locks of their hair for him to take on his ancestral journey; the *akrafokonmu*, a flat gold half-moon and star, specially treated, to draw to it any elements that would endanger the balance of the King's *kra*, the essence that flowed through him and every other human being; several of the King's sandals, black ones with gold cowries, leather ones with golden stars, gold ones with the symbol of the leopard on them; thick faded Kidderminster carpets, damask sofas, a large silver chair, an ivory gold-embossed cigarette box, Arabic *yataghans* and scimitars and brass blunderbusses that belonged to my grandfather; gold rings, twirled, sculpted, incised and with the motifs of animals; a large heavy gold bracelet; delicate gold weights of brass hunters and horn blowers, an upright man with an offering of eggs, another seated on an *asipim* chair holding a sword, two figures intertwined, curved and flat fish, turtles, crocodiles, antelope and deer; a whole world in miniature; scales, spoons, a sieve, a set of small brushes; and brass vessels and boxes made of brass with Arabic engravings brought from the deserts of North Africa, their lids sculpted with figures, an orchestra, three women, a child; a mud-brown *batakari kese*, a warrior's smock; three *amanpam pom*, spokesman staffs, two gold and one blackened; two *mfena*, sacred swords; four *ahoprafo*, their silver-and-gold elephant tail whisks. I had documented each of these, tried to find their provenance, and now, James Murray said, he had something to tell me.

I took off my pyjamas, showered, got on the number 7 bus to Russell Square, and walked in under the vast criss-crossed glass roof of the Great Court of the British Museum.

James Murray was at reception, with folds in his large dark bushy eyebrows that cast a shadow over his long

pale face and white beard, like the clouds over the Black Mountains of his native Wales. He put his right hand over the side of his mouth as he talked and I wondered how it must feel to grow old and watch your body decay with each passing day.

'Your favourite professor has found someone you know, who will take on the entire cost and logistics of the building of—'

'Who?'

'His name is Gideon...'

'I know him; he's been trying to get me to work with him.'

'He has the money, and he's been looking for someone to help him, someone who knows the ropes—'

'You mean someone he can steal from? He's a businessman. He knows nothing about art or culture...'

'When will you learn to cut your coat accordingly?'

'He's not even from Ghana.'

'Stop being such a cultural imperialist, or should I say racist...' He stopped and looked down at me. 'You don't have to be African through and through or be called Olufemi or Abena to be qualified to research an African country. In fact, you're not. I don't know how your name fits in with your cultural puritanism. And, as a matter of fact, you sound more like the English establishment than he does.'

'But it's time for us to tell our own histories, you've said so yourself. They've been told for us long enough, and not very well.'

'Well, if you feel like that, then bloody well take the opportunity when it's handed to you. Undeservedly, at that.'

'What has he done to deserve it? You say it makes no difference where you're from, but you're wrong. It does.

That's why he'll be heading the project with no knowledge at all, and I'll be assisting him, with all of it.'

'Yes, and when you've gained some humility and experience, you'll be heading one all of your own.'

James Murray went down the steps that led into the Africa Gallery. It was already dark in the staircase, except for the spotlights that lit up the masks, shields and feather headdresses in glass cases on the walls.

I followed him down. 'Did they have lighting people come in specially to reconstruct the heart of darkness?' I asked; then, quieter, 'Why are there never any black people at these events?' I looked around: there was a woman with long dreadlocks among the men in suits and ladies in 'smart casual'. It was Juliet Fagunwe, a Nigerian artist patronised by the British Museum. 'Oh, sorry. I spotted a token.'

'Pipe down now,' James Murray said to me, 'or you'll be fed to those lions pacing up and down outside your front door.'

'And wouldn't that make a pretty headline.'

'Wait here, and try not to cause havoc. I'm going to see what I can do on your sorry behalf.'

I turned to look at the black-and-white photographs on the wall. They were even worse than I had imagined. Mostly they were of naked girls with pert breasts, like you would see in Victorian peep-show pictures, arms lifted behind their heads or crossed coyly in front of them. They either had no titles or ones like *Benin Girl* or *North African Nudes*. The girls in the latter were no older than thirteen or fourteen and were wearing large jewels or smelling flowers or had scarves draped loosely over their heads. They were alongside portraits of Egyptian and Moroccan women, wholly veiled, showing only their kohled beguiling eyes, which cried out, with all the semantic subtlety of an African child with flies on its face and a distended

belly, *Save us, oh brave liberal-minded Westerners, from our savage fates and entrapments.*

I scoured the wall plaques for some context or explanation as to why they were side by side, but found none. I moved on to a picture taken by that harbinger of aesthetic fascism, Leni Riefenstahl, of a young virile oiled woman, ready to dance or pounce, or whatever else the occidental imagination would have her do. The plaque read *Nuba Dancers of Kau* and Riefenstahl myopically described the physical strain and difficulties she had endured in capturing these trophies. At least, I thought, they did not have the generic ones of older women with drooping breasts. I wanted to leave.

I looked for James Murray and saw him through the throng of people, sipping a glass of white wine with his left hand and reaching into a bowl of crisps with his right. He was listening with one ear, to a thin wiry gesticulating man in a cream suit with a silk scarf tied around his neck, and to Gideon, who looked grey-haired and handsome in a navy-blue jacket.

I turned back to the photographs, skipped the rest of the nudes and started looking at images of the men; the gender division was the only concession to curatorial arrangement that I could see. The first image, of a man in a long white robe and a brocade-decorated *joho* mantle, was described only as *African Man with a Fierce Look*. I was sure he'd look fiercer still if he knew how he was being portrayed here.

I remembered what Kojo had told me of the palace drums, which when played in the olden days on the battlefield could awaken all the dead to fight on their kingdom's side. I wished I had those drums to hand now to animate all the figures frozen in the photographs – the half-naked boy carrying a dead leopard upside down and the giraffe

in the typical scene of an 'African landscape' – to make them step out of the pictures, stand face to face with the throng of English tribal-art lovers and show themselves as they were, rather than as the exoticised objects they had been reduced to.

I looked at the plaque next to a picture of four crouching men with large feather headdresses and skins wrapped around their waists, which quoted the inscription on the back of the picture: *The dance symbolises a continuous, unchanging element in the lives of the people – their ancient traditions and tribal lore.* The only hint of any evolution was the inclusion of a photograph by the Malian photographer, Seydou Keïta, whom an Italian collector – having recognised contemporary African art as a good business investment and knighted himself Ambassador of African Art, insisting that none of his artists had any formal education – had made into an art star. This picture with the trademark patterned backdrop was of a young couple wearing contrasting patterns leaning into each other. It might have been the exhibition's small saving grace, if not for the plaque, which read: *Despite his basic technical obstacles, Keïta revealed his subjects as they had not been seen before, wearing Western suits and bow ties, sitting on motorbikes and holding radios.* Not been seen before by whom? I looked around with disgust at the infinitely civilised West. I wondered if they all thought I was little more than an anomaly, a female Tarzan who had escaped the wilds and taken on their garbs and mannerisms. I had to leave.

I almost collided with an open-shirted man.

Sweat mottled his thinning hair and sat on his upper lip like a dewy moustache. 'Hello there,' he said. 'What do you think of these?'

I had no interest in answering him. Whenever I went to performances, exhibitions or theatre pieces where

the theme was Africa, people inevitably solicited me as the voice of authenticity, and I had no urge to satisfy the smug man's desires. China Delville, a gallerist specialising in contemporary African art, who was wearing a deconstructed linen tent and narrow multicoloured glasses, came to stand with us. She nodded intensely at the pictures, though her eyes seemed to be looking at a point beyond them.

'Beautiful, aren't they?' she said dreamily.

'You really think so?' I asked.

'Mmm. You don't?'

'There's no context, no explanations. It's as if nothing has happened, no revolutions, no post-colonialism, no deconstructions, no Said.'

'I think the curator was going for an aesthetic, rather than an anthropological, investigation.'

'Investigation?' I almost choked.

'It might have been interesting to put them next to African photographers' portraits of the time.'

'Exactly…'

The open-shirted man cleared his throat. 'If it's not too much bother, of course, I wondered if I could give you my card? I'd be very interested in taking some photographs of you…'

'No, thank you,' I said.

'Ooh,' China said, 'how exciting. Maya, take it.'

I looked at China's face. The excitement was genuine; it spoke of a youth spent trying the enlightening substances of all the different peoples of the world and of an old age spent dancing in the nude in experimental theatres, trying somehow to nullify the passing of time. I took the card for China, because I wanted to please her, in the same way I would have pushed a little girl on a swing even if I did not want to. I walked away without looking at the

man. *Richard Hunter*, the card read, *Chartered Surveyor*. He wasn't even a photographer, just a horrible old pervert. I stopped and stood in the middle of the room, looking for James Murray.

'Splendid,' China was saying. 'Oh, Paula Jones is going to speak. She is fabulous. A dear old friend.'

A woman with long red wiry hair, a loose linen blouse, a flowing patterned skirt and very large beads around her neck and wrists, began speaking. Her voice was deep-throated and velvety in the manner of women who sipped Chardonnay in country gardens in Hunter wellies and ethnic scarves. 'I'd like to tell a little anecdote from my travels.' She threw her hair back. 'It happened whilst I was amongst the Luba peoples last year, taking photos of their beautiful features, and teaching the girls how to bead. I asked the chief if there was anything I could give to his people as a gift. I had brought pens and chewing gum, obviously. But, in front of his people, the chief told me, with the help of a translator, that yes indeed there was something I could do for them, and that was to show my breasts.' Here, she leant back and paused theatrically to allow the audience to laugh, which they did in a civilised way.

A man behind me shouted something.

'Excuse me?' Paula Jones asked, cupping her ear.

'I said: boobies!' the man shouted again in a faintly Teutonic accent.

'Yes, quite. As I was saying, the chief asked me to show the village my breasts in return for having photographed them bare-breasted, and I said—'

'Boobies!' the man shouted a third time. 'Boobies!'

I and all around me turned to see who it was, but I could not make him out through the throng.

'Will you be quiet?' It was the wiry man James Murray had been talking to.

'So I tried to explain to him that this would be difficult for me,' said Paula Jones, beads clanking, 'I've had three children, after all.' She laughed and the crowd laughed with her.

'Boobies!' the man shouted once more and this time the crowd began to murmur.

'I tried to offer him all kinds of alternatives: money…'

'Motherfucking boobies!' the man shouted out, this time with venomous force.

'Now that's quite enough of—' the wiry man started saying, but was cut off.

'Motherfucking boobies! Motherfucking—'

There was a scramble near the entrance and I could see two of the museum guards taking out a young man in pressed jeans and shirt. I went nearer to get a proper look. Just as I did, a young woman with shiny tawny hair dropped her leather trousers and knickers to reveal that she was cleanly shaven. There was a commotion as another guard tried to grab the woman in an awkward manner and haul her up the stairs. I began to laugh.

'Friends of yours, are they?' James Murray was standing beside me.

'Not yet.'

'Disgraceful act of anarchy.' His friend had also moved closer to the door to see what was going on. 'Utterly pointless. I can't think…'

'I think they might have been demonstrating the obscenity of the continued objectification of the colonial subject,' I said.

'I don't think they had to be quite so rude.' He looked at me quickly and walked towards Paula Jones.

'Neither did you when you colonised us,' I smiled.

'Gideon's upstairs. Have a word with him,' James Murray said. 'I'm off to Spain for the summer so I'll leave

you to each other, and hopefully the outcome will be to both your advantages. Now, you'd better come with me.'

'How brilliant was that?' I asked. 'At least someone cares enough to make a stand against the whole charade.'

'And you will too one day, but in a far more articulate, coherent and considered way. They just made fools of themselves. And no one knew what on earth they were doing.'

'Yes, but I wish I didn't have to compromise myself to do it.'

'We all have to sooner or later in life. That's one of life's laws.'

'Is it really?'

'I have to rush for my train. Try and stay out of trouble. Bye for now.'

I stopped on the staircase and looked once more at the mostly sacred objects that had been bought or taken for the entertainment of others. I heard running and shouting from upstairs, craned my neck and barely missed being hit by an onslaught of magazines being thrown down by the same young woman who had lowered her trousers before.

A security guard grabbed her from behind, while another picked up her kicking legs and carried her out to the soundtrack of loud shrieking and screaming. I looked at what had been thrown down. They were porn magazines. Another of the guards came down and gathered them up from the floor, but left me holding one, on the cover of which was a picture of a woman on her knees in front of a broadly grinning man. I placed the magazine on top of a glass cabinet and headed up.

Gideon stood at the top of the stairs. 'Walk with me?' he said.

I nodded.

'I think we're both trying to do the same thing,' he began. 'And I think you need me—'

I stopped. 'I need you?'

'Yes, I can help you, give you the infrastructure, support you—'

'No, thank you.' I began to walk towards Oxford Street.

'Wait.'

'Why not admit that you need me, that you don't *have* a museum without me?'

He looked at me, annoyed. 'OK, I need you.'

'What is it you actually want?'

'I want to help…'

'I'm sure. Like all the NGO workers in Ghana with their four-wheel drives, servants and swimming pools. You know, we're not going to get anywhere, unless you tell me what you honestly want.'

'Generally, or specifically?'

'We can start with generally.'

'I want to be happy.'

I laughed. 'That's a start. And specifically?'

He paused. 'I want to be part of something.'

'That sounds honest, we can work with that… I need to finish something first. You'll have to give me a few months.'

'OK,' he said, but he did not.

He called every day, until the book I was writing faded slowly into shadow. We would have to gather objects, I told him, from as many of the kingdoms and groups as we could; have a section on the birth of the nation state in the context of other cultural independence movements, like the Négritude movement in Senegal and the Zaria art movement in Nigeria. The dream of a pan-African state stalled. An exhibit of the present, with all its different strands – all the paintings, sculptures and installations

that came out of the academies based on foreign models, as well as those of our friends – that would point to the future as much as the past. And yet, slowly, until it was unavoidable, article after article came out, in newspapers and magazines, pronouncing as Gideon's the narrative I had crafted.

He asked me for lunch, as he did most days.

I agreed and tried to swallow my anger when I saw him, but could not. 'What the hell is going on?'

'Hello to you too.'

'What is all this?'

'I don't know what you're talking about, Maya.'

I had no time for false innocence. 'Don't you see how damaging this is to us? How it is repeating the same old story? How the white man just comes in, takes over everything with no regard for what he found, for our agency, our truth? That this is not the time, not the place?'

'You know, for someone who seems very smart, you're acting like an idiot right now.'

I had rubbed at something that mattered; even his voice had changed.

'Did you just call me an idiot?'

'It's just the way I talk, Maya, to all my friends. Everyone knows that.'

'Really? You've never talked to me like that before.'

'Maybe it's about time. You've always said that you wanted to write anyway, rather than all this. So I've decided that, instead of us being co-directors of the project, you're stepping down. It gives you more time for writing. I'll pay for it. You can still advise us.'

As I walked away, I wondered if it was really I who had opened the door to this reality, when I thought I was doing all I could to upend it.

I found out now and not before that Gideon had taken the plans for our museum from Kojo, and had begun laying the foundations for it even before Kojo had died; that the architect Kojo had worked with to design the museum, stone by stone, so that its very form was directed by its narrative, had left to work with Gideon; and that, the night he died, Kojo was on his way to destroy the foundations; to burn and uproot what he could.

I thought of Kojo now, and how fear and anger had consumed him.

I thought of my mother and her shattered hopes.

I thought of my father, who told me, constantly, to call if there was anything I needed, and how I had stemmed myself against him for what I thought of as his weakness.

I thought of my wider family, and of how they were now again where they had always thought they should be; of how Kojo and my mother, who had dreamt so hard, were no longer there to witness it.

I thought of the man at home, and of all the obstacles and worries, and of how despite them, if you were clear enough, it was whatever was true and constant that shone through, and connected with what was so in you, even if you could not define it.

28

I returned home, as she had always wanted, and yet there was no resonance in the things I knew.

The leafy buildings in Cantonments and Airport Residential Area, the large-trunked shade-giving trees had been torn down and replaced by new anonymous condos. I walked the few old streets remaining, past trees flecked with fuchsia. At the traffic light, a girl stood with headphones, tight pink Lycra leggings holding in her fullness as she danced to the music in her ears. She was full of joy, and the sight of her made me, for a moment, so happy I wanted to stop and tell her I loved her; but we did not live in that kind of world.

I walked down the dusty back roads, until I reached a shack with wooden benches outside. There was a small TV inside with boys crammed onto the plastic chairs and on the floor. Some of them had their shoeshine equipment and barrels with goods to sell next to them. All over the walls of the shack, there were posters: of two black angels exorcising a white devil; a horned creature from *Star Wars* with a man draped in a leopard skin brandishing a spear next to a priest holding a Bible; a Bosch-like tree behind

two goat-headed creatures poking out the eyes of a bound man; of another man being rescued from a *Jurassic Park* dinosaur by two giant dwarfs with red-pointed hats and backward-facing feet. They were showing a film, in which the man was going to a traditional priest, who had white caked make-up on his face and seemed to be having a fit, all rolling eyes and tongue, half Godzilla, half goon. In the next scene, a woman on her knees prayed with a pastor for deliverance.

I walked to the corner shop, which was also a hairdresser's, and stopped to buy food and water.

The hairdresser asked me if I wanted my hair braided. I nodded and sat down. Her little girl came to sit in my lap.

'How many children do you have?' I asked.

'Please. Three.'

'How old are you?'

'Twenty-three.'

We were the same age.

'How long have you been married?'

'Five years.'

'You're still in love?'

She laughed. 'Love? What is falling in love? He calls you. You call him. You go and see film. One time. Two time. Then you are bored.'

I laughed. 'So you're not?'

'Sister. Eh. Don't get me wrong. I love my husband. But the most difficult part of all is to live with him, not to be in love with him. To see him every day and to accept who this man is. I work with one girl at the shop. She is saying, "I am waiting for the right one." When she says it, I laugh. *Tchya*. You keep on waiting and see.'

'You don't think there is a right one?'

'Of course not.'

'But what if there is? What if there is and you're not ready, because you're not fully yourself yet, because there is so much left to do before you become yourself?'

'Become yourself? You people and your book learning. What are you now?'

'I don't know. I feel like there's so much I have to see, and learn, and get rid of, before I can give myself to someone else... Are you happy?'

'Of course I am happy. I have my husband, my children, my family. I go to church. I see my friends. Don't go wandering round-round looking for something you are not going to find, eh?'

I looked out into the courtyard; her grandmother was outside asleep in her wheelchair, her mother was hanging up clothes on the line, her daughter crawled on a blanket on the ground.

My mother occasionally used to sing the song 'Sometimes I Feel Like a Motherless Child', and when she did, it was full of pathos, and mourning.

I had learnt from her to be a woman and now I was painfully giving birth to myself.

I had made the same mistakes we had been making for centuries, even though I thought I could see better, and yet I knew the outcome would not be the same.

I felt the beginnings of relief and release from centuries of obligation; from the fear of never doing, never being, enough.

Just like the girl in the pink Lycra, before I was my mother's daughter, the seed of my ancestors, I was a child of the universe, and perhaps we did live in that kind of world.

I thought of the cycles of belonging that bound us, that had written our paths even before we were born; of the wordless whispers that had been with me since birth.

I thought of the stool house, a room within a room, in which stood the symbols of our past and our reincarnated future.

I thought of the vision of a bare table covered in layered faded scrawl, of the empty chair that stood before it, of the shadows of those who had long left, and of the open door through which, if only I wanted, I could walk.

Appendix

The Book of Histories

Fragments of the Life of Yaw Gyata

The four of us were always together then, and what we shared, or so it seemed, was the same grand sense of entitlement. Kwamena, son of a cocoa farmer. Your mother, Amba, granddaughter of a slave and daughter of my father's chauffeur. Your aunt, Yaa, royal princess. And I. Amba's sense, like Kwamena's, came from knowledge, but unlike he who always seemed to know everything best, she knew it all first. All the market women, the traders, the palace courtiers knew Amba by name. She, the daughter of the only one of my father's staff who never drew any criticism from him. Paa Kwesi polished my father's Imperial, Studebakers and Chryslers with such fervour and wore his uniform with such precision that my father kept him with him at all times. When Amba arrived, she did not at first seem prone to her father's fastidiousness; she wore only a printed wrapper around her body, and no sandals on her bare dusty feet. Her eyes, large in her closely cropped head, surveyed the stone room, the pots and bowls and rugs and furnishings my mother had received as gifts from my father and her

brother, Uncle Kagya. Then, when my mother left to spend the night in my father's quarters, she filled the space, by busying herself with the bowls they had eaten from, with more authority than I had in my own house. She became my mother's silent and unbidden helper, rushing to Yaa as soon as she got home from school, tying her to her back to lull her to sleep, as if the silent satisfaction of the child gave her everything she needed. We sometimes played parents in those days, she and I. I more indulgently, she with the deathly seriousness that was her wont.

When I think of you as a child on her back, it is really your Aunt Yaa that I am thinking of, as we pamper and feed her, until she erupts like the volcanic mountains of Sicily. I hope you have seen Sicily in your time. Your mother never did. I never took her.

But perhaps she already knew then that I would one day leave, just as she knew before us all that the Amantoomiensa would try to take the sandals from my father's feet, while he still slept the sacred sleep of forgetting, and that Yaa would fall in love with Kwamena.

The dryness that began in April persisted, as did the court case, and with it everything dissipated.

My mother built on the plot of land she had kept, a house so small that we could not fit the remainder of our furniture and clothes in it. We had to give away those we could not sell at the market.

She began to farm, as if she had done it all her life, getting up before the sun and returning home after it was long dark. I accompanied her and did, as she did not, complain at the harshness of the sun. She did not complain even when the droughts truncated the growth of the cassava, yams, plantain and kontomire we planted and we barely had enough to eat, let alone sell, for Yaa and Amba's school fees. After school, the girls sold the produce we harvested at the market.

If not for visits to my cousin at the palace, our former life would have seemed an illusion. My mother would not accept money from any family members, but one of my brothers heard Yaa was selling goods, and arranged for her to be sent to the local boarding school. Without Yaa, Amba wanted to go to the missionary school; and without their school fees to pay, she no longer had to work on the streets.

It was not often my mother was tired, but once a month she stayed home to rest. I went out to farm on my own.

A letter came from Kwamena. I sat under a palm tree to read it, but the first sentences, his talk of Du Bois and Garvey, of names that were no longer my currency, were already too much.

I took up my cutlass. The sun beat down on my head, which was full of thoughts of Kwamena, in jacket and tie, in a lecture hall.

I went home. When I turned into our courtyard, I saw my mother hanging washing out to dry. My ire increased.

'Has it come to this, Mama? Have you forgotten who you are?'

'It is because I have not forgotten that I do this.'

I sat on a rock by the wall. 'I don't understand. I don't understand why you must lower yourself like this.'

'This is your sister's laundry.'

'Yaa's? You're picking up her laundry? You want her to grow soft and useless? Like the other royals who can do nothing for themselves?'

My mother did not stop hanging and she did not raise her voice. 'You did not have to suffer as you grew, or lift a finger for yourself. You will not remember, but she was born with a mark on her forehead, and your father outdoored her, not in common cotton, but in Adwinasa kente and Ago velvet. She was born for greatness, not this life.'

'Yes, Ma, neither were we. Mark or no mark. None of us were born for this, but what do you think it is doing to this

girl, to have to sell oranges for her school fees on Monday, and have her clothes washed and ironed by her mother on Tuesday?'

'I am giving her the only thing I can, to remind her of who she is.' My mother stopped hanging and looked at me. 'I went to her school today. They are coming on a school trip to Kaba tomorrow and the whole class wants to see her home, because they know she is a princess. She was crying, "How can I bring them to this house?" I have only one day. I shall borrow some rugs. I will make curtains with some of the lace left me by your father.'

I looked down at her callused thinned hands, at her back once straight and proud, at her hair that had always been tied up in the most sumptuous of cloths that now stood coarse and grey, and nodded.

All night, she sang and prayed for our health, well-being and happiness. All night, she sewed and cleaned and arranged.

Amba was in Akakom with Miss Meiklejohn doing missionary work, so it was only my mother and I that waited the next morning for Yaa and her schoolmates to arrive. My mother wrapped her Adwinasa royal kente around her, tied her hair in silk cloth. She put out one of my old kentes on the bed for me to wear. We sat on the porch outside the house, as if there was nothing else to do, as we had not done for a lifetime. Under the shade of the odum tree, I drank cold beer and my mother water, as the town people stopped and talked of the price of cocoa, of their families, of my work with my Uncle JB.

'Do you think she has got lost?' my mother asked me as the hours crept.

'To her own house?' As I spoke an image rose in my mind. 'Mama, I'll be back.' I walked to the palace.

There was a large bus outside its gates and through them I could see young girls in green-and-white checked dresses

and straw hats. I walked past the guards towards the palace building. There she was, rushing from room to room, shouting orders as if she had never stopped, holding one courtier by the arm, motioning to another. She ran up the stairs holding on to the balustrade, opened the door to the King's chambers, walked in. I looked at the girls as they watched the door, talking and laughing, their voices like the songs of the koko-kyinaka bird that hid in the forest mountains outside Kaba.

My cousin appeared at the balustrade with my sister and his spokesman. It seemed that he had grown taller, as well as older. He looked down at the girls and waved, then held my sister by the back of the neck, laughed at something she said.

How did she do this; how, despite the depths we had fallen to, did she manage to create laughter all around her? Maybe, it was true what my mother had said, that she was marked.

I walked back out of the gates and towards the dried-up River Birim.

Maybe our father's worldly departure, our fall, had forced her to enhance her wit, her ability to draw attention to herself, as if constantly trying to move from the shade into that first-promised light.

When she later came to the capital with me and my brothers, despite her being a girl, we involved her in our political discussions, allowed her to sip port and claret, smoke the long thin cigarettes that were my father's habit. Working for our brothers in the holidays, she asked for money so she could get the best clothes and food to take to school, as if it were all a game.

What was in her that could not be quelled? That shone from her eyes, filled her laugh, her dresses, the room, so that even if she had brought the girls from school to our house, they would not have believed she lived there. How could it contain her?

There was her laughter again, through the open windows, as I approached.

'He made us soup with snails, and the meat in it, Mummy, you should have seen…'

I opened the door.

'Bra,' my sister ran to me, her mouth an open smile, 'have you seen what Mummy has done to our house? It looks like the palace. And only for me. Tchya.' She danced the slow dance of the Adowa. 'Hmm. They thought I was bluffing, but the Gyaase served them more fufu than they could take. You should have seen Martini's face.'

'Martini?'

'She will come and pick me. Now when we go back to school people will know not to bluff me.'

I sat and watched as she made my mother laugh by kissing her and dancing and kneeling by her feet.

I longed for a dream of my father.

'Is it true you and Uncle JB are starting trouble with the English?' my sister asked me.

I had started working for his paper in the afternoons and it was causing some consternation amongst the British. 'Who told you?'

She rubbed her hand across the table. 'Just a friend of Martini's.'

'Martini again. What kind of friend?'

'A civil servant.'

'What kind of civil servant is a friend of a schoolgirl? Is he too coming to pick you?'

She turned towards my mother and started playing with her silk cloth. 'When you have finished with this, I will take it and wear it around my neck,' she said.

'Take it,' my mother said, removing it from her head.

I got up and took the silk cloth from her hands. 'And your school allows this kind of thing? I thought it was a Catholic school, and not a breeding ground for young whores.'

226

There was a moment's pause, as if the walls of the room had to soak in my words, push them back out again.

'Apologise to your sister.'

Yaa lay face down on the sofa and began to cry as if I had beaten her.

But the heat in my stomach would not let me. I walked out of the house, sat on the porch and watched as people went by on their business, everyone seemingly at rights with the world.

A car pulled up outside and a young girl in Yaa's school uniform stepped out.

'Good evening,' she said to me.

I did not think of my sister as anything but a girl, but seeing Martini, the way she held temptation in the sway of her hips, reminded me that she was almost a young woman.

'Good evening. You are the girl they call Martini?'

'Yes, sir.'

'Why?'

'It's a nickname, sir.'

'Its meaning?'

'Sir, I'll be late.'

I walked towards the car.

'Good evening,' I said to the man behind the wheel.

He nodded and got out. He was older than me, wore a hat and suit. 'Oheneba,' he said, using my title. He held out his hand.

I could not shake it. 'I hope you do not find this insolent but, if you are not related to these girls, what are you doing with them?'

He pulled out a cigarette and offered one to me.

I waited.

'I understand your worry, but it is unnecessary. I am a friend of Martini's father. He has asked me to look after her. I buy her books, clothes she can't afford...'

'And what does she give you in return?'

'Even if that were your concern,' he said, 'you would be mistaken in your conclusions. Some of us are Good Samaritans.'

The door to the house opened and the girls came out. My mother stood in the doorway.

'Does your school know you're going back with a stranger?' I asked Yaa.

'He's not a stranger. He's Martini's friend.' She held her chin out towards me.

'I asked you a question.'

She shook her head.

'I will drop my sister off at school, thank you,' I said.

'You have a car?'

I did not answer him, but put my arm around her shoulder and held it there, despite her attempts to break free.

She slept in the bed that night with my mother.

Later, when I was long gone and my mother still wrote me letters in spite of my silence, she told me that Yaa still slept in her bed when she visited, even when she had children of her own.

I heard them pray that night, got up to see them kneeling side by side; their eyes closed; their faces lit with an intensity of faith that I would never know.

*

My first impression of England was of thick low-hanging mists swallowing the tops of the land. They reminded me of the mists that hung above the Kaba Mountains, but born of cold not of heat.

The noise of war followed me to London and mingled with that of the crowded streets, the advertising hoardings, the trams and double-decker buses and automobiles, all the way to the address Felix's friend Nancy had given me to pick up the cheque.

It was only when I arrived there that I found silence.

It was there as soon as she opened the door.

In her matt red lipstick, the powdery white of her skin, the dark of her thick waved hair, and black wrap-around dress that did not give much room to her curves, but was generous to her décolleté, and in the ebony and ivory bracelets that wound up her arms like snakes. She smoked a long cigarette in a holder as she held open the door and its smoke wove its way above her head like a welcome signal. She must have inhaled before she opened, because she did not speak, but waved me inside and nodded.

I entered the hallway. The door to the drawing room was ajar. There were thick Turkish and sheepskin rugs on the wooden floors, colourful paintings in gilt frames crammed on to every space of the high-ceilinged walls and books covering every surface.

'Darling,' her voice was hoarse. 'You look absolutely frozen. Let me get you a throw.'

She did not wait for me to answer, so I went into the drawing room and picked up a thick magazine from the sofa. Présence Africaine. *I opened it. There were articles by the writers Felix had spoken to me about. Poems by Léopold Senghor and Blaise Cendrars and Aimé Césaire. Felix told me Césaire had coined a term, Négritude, that described the collective destiny of black people. He had not answered when I asked him which collective destiny it referred to.*

'On second thoughts,' she stood in the door, 'you'll need a bath. Come. I'll run you one.'

I followed her up the stairs, through a room scattered with furs and clothes of every imaginable fabric and texture, into a room with a bath standing alone and regal at its centre.

She turned the tap and put her red-nailed finger under the pouring water.

'Mmm. Enjoy. I'll put a robe on the bed for you.' She walked out, without waiting for me to answer.

I had not said a single word since I had come in. I could have been any man, any black man, who had walked off the street into her bath. I took off my dirty clothes and got in.

That night she made dinner. The potatoes and vegetables were overcooked and the meat underdone though they were served on the finest blue bone china and with delicate gold cutlery. After the meal she served port in the drawing room in crystal glasses, and I sat back and smiled despite the bad taste in my mouth from the food.

'What is it? You like what you see of London?'

'I have not been treated like this since my father died.'

She said nothing for a long time. 'Let's go upstairs.'

I followed her again up the stairwell. There were three flights of stairs and I wondered who else lived in this vast house and how comfortable my bed would be.

We stopped outside the room with the clothes scattered on the floor like wild flowers.

'You'll sleep with me tonight,' she said.

I looked at her. I had never spent the night with a woman, or spoken more than formally with a white one, yet here was one I had barely met, inviting me to share her bed. I wondered at first if it was a joke or if perhaps she was worried about me catching cold, but when I looked through the open door, I saw that she had already dropped her wrap-around dress to the floor. She had her back to me. Her hands reached behind her to undo her brassiere. I looked at the white of her hands, the red of her nails, the black of the stiff material and of her waved hair.

At home, white was the colour of our beginnings, of water and semen; red the colour of our living, of the earth and blood; black the colour of our ends, of air and power.

As I stood watching her brassiere fall, I thought of the growth of power from temporal to spiritual.

Of the interdependence that made all existence possible.

How I was so stuck in this white, with no red to encompass me, no black to power me ahead.

She turned. And all was silent again.

*

Amba was the first person I saw when I arrived back home at my uncle's house. She lay on the bench by the porch as people did not in London and, when she saw me, she sat up and stared for a long time, as if I was the ghost I felt I was when I left. She walked to me and put my cheek in her left hand and with her right covered my head.

I stood between her hands like the shipwreck I felt then. I left my bag outside the house and walked with her to the sea.

We sat on one of the cliffs and watched the waves rush against them, as if in penitence for sins of which they would never be relieved.

She did not ask me questions about the war or of London and I was grateful, as I had been before, for her company.

I took her hand in mine and kissed it. 'Marry me,' I said. 'My Amba. Marry me.'

She let her hand rest there, and when I got up to walk towards the house, she did not let it free of mine. 'My ring?' she asked.

I laughed. And for the first time I kissed her. The kiss was as familiar as anything I had known. It was like kissing Yaa or my mother or Kwamena. And in that moment I loved her like I never had loved before. Not my father. Or Felix. Or Nancy.

It was a love so strong that I felt I might never leave its current. It was to be the only time I felt this, and my deception might be what killed her.

The promise of everlasting love never fulfilled.

There are so many things I am sorry for.

But most of all for this girl of purity and innocence who loved, as if there were no danger in it, and who thought that her future would be one of love returned.

<div align="center">*</div>

That night, the final Wirempe ceremony was to end the funeral rites, so that my father's spirit would journey to Asamando, the dwelling of the ancestors. I waited by the sacred stones at the palace for the Odumonkomakyerema and the others to take my father's stool to the forest to be invigorated by ancestral spirits. It was my first Wirempe ceremony and that of most of the others. The last one had been thirty-one years earlier. I sat and waited on the bench facing the stones, but no one came. Sweat was forming in my palms despite the night air. I wiped them on my bata- kari smock. The black sky began to lighten. I walked to the Odumonkomakyerema's house, but he was not there. I went to the other elders' houses and they were empty. I arrived at my own. Uncle Kagya was staying with us through the funeral obsequies. He and all the elders were sitting in a circle of chairs in the courtyard drinking schnapps. I could see my mother standing on the steps of the doorway. The girls were long asleep. I went forward. All my kin's faces were closed and I did not know to whom to turn. I stood at the entrance of the courtyard, until I remembered I was no longer a boy, but the head of my family. I went forward to my Uncle Kagya.

'Uncle, good morning.' I bowed my head. 'I am now head of my mother's family and no longer a boy. I hope you permit me to ask what has happened that you are all so solemn, when the final rites are supposed to be taking place?'

'The Odikro of Apapam has disappeared.' He took a sip of his schnapps.

I sat down on the step next to my uncle.

'Until he is found, the Amantoomiensa refuse to take part in the ceremony. They say that we have killed him so that he could follow the King in death.'

Did any of this matter in light of my father's final rites?

'It is absurd. We haven't used human sacrifices for many years,' a senior spokesman said.

'We all know how heavy our King's departure was,' another said. 'They will say that he needed a servant to follow him to the land of ancestors.'

'Nonsense, everyone knows that the Odikro was epileptic. How can a ruler be deformed and rule at the same time?'

They all spoke at once now. The moment for the final ceremony was passing.

'Last year the Sanaahene, the King's Lord Chamberlain, was destooled, because he was circumcised.'

'Ei. They say he had an epileptic fit in the marketplace. To be shamed in public is more than sufficient cause for an Odikro to take his own life.'

'But where is the body?'

'They took it, because they hate us.'

'This is what they have been waiting for to bring us down.'

'What of the ceremony, Uncle?' I asked.

'We will postpone it, until this unpleasant matter is settled.'

They began to speak of the arrangements for the postponement, and were still speaking that morning when the Odumonkomakyerema beat the gong-gong, calling for all the young men to form search parties for the missing man. There was a notice in the Gold Coast Press and the State Council offered a reward of £8.

They summoned the Amantoomiensa to meet them, but they refused, gathering instead in the courtyard. I was in the council chamber, seated between my two uncles. Our new King suggested the State Council join the Amantoomiensa.

When we arrived there, the Odikro of Tetteh was shouting, his voice high and strained. 'Every house in Kaba must be searched. The palace must not be spared.'

The King's spokesman, the Okyeame Abroso, spoke. 'You must be calm and collected, and stop your abuses and insinuation. It is not likely that the missing Odikro is still in the capital for, even if he is dead, nobody could keep his corpse and breathe it.'

The Odikro of Tetteh's spokesman answered for him. 'It is true, we broached the question that the palace must be searched; however if you point your gun, you stain your shoulders. We do not propose to search the palace. After all, we are slaves to be sold in the interest of the Paramount Stool. We have no wish to cross words with Nana, but the Amantoomiensa, the Three Counties, are now reduced to Amantoomienu, the Two Counties.'

With this, they turned and walked away.

In the old days, there was not the thanatophobia, the fear that Europeans had of the unknown beyond the grave, the passionate clinging to life. Death was a transition, like birth, from one kind of life to another, and those left on earth had to see to it that the King entered the spirit world with a retinue befitting his high station. People were killed to resume their duties for their royal master after death. Prisoners of war, criminals sentenced to death, High Court officials, relatives, wives of the dead monarch who no longer had the will to live, all followed him.

But could this death really have been a sacrifice to pacify the elements? An act to re-establish order, to shout out our grief at the loss of this great presence? Would I not have heard of it? Was it being presented as a crime by our enemies? Were the colonial authorities making an example of the arrogance of our family, because we had attacked their prerogative?

There were only a few truths we could all agree on. That the missing man was an Odikro. That he was forty-eight years old. That his ears were small. And that he walked slowly and gently.

Certainties of his life that might have made up for the uncertainty of his death. If the old order had been standing on the edge of a cliff, it was his disappearance that pushed it over the edge and, in its course, changed the fate of a country.

Three months later both Kwamena and I received our acceptance letters to the University of London.

That day the priest Osei Tawiah visited Police Corporal Nuamah, telling him that one of the palace courtiers had confessed to the murder. 'He asked me for medicine to lay the dead man's ghost,' he told the policeman and took him to a place close to the royal mausoleum in Kaba to uncover the remains.

The same night, with only a kerosene lamp, they sank spades in the earth, and unearthed nothing.

Days later, Kwamena received another letter, asking him to come for examinations and interview at the University of Cambridge. An anonymous note arrived with the supposed whereabouts of the Odikro's remains.

The police dug up a skull, lower jawbone, seven limb bones and a tooth. The evidence was as shaky as our traditions would come to seem.

The priest Tawiah had been dismissed from being a servant of his shrine three years before and the skull and bones were said to be those of a woman who had died two years earlier.

And yet Uncle Kagya, three of my brothers, two cousins and Odumonkomakyerema Pipim were arrested and charged with the murder of the Odikro.

I was in the courtyard when the police came to search the stool house.

The King's spokesman told them that no Asante, no circumcised man, and no one in shoes could enter, and the search party was reselected.

'Where is the eighth stool?' the Odikro of Tetteh asked.

'It is on the King's temporary grave in the mausoleum,' the spokesman told him.

We made for the mausoleum, libation was poured and a sheep was slaughtered. There was a white stool resting on a mat on the grave mound.

'This is the stool to be consecrated and blackened for our King,' said the spokesman.

'This is quite untraditional,' the Odikro said, his larynx straining against the skin of his neck as the Amantoomiensa reminded him where he was.

There were those who said the Odikro had been killed to blacken my father's stool.

Blackening the stool was the greatest honour one could give to a king or queen mother after their demise.

Those who harmed the stool through their vices or had been chosen for the lack of suitable heirs did not have stools blackened in their honour.

Some said it was custom that the Omanhene's stool was placed on the grave for at least a year and that there was no link between the epun, the blackening of the stool, and the Wirempe ceremonies.

Others said that the Omanhene's stool was to be left on the grave to rot and a different stool would be blackened.

Some that human blood had never been used to wash stools.

The ritual experts who had supervised the last funeral were long dead.

The question of what was traditional or not was to be constructed, forgotten and remade, as the case ran its course over the years.

*

I looked down at the Justice of the Gold Coast Supreme Court. I knew that his name was Mohammed Fuad, that he was a Cypriot, and that he was coming to the end of a long career. An unhappy man, my uncle had called him, long separated from his wife and family in Cyprus, complaining bitterly of the prejudice against his name and Muslim religion that stopped him becoming a colonial Chief Justice.

Uncle JB got up. 'It is wrong to convict men on circumstantial evidence.

'The facts are that the Odikro was having troubles with his subjects and that they had already tried to destool him.

'Speculation is that he was ready to abdicate after the conclusion of the funeral ceremonies and that he had an epileptic fit in the courtyard during the funeral ceremony.

'Now, it is well known that an Akan ruler is not permitted any physical weakness or deformation and to be so shamed in public is sufficient cause for the Odikro to take his own life.

'We have had witnesses profess that they saw the Odikro at eight a.m. on the Kaba–Adadientem road, after he was supposed to have disappeared.

'We have witnesses that question the credibility of the chief witness of the prosecution, a known thief and wife-beater, dismissed as a servant of the shrine three years ago.

'We do not have conclusive evidence that the disinterred skull and bones are those of a man.

'And last, but not least, all these men, apart from one – Kwadjo Amoako – are devout Christians, whose doctrine prohibits the very act that they are supposed to have committed.

'They are Christian and servants of the court and as such are fully aware of the balance of rights and obligations, the unbroken chain of honour, which exists in a world in which one is never exempt from the eyes of the ancestors, in which any taint on the honour of a king is unpardonable. If there

is a shadow of doubt in your minds, gentlemen of the jury, I beg you to consider it.'

The Assistant Attorney General, J. S. Mensah-Sarbah, the scion of a distinguished coastal family, an excellent cricketer, who had trained at Lincoln's Inn and had been my uncle's former mentor, got up to speak. 'There has been a loss. We have heard from two witnesses, two Okomfo priests, that two of the accused came for Sassaduro, medicine for laying ghosts.

'Let us imagine that, as confessed to the Okomfo priests, on the afternoon the Wirempe ceremonies were to take place, the King's son A. E. B. Danquah invited the Odikro to drink palm wine, and while he was drinking, another of the princes, Ebenezer Agyata, got up, stood behind the seated Odikro and hit and cudgelled him when he tried to rise, that the Odikro's cheeks were pierced with a sepow, that his blood was collected in a bowl to be smeared on the King's stool as part of the epun, the consecration of the stool – all while a memorial service was happening not a hundred yards away in the Presbyterian church.

'We know that we are dealing with a group of people who assert their pride and unassailable belief in their privilege above others at every turn, who do not value the blood of a man unless, and I quote one of the family, it is made of gold.

'They believe it is their divine right to rule.

'It is this attitude that could make an act like this possible and will make it possible again, unless we put a stop to it, once and for all.'

The silence of the courtroom broke and the jury went outside.

My mother got up slowly and walked out. All three of us followed. We went to the car park and the driver opened the door for her to sit in the back. A crowd had gathered outside the white building and I could see the Odikro of Tetteh, in a green-and-blue kente, orating. He was holding a news-paper and I went and stood at the back of the crowd. Copies

of the paper were being passed around and I leant over a young man's shoulder and saw pictures of my brother A. E. B. Danquah in a three-piece suit, of Ebenezer in a top hat and black tie and of Uncle Kagya in a sumptuous cloth.

"'Ofori Panin Fie, until recently the splendid palace of the Gold Coast's most splendid monarch, is now alleged to have been the site of a foul murder,'" the Odikro read out aloud from the paper. "'Not just alleged, but indeed so.'"

The crowd made such a noise that it did not at first hear.

It slowly hushed as a female voice rose higher and louder than all the others. 'Mo yɛ nkwaseafo,' it was shouting. 'You are all fools. Your heads are turned backwards so you do not know which way you walk.'

I knew Yaa's voice before I saw her, alone amongst the crowd of men. She opened her mouth to say more. I saw all the men turn to look at her in her blue shift dress, her hair in a long braid at her back. They were silenced now, but soon her insults would raise their ire. I went towards her, just as the man next to her was trying to calm her by putting his hand on her arm. She pushed him with all her might.

'Mo yɛ mmoa. You are animals,' she was shouting.

Tears streamed down her face as she beat at the man. I put my arms around her and tried to carry her off, but she was intent on fighting and hit out at another man on her left. I picked her up and lifted her out of the crowd. She was crying so hard she could not breathe through her tears.

'Yaa,' I shouted with all my might, not caring who would hear, 'you never do that. You never fight with men, Yaa. I do not care how angry you are or what they have done. If a man shouts at you, you do not fight him.' I was shouting so hard now that my throat hurt. 'You walk away. Do you hear me? There was a crowd of men. Men who hate you and your family and everything you stand for. They could have hurt you or worse. They could have killed you. Do you understand me?'

239

Amba came to Yaa and held her in her arms. My mother was getting out of the car. She had the faraway look in her eyes, but when she saw how Yaa was crying, she ran to her, almost falling over her lace kaba.

'Me ba,' she said in a strange shout-whisper, waving her hands in front of her. 'Me ba. My child.'

Yaa ran to her. The driver led them to the car. He came towards me holding something. It was the Gold Coast Observer.

'Not everyone is against your family, sir,' he said. 'I am taking them home. Let us pray for the right verdict.'

I nodded and looked down at the front of the paper. It read: 'Sacco-Vanzetti case of West Africa. King's sons on framed-up charges.'

I folded it until it was a very small square in my hands and walked back into the courtroom and sat down next to the three empty chairs. My skin felt cold and I was shivering despite the oppressive heat. I rubbed my bare shoulders just as the back doors opened and the members of the jury entered. The bustle of the crowd rose to a new pitch and the judge rapped his hammer repeatedly.

He took off his wig and wiped his brow.

A clerk brought him the verdict from the jury.

The judge looked down and slowly put on his wig the square of black cloth, and sentenced them all to death.

*

I kept my head bowed as I walked past the throngs and photographers and newspapermen and across the dusty street towards the sea.

There were naked boys jumping into the waves, and fishermen pulling their boats in from the reefs.

I dropped to my knees and put my hands into the hot sand. I thought of taking my kente off, walking into the sea, not coming out.

Perhaps the gods would take me as a sacrifice for whatever wrong had been done; whether it was our pride or some cruel onslaught of history that could not be stalled, I did not know, but the outcome was the same.

Over the next months, the press would make much of our wealth, status, our privileged personal ties.

They praised the police and Governor Burns, and poured blame, not just on the accused men, but on all the structures of the palace.

The Amantoomiensa drew up charges against my cousin and forced their way into the palace, with the aim of marking him so badly that it would warrant destoolment on the grounds of his physical deformity.

It took forty members of the Native Authority Police to beat them back.

But all this was before us.

I watched the boys jump and run into the waves.

The sun sank into the crystal drops of water on their skin.

I closed my eyes and tasted the salt of tears on my face, and wished there would be nothing but these boys and their laughter crashing off the waves.

Hands in hot sand, sun relentless on my head, the cool blueness of sea as far as sight, the sharp taste of salt dissolving, forever dissolving, and nothing before or after.

The pain is too much now and I must stop. I am nearing the end of my story, Kojo.

Do not think I have forgotten you.

I think of it, the river. Of its secrets and many voices.

I think of the bell of the clock tower. Of my father. Of the four of us walking the streets of Kaba, buying chocolate and shelling peanuts amongst the goats and chickens and stray dogs.

And I think of how I knew, but did not know, what light and happiness was.

A Note on the Author

Nana Oforiatta Ayim is a Ghanaian writer, art historian and filmmaker. She is founder of the ANO Institute of Arts & Knowledge, through which she has pioneered a pan-African Cultural Encyclopaedia. Recently appointed a TORCH Global South Visiting Fellow to Oxford University, she is also the recipient of the 2015 Art & Technology Award from LACMA; of the 2016 AIR Award; and of the inaugural 2018 Soros Arts Fellowship. She is a contributor to the 2019 *New Daughters of Africa* anthology and in February 2019 delivered a TED Talk. Ayim will curate the Ghana's first pavilion at the Venice Biennale in 2019. *The God Child* is her first novel. She lives in Ghana.

A Note on the Type

The text of this book is set in Adobe Garamond. It is one of several versions of Garamond based on the designs of Claude Garamond. It is thought that Garamond based his font on Bembo, cut in 1495 by Francesco Griffo in collaboration with the Italian printer Aldus Manutius. Garamond types were first used in books printed in Paris around 1532. Many of the present-day versions of this type are based on the *Typi Academiae* of Jean Jannon cut in Sedan in 1615.

Claude Garamond was born in Paris in 1480. He learned how to cut type from his father and by the age of fifteen he was able to fashion steel punches the size of a pica with great precision. At the age of sixty he was commissioned by King Francis I to design a Greek alphabet, and for this he was given the honourable title of royal type founder. He died in 1561.